Digital Cameras & Photography

FOR

DUMMIES®

2ND EDITION

by Mark Justice Hinton

author of *Digital Photography For Seniors For Dummies*

Wiley Publishing, Inc.

Digital Cameras & Photography For Dummies, 2nd Edition

Published by
Wiley Publishing, Inc.
111 River Street
Hoboken, NJ 07030-5774

www.wiley.com

WILEY

About the Author

Mark Justice Hinton loves taking photographs. He has no regrets about leaving film for the digital era. He stalks the Southwest with a camera in his hands at all times, or so it seems. His friends and neighbors have gotten used to that. Hinton is a nature photographer, if thousands of photos of flowers, bugs, and birds are any evidence.

Hinton is also a long-time computerist and author of *Windows 7 For Seniors For Dummies* (published by Wiley). He has taught computer classes for the University of New Mexico for more than 20 years.

Dedication

To Merri Rudd, brilliant on both sides of the lens. — MJH

Author's Acknowledgments

From a distance, a book appears to follow a straight line from writer to reader. Up close, one sees the web of other critical participants. A surprising number of editors turn raw into readable. Still more people make the book real and bring it to your hands. My thanks to everyone in the web of this book.

More specifically, I could not have done this book without Rebecca Senninger. (And I'm still thanking Jodi Jensen for her work on the first edition.) I am also grateful to Steve Hayes for this opportunity, Debbye Butler, and Cherie Case.

I have lived with two great photographers. John Merck taught me to take lots of pictures and show only the best. (I'm still learning the second half of that lesson.) Merck also taught me the eponymous Merck Shot: a breathtaking close-up.

For more than 29 years, I've learned from Merri Rudd, who taught me to change my perspective in more ways than one. Merri let me use the same camera she had used as she crawled on her belly among mountain gorillas the jungles of Rwanda. Her two shots were always better than roll. I owe her this book. (Not a valid contract.) — MJH

"Long ago, it must be, I have a photograph
Preserve your memories; they're all that's left you."
Paul Simon - Bookends

Publisher's Acknowledgments

We're proud of this book; please send us your comments at http://dummies.custhelp.com. For other comments, please contact our Customer Care Department within the U.S. at 877-762-2974, outside the U.S. at 317-572-3993, or fax 317-572-4002.

Some of the people who helped bring this book to market include the following:

Acquisitions and Editorial

Project Editor: Rebecca Senninger

Executive Editor: Steve Hayes

Copy Editor: Debbye Butler

Technical Editor: Dave Hall

Editorial Manager: Leah Cameron

Editorial Assistant: Amanda Graham

Sr. Editorial Assistant: Cherie Case

Cartoons: Rich Tennant
(www.the5thwave.com)

Composition Services

Project Coordinator: Patrick Redmond

Layout and Graphics: Carl Byers, Samantha K. Cherolis, Joyce Haughey

Proofreader: John Greenough

Indexer: Sharon Shock

Publishing and Editorial for Technology Dummies

Richard Swadley, Vice President and Executive Group Publisher

Andy Cummings, Vice President and Publisher

Mary Bednarek, Executive Acquisitions Director

Mary C. Corder, Editorial Director

Publishing for Consumer Dummies

Diane Graves Steele, Vice President and Publisher

Composition Services

Debbie Stailey, Director of Composition Services

Table of Contents

Introduction

Smile! Everybody say "cheese."

Photographs freeze a moment in time forever. Even an underexposed, out-of-focus photo may affect you as strongly as the finest photo art. Photographs fascinate and entertain. People like photos.

Whether you use a cell phone camera or a top-of-the-line professional model, the widespread availability of digital cameras has energized popular photography. At any moment — triumphant or embarrassing — you can be ready to capture the scene.

Some things about photography haven't changed with digital technology. Your pictures have a subject and a frame. You can compose your photo by following guidelines that go back further than anyone reading this book can remember. However, digital photography has brought a few radical changes to photography:

- Photos are immediately accessible and shareable — no more delayed gratification
- Photos last forever — digital never fades or curls
- Technology makes things easy that used to be impossible by enabling you to stop action and capture great details

The phrase *point and shoot* promises an ease of use that most digital cameras deliver. But this simplicity also brings new challenges, such as what to do with the 30,000 digital photos stashed on your hard drive.

Your camera's Automatic mode almost guarantees that you'll take adequate photos under most circumstances. That mode leaves some room for improvement in your shots, however. Your camera has more sophisticated modes and settings, and this book tells you what they are and how to use them.

After the shot has been captured, you can still do more with the photo. A few simple edits can transform a photo from "okay" to "Wow!" You can share your snapshots or art with the world or with just a few friends.

About This Book

Taking good photographs does not require you to be exceptionally talented or studious. Neither should your photographs force your friends to yawn and make excuses to avoid looking at 300 similar shots from your vacation. The

goal of this book is to help you enjoy taking pictures and to help you experiment with all the features of your camera, as well as to deal with your photos after the shot.

This book provides an overview that takes you from buying a camera to taking easy photos, to better photos, to sharing your photos. Along the way, I provide enough depth to help you gain confidence in your photographic endeavors. You won't find any long-winded lectures here ("Lens Caps: Impediment or Opportunity?"), but you will find helpful steps and friendly advice from someone with a lot of experience with digital cameras.

In this book, you discover

- What to look for in your next camera
- How to choose among camera settings
- How to move pictures to your computer
- How to make easy, effective edits
- How to share photos with friends through the Web and printing.

Whom This Book Is For

You may already have your first digital camera, or you may be ready to get a new one and are looking for some guidance on what type of digital camera to buy. Perhaps you want to take advantage of your camera's automatic functions, but you're curious about what else your camera can do. If you want to find out the essentials of digital photography — from choosing a camera to sharing your photos, and all the steps in between — this book is for you.

How This Book Is Organized

The book is divided into five parts, and each part is divided into multiple chapters. Although I'm happy to have you open this book at Chapter 1 and read it from cover to cover, it's organized so that you can quickly flip to any section of any chapter and find just the information you need right then. Here is how this book is laid out.

Part 1: Getting Started the Digital Way

The two chapters in this part cover buying a digital camera and taking your first photos. In the first chapter, you discover the features to look for in a new camera. The second chapter presents suggestions for using your camera's preset scene modes to take your first photos.

Part II: Taking More Control

Start using more of your camera's features. Chapter 3 introduces controlling exposure for just the right brightness. Chapter 4 focuses on, well, *focus*, along with common guidelines for composing your photos. Chapter 5 discusses how to photograph people and events. Chapter 6 captures animals and landscapes.

Part III: Managing and Editing Your Photos

The chapters in this part help you organize your photos and make them better through editing. In Chapter 7, move your photos from the camera to your computer. Make some common and simple changes using a photo editor (Windows Live Photo Gallery) in Chapters 8 and 9.

Part IV: Sharing Your Photos

Chapters 10 and 11 show you how to publish photos on the Web — specifically, Flickr and Facebook. In Chapter 12, print photos at home or using an online photo printing service.

Part V: The Part of Tens

The book ends in classic *For Dummies* fashion with ten tips for getting better photos, using Picasa to organize and edit photos, and ten photo tasks you can do without a computer.

Icons Used in This Book

You may notice the little icons that appear in the left margin throughout the book. These are standard *For Dummies* road signs to give you some guidance along the way. They tell you, among other things, when to pay especially close attention, when to step lightly, and where to find additional information. Here's what they mean:

Look for this icon for something extra, some suggestion you can easily put into practice right away. These are the chocolate chips in the book's cookie.

Now and then, I want to remind you of something before you go on. I know you remember every word you read. I just want to be sure I didn't forget to mention something already.

When something pops up that could cause some trouble, such as "click Yes to delete all photos," I warn you about the consequences.

If I know of a good reference that covers a topic more completely than I can, I give you a heads-up about it with this symbol.

This icon marks particularly geeky information. This information isn't necessary to know to take great photos; read the text marked with this icon if you have an interest in how your camera takes those great photos.

Where to Go from Here

Take a look at the Table of Contents or the index, and then flip pages and skip along to your delight. Or, you can work your way through the whole book, one page at a time. After all, it's your book.

You can also find this book's cheat sheet for more valuable info at www. dummies.com/cheatsheet/digitalcamerasandphotography.

Please visit the companion Web site for this book at www.mjhinton.com/dp to ask questions, suggest topics for future editions, or comment on the book.

Part I
Getting Started the Digital Way

In this part . . .

Digital cameras come in a range of sizes and capabilities. A pocket-sized, fully automatic camera is convenient but has some limitations on the features you can control. A mammoth professional model is versatile, but it comes with a higher price tag. Is something in between those choices a worthy compromise? In this part, I introduce you to many of the features of digital cameras and help you sort out the details so that you can determine what features matter most to you.

Then, with camera in hand and some help from Chapter 2, you can jump right into taking pictures.

Photo by Merri Rudd

Choosing Your Camera

In This Chapter

▶ Choosing a camera type

▶ Focusing on features

▶ Opting for accessories

*S*hopping for a digital camera is like choosing any other technical device, such as a computer or a car. You can carefully weigh multiple criteria considering expert reviews, or you can buy the blue one. As is true of any device, cameras have features that are more or less important, although people — especially enthusiasts — will disagree about the level of importance of a specific feature.

Your camera should be a good fit for you — not too small, not too large, and not too heavy. You want to feel comfortable carrying your camera, so that you always have it nearby, even when you don't expect to need it.

The camera you buy or have already may not do everything covered in this book. Or, it may do more than you discover here. However, most of the topics are of practical value to any photographer who doesn't already know them.

In this chapter, I focus on the camera features you may want in your next camera. (I had to get that pun out of the way.) This information will help you navigate through ads and reviews to find the right fit.

Amazon (www.amazon.com) is a great source for reviews from real people who have used a particular product. For professional reviews of digital camera equipment, visit http://reviews.cnet.com/digital-cameras, www.dpreview.com, and www.steves-digicams.com. More sites are linked at my Web site: www.mjhinton.com/dp.

Picking a Camera Type

Before you pick up a camera, consider these three categories of digital cameras (just *cameras* from here on):

- **Point and Shoot (P&S)** cameras have a wide range of features which are covered in the section "Considering Camera Features." P&S cameras also range in size (from tiny to two-handed) and in price (from roughly $100 to $500).

 You may find a bargain camera for less than $100, but look closely to be sure it doesn't have some unacceptable limit to the features discussed in this chapter.

- **Digital Single Lens Reflex (DSLR)** cameras are based on the same design as that used for professional film cameras (SLR). In contrast to the *fixed* (unremovable) lens found on a P&S camera, you can change the lenses on a DSLR to suit the situation. You might switch to a macro lens for an extreme close-up, and then switch to a telephoto lens for a distant shot. Removable and exchangeable lenses distinguish DSLR from non-DSLR. DSLRs also give you more options for taking photos. Further, the size of DSLR image sensor promises better quality photos, especially for large prints.

- **High-end P&S cameras** bridge the gap between P&S and DSLRs, and include features otherwise normally found in DSLRs. Often, these cameras are called *superzooms* or *ultrazooms,* for that one feature. At one time, the industry called these "prosumer" (professional + consumer) and *bridge* (bridging the gap between types), though neither term caught on with consumers.

Table 1-1 shows a comparison of the three main types of digital cameras.

Table 1-1		Comparing Camera Types
Style	*Cost*	*Description*
Basic P&S	$125 to $250	Easily slips into a pocket or small purse. Uses fixed lens and internal flash. Generally, few features, mostly automatic.
High-end P&S	$250 to $500	Has much of the power of a DSLR with the convenience of a point-and-shoot model. Usually has a high-range zoom lens. You can select between manual and multiple automatic modes.
DSLR	$500 to $5,000	Aimed at serious hobbyists and professional photographers. Many more automatic and manual options, requiring more experience. Extensive interchangeable lens and external flash options.

A note here about handy cellphone cameras: As cellphones become more sophisticated, their cameras improve, as well. Consider these the ultimate compact P&S. The added issue for cellphones is how do you get your photos out of the cellphone? It may be through a cable, a removable memory card, or via a data service added to your bill. If you're comparing cellphone cameras, most of the features covered in this chapter are still relevant to you.

Point & Shoot (P&S)

With cameras, size matters. Most compact cameras that fit easily into your pocket are P&S. You may want a compact camera that is easy to carry and that you can pull out of your pocket for impromptu snapshots, like the one in Figure 1-1. Keep in mind that you may not be able to capture details from far away or extremely close up. In turn, fewer features generally make a camera easier to use.

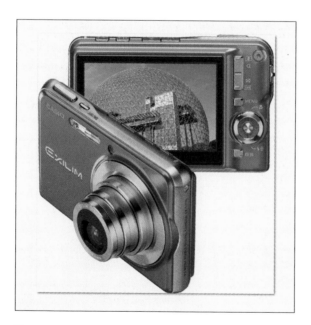

Figure 1-1: A compact P&S.

Within the P&S type, there is a wide range of size from compact (pocket-sized) to large-bodied, but size doesn't always equate to features. High-end features may appear in any size of camera. Still, the high-end P&S cameras with long zoom lenses look a lot like DSLRs, as well as old-school film cameras. These cameras are too large for a normal-size pocket. See Figure 1-2.

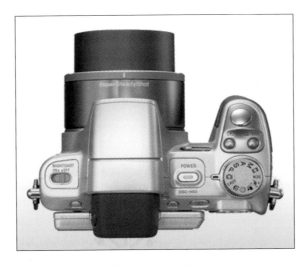

Figure 1-2: High-end P&S are larger than compacts.

If size or cost doesn't matter, the key feature to determine whether you want a compact P&S or a high-end P&S is how much zoom factor you want. A zoom lens has adjustable focus from near (wide) to far (telephoto). A zoom lets you get closer to a distant subject and fill the frame. Zoom is measured in factors: 3x is three times closer than the wide angle lens; 10x is ten times closer. Most compact P&S cameras have a maximum of 5x or 8x. High-end P&S start at 10x — 30x is the current extreme. Figure 1-3 shows the same scene using a zoom ranging from 1x (no zoom) to 12x. At 20x, the stop sign would nearly fill the frame.

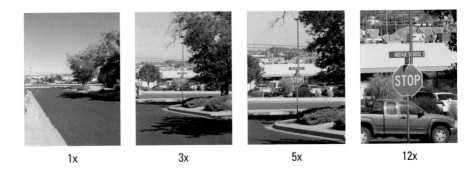

| 1x | 3x | 5x | 12x |

Figure 1-3: Zoom from wide to telephoto.

The appeal of a long zoom may be obvious (getting really close to a distant subject without moving). A zoom of 10x or more is great for an outdoors photographer. There are issues with zooms to keep in mind:

✔ **The longer the zoom the greater the odds of shakiness or blurriness.** You need good image stabilization and very bright light for hand-held shots — or a tripod.

✔ **A long zoom makes a high-end P&S bulky and expensive.** On high-end P&S, zooms lurch a bit (sometimes noisily) between zoom levels, whereas DSLRs zoom smoothly and quietly (qualities you pay for).

A superzoom (beyond 10x) isn't for everyone. However, if you buy a compact P&S, get one with a zoom between 5x and 10x, if you can.

Zoom can be optical or digital (or both). Digital zoom automatically crops the photo, lowering the resolution of the picture. The quality of a digital zoom rarely matches optical zoom. Ignore digital zoom when comparing two cameras.

A rational person would assume all 12x cameras zoom 20 percent farther or closer than all 10x cameras. That is not necessarily so because the *x* refers to the wide angle (near) focal length of the lens for that specific camera. For this reason, to accurately compare two cameras' lenses, you need to know the range from wide to telephoto. This range often appears on the front of the lens. For example, a compact camera with a range from 5mm to 25mm has a 5x zoom. A high-end P&S ranging from 5mm to 100mm has a 20x zoom.

Technical specifications and reviews often convert zoom to film-camera 35 millimeter equivalents. (This is more familiar to film and DSLR photographers.) The compact camera referred to in the preceding paragraph ranges from 30mm to 150mm (5x), whereas the high-end P&S range is 28mm to 560mm (20x).

Digital Single Lens Reflex (DSLR)

As noted earlier, DSLRs have removable lenses. However, there are other reasons to consider buying a DSLR:

✔ **The image sensor is larger.** A larger sensor doesn't necessarily mean larger photos, but better quality photos due to improved light-gathering and processing.

✔ **Overall speed — startup and shooting — is usually higher.** P&S users often experience a lag between pressing the shutter and capturing the image, during which time a subject may move.

✔ **You have the capability to shoot in the RAW format.** Enthusiasts prefer RAW for processing photos in powerful photo-editing programs such as Adobe Photoshop.

The body of a DSLR determines most of the features of that camera, although some designs put features such as image stabilization into the lens instead of the body. Further, the camera body determines the lenses you can use.

(Although, indeed, there are adapter rings that allow a camera from one manufacturer to use the lenses from another, but that's pretty hardcore.)

Figure 1-4 shows the type of DSLR camera that a professional photographer might use.

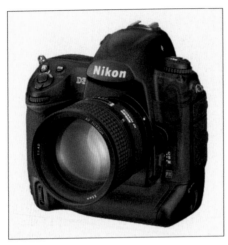

Photo credit: www.sxc.hu

Figure 1-4: A DSLR.

Your DSLR may come with a general purpose lens — double-check before you buy, because some prices are for a body only. Regardless, most DSLR users have more than one lens, including the following:

- A short, versatile **wide-angle lens** suitable for portraits and landscapes.
- A **macro** lens for extreme close-ups.
- A **zoom** lens to range from near to far subjects.
- A **telephoto,** instead of a zoom, with a fixed length for very distant subjects.
- A **fish-eye lens,** an extreme wide-angle that distorts pictures in a way similar to a peephole on an apartment door.

Figure 1-5 shows a few lenses.

Filters screw to the end of DSLR lenses to protect the lens, filter ultraviolet light (UV), reduce water or glass reflections (polarizing), and more.

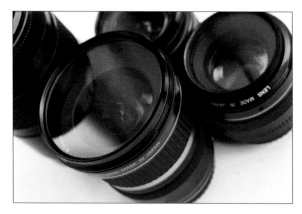

Photo credit: iStockphoto.com

Figure 1-5: Lenses give DSLRs versatility.

Considering Camera Features

Some camera features are universal, whereas others vary with the manufacturer. For example, every camera has a button you press to snap the shot (the shutter release). Where that shutter button is located and how hard you press it varies from camera to camera.

Every camera has the following features:

✔ The **lens** focuses the scene. The lens could be plastic but is usually glass; also, it may be immobile or may extend from the camera body when you turn the camera on or adjust focus.

✔ The **lens cover** protects the lens. The cover may slide automatically or detach manually as a lens cap. (Don't lose it.)

✔ The **shutter release button** usually has two steps. Press partly to set the focus and other automatic settings and fully to take the picture. Smile. Click!

✔ The **viewfinder (VF)** lets you put your eye next to the camera to compose a shot. The area you see in the VF may be a little more or less than the area of the picture. The viewfinder may be optical (clear glass or plastic) or **electronic (EVF)**. An EVF displays useful information about camera settings but may be hard to see in bright light.

✔ A **liquid crystal display (LCD)** shows the scene and camera settings before you take the picture. A large (at least 3 inches), bright LCD is great for viewing pictures after you take them and for dealing with

menus and other settings. Some LCDs are touchscreens enabling you to use menus with your finger. Some LCDs fold out from the back of the camera, allowing you to hold the camera high or low for a different perspective.

Some cameras have only an LCD, not a VF. I recommend you buy a camera that has an EVF. Without it, you have to hold the camera at arms' length to compose your shot, which is hard to hold stable. Further, most LCDs are hard to see in bright light.

- **Viewfinder/LCD toggle** switches between an electronic viewfinder (EVF) and the larger LCD display, which is best for menus, macros, and reviewing your pictures.

- **Review or playback control** shows the pictures you've already taken on the LCD or EVF.

- An **image sensor** receives the incoming image, which is processed into a stored file. The image sensor is likely to be a charge-coupled device (CCD) or complementary metal-oxide semiconductor (CMOS). Either technology is satisfactory for most photographers. As noted in the "Digital Single Lens Reflex" section, the larger issue is the size of the image sensor: Compact P&Ss have the smallest sensors, whereas DSLRs have much larger sensors. (In comparing two DSLRs, you may want to compare sensor size and reputation among professionals and enthusiasts.) Image sensor size matters most in advanced editing and printing photos.

- **Batteries** power all the camera functions. Some cameras require a special battery; some use generic batteries.

Buy and carry extra batteries. If you want your photographic endeavors to be a little greener, use rechargeables and travel with a recharger.

- A **storage or memory card** holds your pictures. Most cameras have built-in storage, but that is surely too limited. See the "Removable memory cards" section, later in this chapter, for more about storage.

- A **mode dial** turns to enable you to switch among settings for different conditions, such as sporting events or nighttime (see Figure 1-6).

- A **Function dial** provides buttons necessary in menus, such as up, right, down, and left. The center of the function dial is a raised button for OK or Enter. Most cameras assign additional functions to these five controls when you are not using a menu, such as the self-timer and the flash control.

Look for reviews on the Web that describe and critique the menus used in a camera you're considering. Once you have a camera, spend some time exploring your camera's menus and documentation so that you have a better understanding of how to get the most out of your camera.

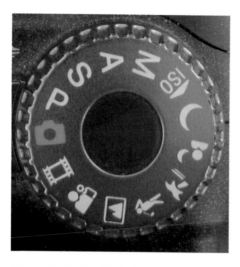

Figure 1-6: Use the Mode dial to change camera settings.

✔ **Flash control** turns the flash on or off.

✔ **Self-timer** lets you jump into the picture before it's taken.

✔ All but the most basic cameras also have a **flash.** Some flashes pop up or out automatically; some are controlled manually.

You may find any of these additional controls on a camera:

✔ A **dedicated video control** on a few cameras lets you start and stop video with one button. Most cameras require you to switch to Video mode with the mode wheel and start and stop with the shutter button.

✔ **Image stabilization** reduces shakiness or blurring and is critical for zoomed photos and some low-light photos.

✔ **Focus control** lets you set a specific distance between the camera and the subject to override autofocus. This is most useful when autofocus is unreliable, especially in low light.

✔ **Burst mode** lets you hold down the shutter button to capture as many photos as possible in rapid succession, which is especially useful in sports or with wildlife.

✔ **Bracketing mode** takes multiple shots when you press the shutter button, but adjusts each shot's exposure slightly. This is useful in situations where the camera may be wrong about automatic settings or you may be wrong about manual settings.

✔ **Face or smile detection** assures the camera focuses on faces. Newer technology can actually delay the exposure until everyone in the photo is smiling. Go ahead, smile. There is no sincerity filter.

✔ **Panorama mode** prompts you to slowly pan your camera from side to side as the camera shoots multiple shots and stitches them into one wide exposure.

✔ **GPS (Global Positioning System)** tags each photo with the global coordinates of that location (latitude and longitude). This process is called *geotagging.*

GPS built into a camera is still rare, though it is becoming more common. More common are programs for adding geotags manually or by using tracks recorded by a separate GPS device. See Chapter 8 for information on geotagging.

✔ **Remote controls** are rare, but handy for tripod-mounted shots or for playback and slide shows.

High-end P&Ss and DSLRs have even more specialty features and capabilities.

Exposure Settings or Modes

There is more to taking a picture than pointing and shooting. In addition to a fully automatic mode that controls everything, most cameras feature *scene modes* that automatically set the camera for certain conditions. As you compare cameras, you may want to consider specific scene modes they provide, especially those on the Mode dial, which will be the easiest to access.

The purpose of these scene modes is to make it easy to adjust the camera to different conditions. The camera settings required to photograph a tiny flower are different from those required for a mountain or a person running. Some newer cameras analyze the scene and choose scene modes automatically.

Recent cameras offer such a huge number of specialty modes (for example, *fireworks* and *party,* whatever that means) that the sheer number of scene modes may not matter in your buying decision.

Look for symbols or letters that represent these modes around the Mode dial (refer to Figure 1-6). In some cases, you select scene modes through a menu. Consider these common scene modes:

 ✔ **Landscape** mode sets the focus to infinity; look for a mountain-like triangular symbol indicating this mode.

 ✔ **Macro** mode, signified by a flower symbol, sets the focus very, very close — a fraction of an inch.

✔ **Sports** mode takes very fast pictures to freeze the action. You may see a golfer or a runner as the symbol for this mode, although a soccer player seems more appropriate.

✔ **Nighttime** mode (look for a crescent moon or a star) adjusts for low light.

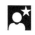

✔ **Video** mode turns your camera into a camcorder. The symbol may be a piece of film with sprocket holes along the edge or a reel-to-reel projector (both of which are now rather antiquated symbols). Press the shutter button to start recording a video and again to stop.

Beyond the preset scene modes, high-end P&S and DSLR cameras typically include the following functions for controlling camera functions:

✔ **Aperture Priority (A or Av, for Aperture Value)** lets you control the size of the lens opening *(aperture);* the camera adjusts the shutter speed. A bigger aperture lets in more light, which is best in low-light conditions, but has a narrower *depth-of-field* (how deep an area is in focus). A smaller aperture lets in less light but has a deeper depth-of-field, which is best for a landscape on a bright day. Aperture values often appear stamped on the camera lens.

✔ **Shutter Priority (S or Tv, for Time Value)** is the opposite of Aperture Priority: You control the speed of the shutter; the camera controls the aperture. Capturing action requires a faster/higher shutter speed. A slower shutter speed is appropriate for low light.

When you compare two cameras, if all other things are equal, the one with the wider range of both aperture values and shutter values may be the better camera (or lens), if you intend to learn the subtleties of controlling settings. See Part II for information on controlling these settings.

✔ **Manual (M)** enables you set both the aperture and the shutter speed. Manual control enables exquisite control over the exposure, but requires experience and experimentation.

Examining Image Size and Storage

Digital images are made up of dots *(pixels,* which is short for *picture elements).* More pixels in an image mean more dots. These dots are bits of information, such as color and brightness, about each spot in the larger image.

Each picture you take is stored in the camera as a file. Bigger files store more information, increasing your editing and printing options. Three features combine to determine just how many pictures you can store in your camera: the *resolution* of your images; the file format in which your camera stores

your photos; and the type of memory card on which you are storing your photos. I discuss these three features in the following sections.

For the greatest flexibility, buy a camera with high resolution. Set the resolution to the max. Choose the format that stores the most information (biggest files). Buy the largest memory card the camera supports.

Image resolution

A *pixel* is a dot of information about color and brightness. Your computer screen may be 1,024 pixels wide by 768 pixels high — 786,432 pixels or .78 *megapixels* (MP — millions of pixels) in area. Consider an image that is 800 pixels wide and 600 pixels high (480,000 pixels in area). That image doesn't fill your screen. Printed on the average personal computer printer, this hypothetical photo is a little bigger than a postcard.

If you want a bigger photo on-screen or on paper, you need more pixels. The maximum number of pixels per photo is a camera's *resolution.* The more pixels in an image — the higher the resolution — the bigger you can print the image. You set the image resolution through your camera's setup menus up to the maximum the camera supports.

The ideal resolution for you depends on what you plan to do with the photo. Most of the photos displayed on Web sites are 1,024 by 768 pixels or smaller — less than 1 MP. An e-mailed photo might be even smaller, unless the recipient wants to print it. If you'll never print that photo at all — or at least never larger than at the standard print size of 4 x 6 inches — isn't 2 MP enough?

To answer that question, consider that you'll surely want to *crop* photos occasionally to eliminate some of the outer portions of the image in order to draw attention to a specific detail. The more megapixels you have, the smaller the portion of the original you can crop to and still have something to see and print. Even if you never expect to print especially large photos, having a 16 MP camera means that you can print large if you want, and it gives you the capability to crop your photo to a tiny area and still have a decent-size image.

If you plan to edit your photos, the more pixels available, the better.

Figure 1-7 shows a photo of a Cooper's hawk soaring. Figure 1-8 shows the hawk cropped from Figure 1-7. The original photo's resolution is 3,072 wide (W) x 2,304 high (H) — not quite 8 MP. The cropped area is 853W x 586H. If the original had been a lower resolution, none of the detail of the hawk would be visible cropped. That picture would be made up of too few dots, resulting in a blotchy, pixelated effect. As it is, Figure 1-8 is too small to blow up into a large print.

3072 (W) x 2304 (H)

Figure 1-7: The subject is a small part of the original photo.

853 (W) x 586 (H)

Figure 1-8: Cropping eliminates part of the picture to emphasize the subject.

Can you have too many megapixels? Sorta. A deep consideration of megapixels requires returning to the image sensor, which receives the light that becomes the photo. Imagine a compact P&S with 12 MP and a DSLR with 12 MP. The sensor on the compact P&S is much smaller — less than 25 percent as large — so those pixels are small and packed together, whereas they are larger on the DSLR. The smaller sensor is subject to more electrical interference ("noise") resulting in less satisfactory images, especially in low light or blown up large. Most compact P&Ss top out at 10 to 12 MP, whereas DSLRs may have 18 MP or more.

There is another negative aspect to lots of megapixels: The resulting file size is larger, taking more space on the memory card or on your hard drive and creating bigger attachments to e-mail, as well as making files slower to copy. This is why your camera's setup menu enables you to choose lower resolutions if you want to store more pictures per memory card. Better to buy a larger card than sacrifice pixels.

See Part III to find out about editing your photos.

File formats

You need to know how big each photo is before you know how many photos you can save per gigabyte. Digital cameras store photos and videos in various file formats that use file extensions such as `.jpg` and `.mov`. Some formats produce larger files, which take up more space on your memory card. A larger picture takes more storage space and more time to save and copy, but may produce better photos.

The available formats are determined by the camera manufacturer. If you have a choice, use your camera's setup menus to select the file format you want to use.

- ✔ The **JPEG** format (Joint Photographic Experts Group) is the most widely used in cameras and on computers. It is a very logical choice for cameras.

 You may be able to select among JPEG types, such as Basic or Fine. JPEG compresses files and you want the least compression — the finest — available.

- ✔ The **RAW** format (not an acronym) is very popular on DSLRs. Unfortunately, there are different RAW formats and none is as universally recognized as JPEG, which complicates editing and sharing these photos. However, RAW stores all the information the sensor can capture, whereas JPEG mathematically compresses some data that might be useful in editing or printing — *might* being the operative word, so don't obsess over this.

✓ Video file formats include **MPEG** (Motion Picture Experts Group), **MOV** (Apple's QuickTime), and **AVI** (Audio Video Interleave). More and more cameras offer high-definition (HD) video suitable for HDTV.

The more important video is to you, the more attention you should pay to video format and resolution, as well as camera connections such as HDMI for connecting to HDTV.

Removable memory cards

The more gigabytes your memory card holds, the more pictures you can store on it. The type of card you use is determined by your camera; however, you can probably buy the card your camera requires in various storage capacities (more or fewer gigabytes). Table 1-2 shows a comparison of card types. (A *gigabyte,* which the numbers in the middle column refer to, is equal to one billion bytes.)

Table 1-2		**Types of Memory Cards**
Media	*Gigabytes*	*Description*
CompactFlash (CF) card	1, 2, 4, 8, 16	Largest in apparent size (not necessarily storage size) and the oldest card type still in use.
Secure Digital (SD) card	1, 2, 4, 8	More compact than CF; most common mini and micro sizes used in other, smaller devices or in cameras using an adapter.
Secure Digital High Capacity (SDHC)	4, 8, 16, 32	Newer version of SD card; faster, smaller but larger capacity. The Micro SD is the size of a fingernail. Class 6 is currently the fastest version.
XD picture	1, 2	Used primarily by Olympus.
Memory Stick card	1, 2, 4, 8	Used with Sony cameras and Sony devices; Pro (greater capacity), Duo (small form), and Pro Duo (more capacity in a smaller package) versions are also in use.

The cards shown in Table 1-2 are available in various speeds. Slower-speed cards may be less expensive than faster cards but can affect camera performance. The slower the card, the longer it takes the camera to read and write to the card. Card speed affects how many photos you can take per second. Card speed may affect the frames per second (fps) for video. (Lower fps results in jerkier video.) However, don't buy a faster or higher-capacity card without determining whether your camera can take advantage of it.

Figure 1-9 shows the following items from left to right:

- ✔ An adapter that makes it possible to plug the Memory Stick Pro into a computer, a digital photo frame, or a suitable TV.

- ✔ Memory Stick Pro, used by Sony cameras. Nearly three times larger than the Micro SD, this Memory Stick Pro has half the storage capacity.

- ✔ A tiny 4GB Micro SD card. SD cards are the most commonly used cards, except as noted in Table 1-2.

- ✔ An adapter that enables the Micro SD to fit a camera that requires the older and larger style SD card. There is also an adapter for the in-between-size Mini-SD. Most Micro SD cards come with a larger adapter.

- ✔ An adapter that makes it possible to plug an SD card into a computer, a digital photo frame, or a TV with a USB port.

Strictly speaking, you can save a limited number of photos directly to your camera's built-in memory. Then, you can use the cable that came with your camera to transfer the images directly to your PC. However, this severely limits how many pictures you can take before you have to move them to your computer. Insert a compatible memory card, and your camera uses it automatically. For more information about transferring photos to your PC, see Chapter 7.

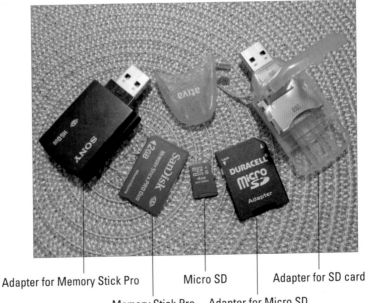

Adapter for Memory Stick Pro Micro SD Adapter for SD card

Memory Stick Pro Adapter for Micro SD

Figure 1-9: Two memory storage cards surrounded by adapters.

Accessorizing Your Camera

You start with a camera, but you end up with more stuff. Gear gathers more gear. You may end up with all of these things, as you need them, of course.

- **Extra batteries and charger:** Whether your camera uses a special proprietary battery or generic batteries, you don't want to run out of power. Have backup batteries and practice switching batteries with one eye on the scene. For car trips, you may need an adapter to plug your charger into the DC connection. For foreign travel, you may need an adapter for local outlets.

- **Extra memory cards:** In one outing, you may not shoot enough pictures to fill your memory card. Still, the longer you go without moving those pictures off the camera, the more you need an extra card. For long trips, you also have to consider what happens if a card fails — they do sometimes.

- **Extra camera:** Seriously. Again, in a travel situation, what happens if your camera fails or gets lost or stolen? Even without that concern, if your primary camera is a high-end P&S or DSLR, there are times when that just stands out too much and a compact P&S would be very handy.

- **Tripod:** By attaching your camera to a tripod, you make the camera extremely stable for long zoom shots, shots in low light or at night, and for self-portraits, including group shots you jump into. A good tripod collapses small enough to carry comfortably and expands easily but securely to a height you don't have to bend over for. (A flip-out LCD on the camera helps here.) Ideally, the tripod head turns up or down and left or right and locks in a position.

 Everyone needs a pocket-size tripod for quick self-portraits and group shots. Some small tripods wrap around or clip to objects for extra stability.

- **Monopod:** Like a hiking stick or ski pole with a connector at the top, a monopod is easier to move than a tripod, but a monopod is much less stable.

- **External flash:** Primarily an option for DSLR, an external flash triggered by the camera gives you more lighting options.

- **Reflectors:** With any camera, you can use reflectors to change the light on the subject, particularly to remove shadows. Reflectors may be large squares, ovals, or umbrella shaped, in shades of white or gray. Position in front of and to one side of the subject to reflect natural light or a flash.

- **Extra lenses:** Another DSLR option, particularly Macro and Telephoto or Zoom. One lens is never enough (except for P&S users).

- **Lens filters:** Uncommon for P&S, filters protect lenses (neutral filter) and usually modify the light in various ways, such as a polarizing filter to reduce haze and intensify blue sky and water.

- ✔ **Camera bag:** You may be thinking "suitcase" by now. Consider two bags. Get one small padded bag for your camera plus extra batteries and cards to hang from your shoulder or your belt. Use another for everything else — perhaps one with wheels.

 When you take a trip, think carefully about what gear you can't live without and how to transport it safely.

- ✔ **Cables:** If you intend to connect your camera directly to a computer or TV, you need cables for that (they should come with the camera). A few cameras have power cords.

- ✔ **Card reader or adapter:** Instead of connecting your camera directly to a computer or TV, you can remove the card and put it into a card reader or a USB adapter, which turns the card into a flash drive.

- ✔ **Computer:** You do not have to have a computer to take and enjoy photos (see Chapter 15). You can do a lot with just your camera's LCD. You may be able to connect your camera or card to a TV. You can insert the card into a digital photo frame. You can take your camera to a photo printer. Still, a computer gives you much more, enabling you to organize, edit, and share your photos. For travel, a small laptop or netbook is ideal.

- ✔ **Printer:** There are portable printers, but here I'm thinking about a printer for your home computer. See Chapter 12 for information about printing at home and about printing services.

You're well acquainted with the camera strap most photographers use to hang their cameras around their necks. Compacts usually come with a lightweight wrist strap. You may be able to add a neck strap to your compact. For any size camera, consider a wrist strap sturdy enough to keep your camera safe and close at hand.

Fast and Easy Picture Taking

*W*ith camera in hand, you're ready to shoot. In this chapter, you discover enough to jump into using your camera with confidence. Before your first shot, set the image quality and get a sense of your camera's many automatic modes. Check out a few tips about light — photography is all about light and dark. And then take some fun shots before you review the photos on your camera's LCD.

Because of differences between camera makes and models, some setting names and locations may be different from what you find here. Be sure to have your camera's user manual handy, and remember that nothing beats getting out there and running your camera through its paces. Try every setting, take a shot, and see what happens: That's really the only way to truly feel comfortable with your camera.

Setting Up Your New Camera

Out of the box, there are a few things you need to do just one time with a new camera. Follow these steps:

1. **When you get your camera, lay out all the items that came with it and confirm that you received everything you expected from the packing slip, box label, or ad.**

 If your camera came with specific step-by-step instructions for setting up the camera for its first use, follow those steps instead of the steps here before you take your first picture.

2. **Remove all packaging, including tape.**

 Store this material until you're sure you won't need to return your camera to the seller.

3. **If your camera has a neck or wrist strap, thread the strap ends through the slots on either side of the camera body.**

 Take care to attach the strap securely. Test it gently. You don't want your camera to fall off this strap.

4. **Install the memory card, if you have one (see Chapter 1 for information about memory or storage cards).**

 Look for a small cover on the bottom of the camera or either side. Many cameras have one cover for both memory card and batteries, as shown in Figure 2-1. Open the door by pushing or sliding the cover. With your thumb on the label side of the memory card and any exposed metal contacts away from you, gently insert the card into the card slot. If you meet resistance, pull the card out and turn your hand to try inserting the card the other way. The card should slide in easily and stay in. (It may click in place.) Do not force the card. Close the memory card slot cover.

Battery Memory card

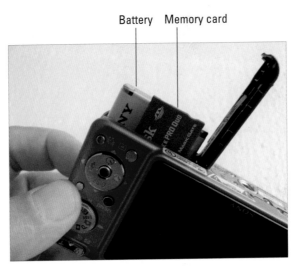

Figure 2-1: The memory card and battery may share a compartment and cover.

To remove a memory card, with the cover open, push the card in slightly, and when you release, it should pop out. Never pull or pry a card out.

Never install or remove a memory card while the camera is on. You could lose photos or damage the card.

5. **Install the battery or batteries.**

 Look for a small compartment on the bottom or side of the camera. Open the door by pushing or sliding the cover. If the battery is rectangular, put your thumb on the label and gently push it in — the battery will go in only one way. If your camera uses two or four standard batteries, look for an indication of which end goes in for each battery. (The standard batteries don't all go in the compartment facing the same way; they alternate.)

6. **Locate the lens cover.**

 If it's a separate piece, leave it unattached for now. If the lens cover clips in place, remove the cover before you turn on the camera. (In some camera models, when you turn on the camera, the lens will strike the lens cover if you forget to remove it.) If the cover slides, gently sliding it may turn the camera on. Don't force the lens cover off or on.

 Some lens caps come with a thin string you can slip through a hole in the lens cap and another hole in the camera body or around the camera strap to keep the cap with the camera. When the camera is off, the lens cap should be in place.

7. **Turn on the camera if moving the lens cover didn't do that automatically.**

 Look for a message on the LCD or in the viewfinder.

 The camera may automatically ask for the current date and time, which will be recorded with each photograph. Enter that information using the up and down buttons to change numbers and use the right and left buttons to move to different parts of the date and time. These buttons are usually arranged around the outside of a circular button. After you've selected the current date and time, press the center button to set the changes.

8. **Take a picture of anything.**

 Go ahead. You know you want to.

9. **If your camera came with a CD or DVD, you can install that software on a computer later.**

 The software may include a program for viewing and editing your pictures. See Chapter 7 for information about copying pictures from camera to computer.

Stick an address label (plus your phone number and e-mail address) onto your camera in the hope that someone will return it to you if you lose it. I also put a copy of this info on a small label I stick to the battery of my camera.

Setting Image Quality

You want to take great photos, so make sure your camera is working with you. Set the image quality to yield the best photos and to give you maximum flexibility in editing and printing.

Image quality can be affected by two different settings: resolution and file format (both introduced in Chapter 1). For maximum flexibility after you've taken a photo, you want the highest resolution your camera is capable of, although that does produce the largest files. That means fewer photos will fit on your memory card. So you need to find a balance between resolution and file size. Use your camera's setup menu to see what options are available.

Figure 2-2 shows a sample Image Quality menu with quality options listed from highest to lowest (top to bottom) — and, in effect, file size from largest to smallest.

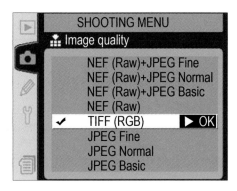

Figure 2-2: Choose a setting from the image quality menu.

Cameras support at least one of the following three file formats:

 ✔ **JPEG/JPG:** This is the most widely used format for photographs. After all, JPEG originates with the Joint Photographic *Experts* Group. JPEG is designed to compress images in a very clever way by calculating what information you won't miss. JPEG compression varies by percentage, although most cameras don't specify a percentage. In Figure 2-2, notice the two options: JPEG Fine (which uses little or no compression) and JPEG Basic (which uses greater compression but probably still results in adequate quality except for the highest grade and largest prints). In between the two in size and quality is JPEG Normal.

If file size isn't an issue, you want JPEG with the least compression. On the menu shown in Figure 2-2, for example, you would choose JPEG Fine.

✔ **TIFF/TIF:** This *tagged image file format* is an old format originally used for scanned images. There are variations on TIFF, including some with compression, but it is usually a *lossless* file type — no data is removed during compression — and files are large, which results in higher-quality images but fewer photos per memory card. Although TIFF is common on computers, it is less common on cameras.

✔ **RAW:** This is the newest format and can vary among cameras. The goal of RAW is to capture more information — everything the image sensor sees. RAW might include additional copies of the image with different exposures or formats, such as RAW + JPEG.

So, is RAW best and JPEG worst? Not necessarily. Remember that you will be viewing these pictures on your computer, attaching them to e-mail, uploading them to the Web, and editing them for hours. (Some people do. See Chapters 7 and 8 on photo editing.) Every program for working with or viewing photos handles JPEG easily. Only the latest software handles RAW. If you e-mail a huge RAW file to a friend, she may not be able to see it. JPEG gets points for longevity and ease of use, as well as smaller file size.

So, JPEG is best, right? Hold on. JPEG is lossy — JPEG compresses by throwing away data. If you repeatedly edit and save the same JPEG photo, you compress it more and more, eventually substantially degrading the quality.

For the record, Adobe, the maker of Photoshop and other photo editors, has created a RAW variant called Digital Negative (DNG). Microsoft has its own format, HD Photo. The question remains as to whether camera makers will adopt these formats.

On some cameras, you can shoot both RAW and JPEG simultaneously, thereby giving you more options in postprocessing. Just be sure to have plenty of large-capacity memory cards on hand.

Not to belabor this point, but for flexibility in editing and printing, you want the image resolution plus the file format that together, not coincidentally, produce the largest files (because they contain more information). It isn't that you want large files, but that you want the *benefits* of the information that makes those files larger. Complicating this issue is that large files take up more space (fewer photos per gigabyte), are slower to record to the memory card and to move from camera to computer, and may not be as easy to work with as smaller files.

While you're rooting around in the setup menu, look for a sound option that controls the sounds the camera makes. A shutter sound may provide good feedback when you're shooting, but it may also be disturbing, especially in a quiet setting. You may be able to turn the sound down or off.

Relying on Automatic Mode

Regardless of which model of camera you have, there is an automatic mode that manages all options for taking pictures. You still have to aim the camera and press the shutter release, but the camera does everything else for you. This mode is truly point-and-shoot.

Look for a mode dial, dedicated buttons, or menu options. Figure 2-3 shows a mode dial set to A for Automatic. Your camera may show Auto or a camera icon. This control will be highlighted differently from all others.

Some cameras have a separate *Easy* setting, which displays less info on the LCD and may limit other options. It's your choice, but I think you want the information and options, eventually.

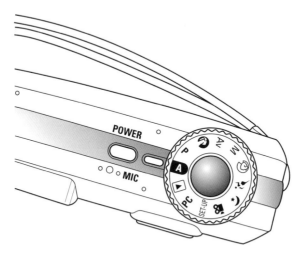

Figure 2-3: Use the mode dial to select Automatic mode and to have the camera choose all other settings.

The following steps guide you through taking your first photo with Automatic mode:

1. **Set the Mode dial or button to Automatic mode.**

 In Automatic mode, your camera makes all the decisions.

2. **Compose your shot in the viewfinder or LCD screen.**

3. **Press the shutter button halfway down to give your camera a moment to focus.**

 This takes a fraction of a second, in most cases. You may see a green indicator on the LCD or electronic viewfinder (EVF). You may see on-screen information about the settings the camera is automatically using.

4. **Press the shutter button the rest of way to capture the image.**

 Writing the captured file to the memory card takes a fraction of a second — longer for bigger files.

5. **Repeat Steps 1–4 as many times as you like.**

See the section "Reviewing Photos and Videos on Your Camera," later in this chapter, for information about seeing the photos you've taken.

Although Auto mode will serve you well 90 percent of the time or more, you do have other options. You can guide the camera toward the right settings using scene modes (covered in the next section) or you may be able to take more direct control over settings, depending on your camera. (See Chapter 3.)

Using Preset Scene Modes

Automatic mode does it all, of course. Don't be afraid to operate on Automatic — even professionals do. However, you will surely shoot in conditions in which other modes produce better pictures. Your camera probably has various scene modes that configure the camera for specific shooting conditions. Using these modes is easy and may produce better pictures than leaving the camera in Auto mode — you just have to experiment.

Auto mode actually selects specific scene modes automatically. You may see an icon for the selected mode on the screen. Choose the scene mode yourself if Auto mode makes the wrong choice.

Some cameras have separate options on the mode dial for the most impor-tant scene modes. Most cameras have a Scene (or SCN) setting on the mode dial, which allows you to use a menu to specify the scene mode. Not all cam-eras have the same scene modes. Further, names and symbols for scenes vary between cameras. Consider a few common scene modes (names may vary on different cameras):

- **Portrait** sets the camera to focus on and expose the subject and not the background. The symbol is often a head and shoulders icon.

- **Landscape** sets the camera to focus and expose the entire scene. You may have separate modes for special landscapes such as beach or snow, both of which are very bright. This symbol is usually two or more triangles, meant to look like mountains.

- **Twilight** sets the camera for very low light. You may also have twilight portrait mode for portraits in low light and night mode for the darkest scenes. This symbol may be a crescent moon or a moon and star.

- **Sports** sets the camera focus on and freezes fast action. This symbol may look like a stylized runner or soccer player.

- **Other special modes** include fireworks, underwater, even food. Some cameras have dozens of special modes, many of which probably produce similar settings.

By selecting a specific scene mode (for example, Landscape), you guide the camera toward settings appropriate for the scene you're shooting.

Take lots of pictures. Take the same picture several times, switching modes. See Chapter 3 to find out about Manual mode and other advanced settings.

Shedding Some Light on Your Subject

Nothing is more important than light in photography. Or is darkness more important? In fact, a photo captures light and dark, as well as color. Photographers use numerous terms to describe the interplay of light and dark, such as exposure, contrast, and brightness.

Your camera's scene modes are preset for certain conditions of light and darkness. Start with the available light and consider the available modes. Eventually, you may want to add a separate light source (such as a flash) and delve deeper into your camera's controls.

Finding the light

Exposure refers to the amount of light that enters the lens. You can think about light in several ways, such as the direction, intensity (brightness), color, and *quality* of light. To incorporate these characteristics of light into your compositions, here are a few tips:

- **Time of day:** The best light for photographs is usually around dawn or dusk. The light is warmer and softer, and the shadows are longer and less harsh. Avoid midday light when the sun causes harsh or sharp shadows and squinting. If you must shoot at noon, move your subject

into shady areas or turn your flash on to reduce shadows on faces. (This is called a *fill flash* or *forced flash*.)

The Flash control usually looks like a lightning bolt or spark. Press it repeatedly to cycle through options, including on or off. This may not be possible, if the camera keeps control of the flash in Auto mode.

✐ **Weather:** Cloudy or overcast days can be excellent for taking photos, especially portraits. The light is soft and diffused. An empty sky may be less interesting than one with clouds.

✐ **Direction:** Photographing a subject with *backlighting* (lighting that comes from behind) can produce a dramatic image, as shown in Figure 2-4. Avoid *lens flare* — nasty light circles or rainbow effects that mar images — by not having your brightest light source shine directly into your lens.

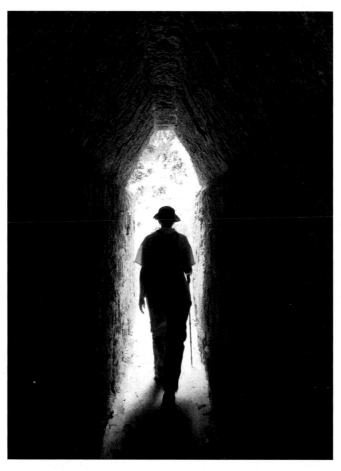

Photo credit: Mark Justice Hinton

Figure 2-4: Use backlighting creatively in an image.

Be careful shooting photos when the light source is directly behind your subject. Your camera may adjust the light meter to the lighter background and not to your subject, thereby creating an overly dark foreground or subject. If the exposure of the foreground subject is good, a bright background may be too bright in the photo. The effect can be dramatic or awful. Consider forcing the flash, if necessary.

Turn every rule or suggestion upside down to see for yourself whether it's valid. Have a shootout at high noon. Where some see ugly shadows, you may capture something strong or dramatic. (Remember, no one has to see your mistakes.)

✔ **Color:** The light at midday is white, the light at sunrise and sunset is orange and feels warm, and the light in shaded areas and at twilight is blue and appears cool.

Your camera's modes may push color in different directions in an effort to enhance the image.

Your camera's setup menu may offer color options such as vivid (to saturate color), sepia (to drain color), or black and white. I recommend the vivid option, unless it proves too lush for your tastes.

✔ **Creative:** When possible, use lighting creatively to lead the eye, create a mood, or evoke an emotion. Look for compositions created with light illuminating or shadowing an object.

Using contrast

Contrast describes the degree of difference between light and dark areas. High contrast defines stark differences between light and dark areas; low contrast appears softer and more muted.

Mixing light with dark provides contrast, which in turns creates impact, as shown in Figure 2-5.

In color images, you can also achieve contrast by using complementary colors, such as red and green, yellow and blue, and cyan and orange. Look for contrast in both nature and your own setups.

Even basic photo editors enable changes to brightness and contrast after the fact. A too-dark or too-bright photo may be repairable. See Chapter 9.

Photo credit: Mark Justice Hinton

Figure 2-5: Contrasting light and dark creates impact and depth.

Taking Some Fun Shots

Without delving any deeper into your camera's controls or photography's bigger picture (sorry, couldn't resist the pun), you can easily move beyond the standard snapshot. (Although snapshots have their place, and not every picture needs to be art.)

You should look into (they're coming frequently now) changing your perspective. Get closer to a tiny subject with your macro setting. Bring a distant subject closer to you with zoom. Squat, crouch, stretch to put the lens higher or lower than standing height.

Shooting close-ups in Macro mode

How close can you put your lens to an object and still take a clear photo? If you're too close, the photo may be blurry. For extreme close-ups, many cameras have a separate Macro mode to enable you to photograph objects within inches — even less than an inch, for some. Look for a flower symbol on the camera body and on-screen.

Your camera may automatically switch in and out of Macro mode based on distance to the subject. Otherwise, use the Macro control.

A macro exposure makes the small large — even huge. Figure 2-6 shows a close-up of a one-inch June bug on a chamisa bush. The original scene is barely two inches square, but it fills a computer monitor larger than life.

Photo credit: Mark Justice Hinton

Figure 2-6: Set your camera to Macro mode for close-up shots.

You may need to experiment with exposure settings. Start with Automatic or the Sports setting (for things that move fast, such as bugs or flowers in a breeze).

Don't use a flash with macros. A flash won't do any good that close and may ruin the shot. If your flash is set to Auto, you may have to suppress it (turn it off).

For flowers and small creatures, you may want to get on your knees or stomach for a good shot. A movable LCD can spare you that effort by flipping up or out.

The closer you get to the subject, the greater the odds that you'll actually bump into it or cast a shadow over the subject. Even a breath of air can move the subject and cause blurring. Consider placing the camera on the ground or a tripod and using the self-timer.

Check your camera's documentation to find out the particular focusing distance that Macro mode is capable of. Less than an inch should be possible.

Follow these steps to take a macro exposure:

1. **Set the Mode dial or button to Macro on your camera.**

 Look for a flower icon.

2. **Compose your shot in the viewfinder or LCD screen.**

3. **Press the shutter button halfway to give your camera a moment to establish the shot.**

 Focusing in Macro mode can be tricky, so be sure that the subject you want is in focus; if it isn't, make the necessary adjustments.

4. **Press the shutter button the rest of way to capture the image.**

Shooting from unexpected angles

To see the world differently, change the way you look at it. Get down (or up). Walk around your subject, if you can, crouching and stretching. Try not to frighten people in the process.

Take some photos from angles other than straight on at five to six feet off the ground — the world of the average snapshot. Changing your viewpoint can exaggerate the size of the subject either larger or smaller, enhance the mood of the shot, or make a dull shot more interesting, as shown in Figure 2-7.

Depending on your particular subject, try a bird's-eye view (above the subject) or a worm's-eye view (below it).

Photo credit: Mark Justice Hinton

Figure 2-7: Use an unexpected angle to exaggerate a subject. (Don't push the red button!)

TIP

Most flower photos are face on and nice enough. Try photographing flowers from the side or the back in the morning or evening — people seldom see this perspective.

Zooming in on your subject

Whereas a macro shot gets you closer to something that's already close by, a telephoto shot brings the distant object close to you. Strictly speaking, a *telephoto* lens has a fixed focal length. A *zoom* lens is a magical lens that easily ranges from normal to telephoto and steps in between. On your camera, look for a long switch labeled *W* (for wide angle — normal) at one end and *T* (telephoto) at the other. This kind of switch is called a *rocker*.

Gently press the *T* end of this odd switch while looking through the viewfinder or LCD. Zoom. With your eye glued to the camera, press the *W* end. Zoom back. An electronic viewfinder or LCD may display the degree of zoom or magnification from 1x (normal) to the maximum for your camera (10x is 10 times closer than normal; 30x is the current maximum for non-DSLRs).

The scene in Figure 2-8 took place nearly half a mile from where I was sitting, along the Continental Divide Trail. The 20x zoom got me close enough. However, if I wanted closer pictures of the horses, I would have needed an even longer zoom.

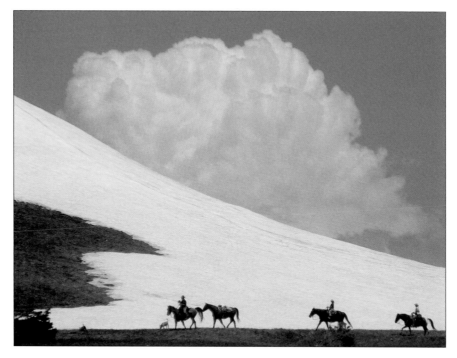

Photo credit: Mark Justice Hinton

Figure 2-8: Zoom in to get closer to a distant subject.

Follow these steps to zoom:

1. **Choose a subject more than a few feet away. Press the T end of the Zoom rocker just enough to zoom closer to the subject.**

 Zooming may be jerky or noisy on some cameras. You may not be able to zoom precisely to a particular point — over-zooming and under-zooming are common problems.

2. **Zoom in on your subject as close as you can get.**

3. **Press the W end of the rocker to zoom back out a little at a time.**

4. **Repeat this process with subjects that are close and others very far away.**

5. **Take as many photos as you like.**

 Get a sense of just how close you can get to a distant subject without moving toward it. (In practice, you may want to move closer and zoom in.)

If your camera has an image-stabilization feature (often a waving hand), be sure that it's activated to help eliminate camera shake and the resulting image blur. (Automatic mode probably turns image stabilization on.) The

longer the zoom, the more of a problem camera movement is. A tripod is helpful with a long zoom, especially in less bright conditions. (The shot in Figure 2-8 worked without a tripod because the scene was bright and I was sitting with my arms propped on my knees.) Some DSLR manufacturers recommend turning off image stabilization (IS) if you are using a tripod. IS compensates for small movements; it may misbehave when there are no small movements to compensate for (as is the case when you use a tripod). Check your camera documentation.

You can use your zoom with subjects close by. Keep in mind that zooming in with an optical zoom shortens the depth of field (DOF). (Chapter 3 discusses DOF in depth. Ahem.) Objects outside the DOF — nearer or farther — will be out of focus; the background may become blurrier, as shown in the close-up of a coreopsis flower in front of a green lawn in Figure 2-9.

Photo credit: Mark Justice Hinton

Figure 2-9: You can zoom in on an object close by for special effect.

An *optical* lens uses the optics of the camera (the lens) to bring the subject closer. A *digital* zoom isn't actually a zoom lens. It simply enlarges the center of the scene in the camera and crops out the rest. A digital zoom can degrade image resolution and quality. Therefore, you probably want to avoid using a digital zoom. If your camera has a digital zoom, you may have to disable the digital zoom by using a menu option. Some cameras switch to digital zoom if you zoom past the maximum optical setting. You may see an indication of the zoom level on the screen.

Some cameras enable you to use zoom and macro together. That may seem contradictory, but the result is a macro shot of a distant subject (refer to Figure 2-9). However, some cameras can't use these two together. If that's the case with your camera, make sure the Zoom rocker is all the way to the wide end before taking a macro shot. Check your owner's manual or experiment.

There are three ways to fill a frame with your subject. One is to zoom in from a distance until it fills the frame. Another is to get as close as possible, using Macro mode, if necessary. The third is to crop the subject out of a larger frame during editing (see Chapter 9). You should try taking the same picture all three ways to get a better feel for the impact of your choice on exposure, background, and focus.

Holding Hollywood in your hands

Most digital cameras take videos, too. (Some people call these movies.) The Video function may be on the mode dial or a separate button. Look for a symbol that looks like a piece of film with sprocket holes down both sides, an old school reel-to-reel camera icon, or a box camera on a tripod.

Most cameras record sound with videos. Be mindful of noise — especially wind — and conversations.

Some cameras allow you to zoom in and out while making a video. Do so slowly. Although image stabilization works in Video mode, abrupt or too much movement may nauseate your audience. Keep the camera still or move slowly. Most videos taken with a digital still camera should be pretty short (up to 5 minutes) without too much walking around. A tripod will make videos steadier.

The newest cameras record very high-quality video suitable for watching on HD (high definition) TV using the 720p or 1080p standards. Your camera's setup menu may have an option for video quality or format. Choose the highest option available, keeping in mind that doing so will produce the largest files on your camera card. Even low-quality videos consume a lot of storage space.

Follow these steps to take your first video:

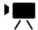

1. **Set your camera to Video mode using the mode dial or Video button, if you have one.**

2. **Press and release the shutter button to begin recording.**

 On-screen, notice the information that applies to videos (see Figure 2-10). You see the REC indicator. When you're not recording, you see Pause

or Standby. You also see the length of the current video in minutes and second (while recording) and the maximum recording time remaining on your card.

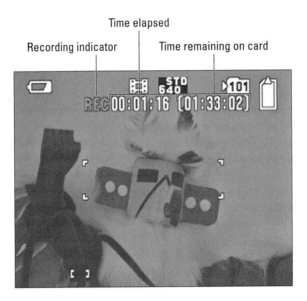

Figure 2-10: Look for a recording indicator, the time used in this video, and the time available for recording.

3. **Slowly move the camera without walking.**

 Try to keep the camera level and steady while turning your body from side to side. Zoom in — slowly — if you can, and zoom out again.

4. **Walk slowly as you record your video.**

 Notice how much harder it is to keep the camera steady. Don't trip over the dog!

5. **Press and release the shutter button to stop recording.**

 Repeat as you like.

For an example of a video, see Figure . . . wait, that's not going to work. Check out www.mjhinton.com/movies for videos I've uploaded to the Web. (See Part IV for information on uploading videos.)

If you're really serious about great video making, you probably want a digital video camera and good video-editing software. For more information, see *Digital Video For Dummies,* 4th Edition, by Keith Underdahl (published by Wiley).

Reviewing Photos and Videos on Your Camera

You may want to see — and show — the pictures you've taken while they're still in your camera. That's instant gratification. Last century, people mailed film to a lab and waited weeks for their photos to come back on shiny bits of paper! A common reaction then was, "Why did I take that?"

In the new century, we no longer have to wait to see our photos and videos. You can see any or all of the photos on your card at any time. I don't know why this function is called *preview* — aren't you reviewing your photos? Look for a Preview button on the camera, which often shows a triangle pointing to the right and which may have green on the button.

If your camera has both an electronic viewfinder (EVF) and an LCD, you can see your photos on either. The LCD will be better, of course, but remember that your batteries are draining, in either case.

Some cameras automatically show the most recent picture you took for a few seconds. You may be able to turn that feature on or off in the setup menus. (This brief display can be distracting if you quickly shoot several pictures in a row.)

Review — I mean preview — your photos and videos with these steps:

1. **Press the Preview button.**

 If you don't see anything on the LCD, you may have to press the button that switches display between the LCD and the EVF. The picture you took most recently appears on-screen.

2. **To see other photos, press the left button to go backward or the right button to go forward through the photos (see Figure 2-11).**

 These buttons are usually at 3 o'clock (right) and 9 o'clock (left) on the buttons arranged in a circle.

3. **Zoom into a picture by pressing the Zoom rocker toward telephoto (T). Press OK/Enter (the center of the circle of buttons) to return to normal display.**

 Zoomed in, the up, down, right, and left buttons usually move the zoomed-in area around the screen.

 You may be able to zoom out to display more than one photo at once as *thumbnails* (small versions). This display is called the *index*. Zoom out again to show more and smaller thumbnails, if possible. The up, down, right, and left buttons move the selection from one thumbnail to the next. Press OK/Enter to see the selected photo.

4. **To end Preview mode, press the Preview button a second time, switch modes, or turn off the camera.**

Press to zoom in.

Press for more thumbnails.

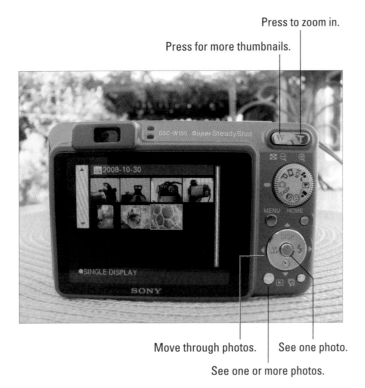

Move through photos. | See one photo.

See one or more photos.

Figure 2-11: Choose a thumbnail and press OK to see just that photo.

Don't bother to delete or edit photos on the camera. Move them to your computer, instead. Chapter 7 shows you how.

Some cameras can connect to TVs using standard RCA, USB, or HDMI cables, allowing you to run a slide show on the TV. In Chapter 12, you use your camera or card to show your pictures on TV or a digital photo frame. You probably don't want to show every picture on your memory card, though.

Part II
Taking More Control

The 5th Wave By Rich Tennant

©RICHTENNANT

"Remember, when the subject comes into focus, the camera makes a beep. But that's annoying, so I set it on vibrate."

In this part . . .

Some people see photography as the intersection of science and art. Lofty sentiment aside, both technology and technique are at play when you take a picture, and knowing even just a little about both can make for better pictures and more fun taking them.

You can find out more about the science behind photography in Chapters 3 and 4. (The test is multiple choice.) Chapter 5 delves into photographing people and events. Chapter 6 examines the art of photographing animals and landscapes, natural and urban. (Just kidding about the test, by the way.)

Photo by Merri Rudd

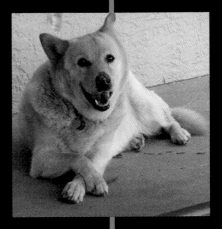

3

Getting the Right Exposure

*L*ook off at a spot exactly four feet in front of your face. (Okay, look around first to make sure no one is watching.) How hard is that? Now, using your eyes — not your camera — make everything five feet away blurry. Can't do it? Cameras can do that: focus precisely and vary the depth of field (DOF) — really the depth of *focus,* with blurring nearer and farther than the DOF.

The point is, the lens isn't really just an extension of your eye. Cameras and eyes (plus brains) have very different optics and follow different rules. You don't have to master camera optics, but you need to be aware that certain factors can affect what you get out of your camera.

This chapter can help you move out of the preset scene modes into various manual options. You start to juggle settings that the scene modes handle automatically for you. DSLRs have many differ- ent settings. High-end P&S have more settings than compact P&S. Understanding some of what's going on inside the camera helps you take better pictures, even if your camera doesn't enable you to control some of the settings in this chapter.

To take great photos, your best approach is to learn the rules and guide- lines first — and then break any you choose. Experimenting is totally safe, as you find out in Chapter 7, where I show you how to delete the evidence of your rebelliousness, and in Chapter 9, where you see how to edit those less- than-perfect photographs.

For now, your most important task is to get to know your camera. Become familiar with how your camera works as you become more comfortable with the fundamentals of photography. Remember that you have no film to process, so get out there and push those buttons.

Understanding Exposure

Exposure refers to the amount of light allowed to fall on the image sensor in the camera during image capture. Exposure is the result of the combination of the length of time that the image sensor receives light *(shutter speed)*, the size of the lens opening *(aperture)*, and the light sensitivity of your image sensor *(ISO)*. The next few sections tell you more about each of these settings.

Figure 3-1 shows the physical relationship of four hardware components. Light passes through the lens. The amount of light that enters the camera beyond the lens is controlled by the aperture. How long that aperture admits light is controlled by the shutter. Whatever light the aperture and shutter let in strikes the image sensor, whose sensitivity to that amount of light is modifiable. The image sensor translates light into digital information that is then written to your memory card.

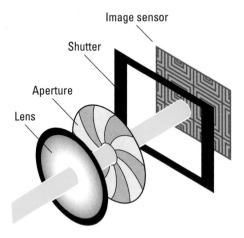

Image sensor

Shutter

Aperture

Lens

Figure 3-1: Light passes through the lens, aperture, and shutter to strike the image sensor.

Figure 3-2 represents the range between darker and lighter exposure. Each setting listed individually in the figure pushes exposure lighter or darker.

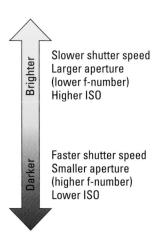

Brighter

Slower shutter speed
Larger aperture
(lower f-number)
Higher ISO

Darker

Faster shutter speed
Smaller aperture
(higher f-number)
Lower ISO

Figure 3-2: Changing one setting changes exposure.

If you change just one of the three settings — say, shutter speed — you change the exposure. Increased shutter speed decreases exposure. That's ideal if the scene is very bright, but it isn't so good if the light is dim because there isn't enough time for the exposure. *Underexposure* translates into a darker image. Decreased shutter speed increases exposure, which is good for low light but washes out a photo in bright light. *Overexposure* translates into a lighter image.

Figure 3-3 shows an overexposed image (left) and an image that is underexposed (right). Notice the differences in details visible in the sky and in the hot air balloons (at Albuquerque International Balloon Fiesta in 2009).

People react to photographs. Light affects mood and emotion. A bright scene may be uplifting; a dark scene may evoke somberness or look strikingly dramatic.

As you see in each of the following sections, your camera may let you control one variable while it adjusts the others. In terms of Figure 3-2, as you push a setting in one direction, the camera will push another setting in the other direction to try for balanced exposure. If your camera has a Manual mode, it enables you to change more than one setting and to choose a combination the camera might not choose. (Results can be good or bad, in any case.)

Overexposed Underexposed

Photo credit: Merri Rudd

Figure 3-3: An overexposed image (left) and underexposed image (right).

Setting the shutter speed

The shutter has to open for any exposure to take place. That's why your camera has a shutter button, also called the shutter release, to trigger the opening of the shutter. How long the shutter remains open after you click that button is determined by the shutter speed setting. Outside on a sunny day, a faster shutter speed may be necessary to avoid overexposure. As the sun sets, you may want to use a slower shutter speed for the same level of exposure.

Shutter speeds are measured in fractions of seconds or whole seconds and usually range from 30 seconds (very slow) to $\frac{1}{4000}$, or sometimes even $\frac{1}{8000}$, of a second (very fast). Some cameras also have a B (Bulb) mode, which enables you to keep the shutter open as long as you hold down the button.

On your camera's LCD or EVF, the shutter speed appears as a whole number like 800, but this is really a fraction of a second — 1/800.

Another consideration in setting shutter speed is whether anything in the scene is moving. When you're using slower shutter speeds and a stationary camera, objects in motion will blur. Higher shutter speeds freeze the action.

A camera's Sports mode automatically sets a higher shutter speed for action shots. Take advantage of that when photographing wildlife, too.

If your camera has Shutter Priority mode (most likely S or SP on the mode dial), use it to specify the shutter speed to use. In this mode, your camera automatically adjusts the aperture, which I discuss in the next section. When you choose a slower shutter speed, the exposure gets more time. Consequently, your camera automatically chooses a smaller aperture to admit less light for the exposure, avoiding overexposure. Conversely, choosing a faster shutter speed allows less time for the exposure, and your camera chooses a larger aperture to admit more light in the time available to avoid underexposure.

Keep the following in mind when you're setting shutter speed:

- **Set the shutter speed by turning the dial located on the front or top of your camera and looking at the LCD display.** On the Mode menu or dial, choose Shutter Priority mode, which may be labeled as S, SP, or Tv (as in *time value*). Setting your camera to Shutter Priority mode enables you to manually set the shutter speed while the camera determines all other settings. If you can't locate the dial, check your camera's user manual to see if your camera offers this mode.

- **Look for an indicator in your EVF or on the LCD that confirms that the camera settings are within an approved programmed range.** You may see a green light if the settings are acceptable or a red light if the settings are not acceptable.

- **Remember the light source.** The brighter the scene, the faster the shutter speed you can use, such as $\frac{1}{4000}$. For speeds slower than $\frac{1}{60}$ of a second, you should use a tripod to avoid camera shake and to ensure a sharp image. If you don't have a tripod and your camera has an image-stabilization feature, be sure to turn it on for slower shutter speeds.

- **When you use Shutter Priority mode, the aperture adjusts automatically.** So, you don't have to worry about setting it manually.

- **Decide to blur or freeze the subject.** To intentionally blur an image with a moving subject *(motion blur)*, set the shutter speed to a slower speed. To freeze the action in a shot, use a faster speed.

Figure 3-4 shows the blurring or motion effect possible with a slower shutter speed.

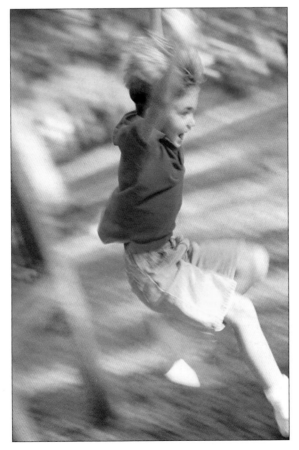

Photo credit: PhotoDisc

Figure 3-4: Set the shutter speed to a slower setting to blur an image.

Figure 3-5 shows action stopped by a higher shutter speed.

Changing the aperture

Like the pupil in your eye, a camera lens can open wide or be narrowed to the size of a pin prick. The lens opening is the aperture. A wide aperture lets in more light. A narrow aperture lets in less light. As you walk through a dark room, your pupil's aperture widens to let you see the dog that you're about to trip over. Flip on the light and your pupil's aperture narrows quickly to reduce the flood of light.

Photo credit: Mark Justice Hinton

Figure 3-5: Set the shutter speed to a faster setting to freeze movement.

A bright scene might call for a narrower aperture, whereas a dimmer scene may need a wider aperture. When you use a scene mode such as Cloudy or Night Sky, your camera chooses a wider aperture to let in more light because those are likely to be dimmer scenes. When you choose a beach or landscape scene mode, the camera automatically chooses a narrower aperture to reduce the light because those are likely to be bright scenes.

Another consideration is that aperture affects depth of field (DOF), the range in which objects are in focus. (Objects outside the DOF — both closer and farther than the subject of the photo — are out of focus.) The narrower the aperture, the deeper the DOF. The wider the aperture, the shallower the DOF.

Words like *narrower* or *shallower* seem vague until you fully appreciate the dimension or direction being discussed. Aperture is like a window. A narrow window lets in less light than a wide window. DOF is like a clear patch on a foggy road. The more of the road ahead you can see beyond your headlights, the deeper the DOF.

Not surprisingly, DOF conveys depth. Photography converts three dimensions into two. A deep DOF can emphasize distance. Figure 3-6 ranges from a nearby ruin (in Hovenweep National Monument, Utah), across a valley toward a distant mountain range. This is the deep DOF that comes from a small aperture.

Figure 3-6: Small aperture; deep DOF — miles deep.

You may want a shallow DOF to emphasize your subject by blurring objects in the background or foreground that distract. Figure 3-7 shows the shallow DOF that comes from a large aperture. The white apache plume flowers are in focus, but objects nearer and farther away are not.

Bokeh (from a Japanese word) is the term used to describe the out-of-focus area in a photo. Bokeh is considered an artistic effect.

This is the tricky aspect of DOF. Focus is not just on a single point or plane in space. There is a range nearer and farther than the subject that is also in focus. If your DOF is 6 feet and your subject is 3 feet away, everything between you and the subject and 3 feet beyond is in focus. With the same depth of field and a subject that is 30 feet away, the effect is quite different. Consider Figure 3-6 again. Imagine if the valley were in focus but the ruins were not — that would be the case with a shallow DOF. Keep that same shallow DOF and focus on the ruins and nothing in the valley will be distinct.

Photo credit: Mark Justice Hinton

Figure 3-7: Large aperture, shallow DOF.

On a cloudy day or in a room lit only by daylight coming through windows, you might need to widen the aperture to get enough exposure. However, that wider aperture reduces the DOF, increasing the odds that some part of the scene falls outside the focus and is blurry or fuzzy. That isn't necessarily bad — you can use that effect intentionally.

Compact P&S cameras may not have an Aperture control (or Shutter Priority, for that matter), but scene modes vary aperture and, therefore, DOF.

Aperture is measured in *f-stops*. For example, f2.8 is a wide-open lens, admitting lots of light (with less DOF), whereas f8.0 is a narrow opening, admitting less light than f2.8 (but with greater DOF than f2.8). Every f-stop has a specific DOF associated with it.

Notice the paradox of f-stops: The higher the number, the narrower the aperture. That's because an f-stop is a ratio (hang in there) of the width of the lens opening to the focal length of the lens. Traditionally, f2.8 is written as *f/2.8;* the lowercase *f* is the focal length and the aperture is the result of dividing the focal length of the lens by 2.8. As the f-stop number (the divisor, really) gets higher, the aperture gets narrower. An aperture of f4 (or f/4) divides the focal length by four. One-fourth is smaller than 1/2.8; f4 is narrower than f2.8; f8 is narrower still (1/8). With each step from f2.8 to f4 to f5.6 to f8, the aperture is narrower, admitting less light (and the DOF grows deeper with each step). See Figure 3-8 for graphic illustration of these differences.

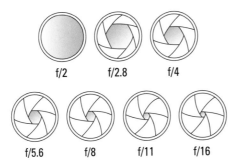

f/2 f/2.8 f/4

f/5.6 f/8 f/11 f/16

Figure 3-8: For aperture, bigger numbers mean smaller openings.

Interestingly, each f-stop admits twice as much light as the next *higher* f-stop and half as much light as the next *lower* f-stop. (Relax, there won't be a quiz.)

If your camera has an Aperture Priority mode (usually an A or AP on the mode dial), use it to set the aperture you want and your camera automatically adjusts the shutter speed.

Shutter speed affects the freezing or blurring of moving objects within a scene.

All these details make you appreciate Automatic mode, don't they? But keep in mind that Automatic mode can't push the settings to change the mood or emphasize one part of the scene.

Your LCD or EVF shows you whether the scene is brighter or darker as you adjust aperture. You won't see the effect on DOF, however. DSLRs may have a Preview button that shows DOF.

Keep these things in mind as you work with the aperture settings on your camera:

✔ **Set the aperture by turning the dial (located on the front or top) and looking at the LCD display.** On the Mode menu or dial, choose Aperture Priority mode, which may be labeled as A or Av (with the latter standing for *aperture value*). Setting your camera to Aperture Priority mode enables you to manually set the aperture while the camera determines all other settings. If you can't locate the dial, check your camera's user manual to see if your camera offers this mode.

✔ **Look for an indicator in your EVF or on the LCD that the camera settings are within an approved programmed range.** The indicator might be a green light (which means the settings are within range) or a red light (which means the settings are out of the approved range).

✓ **The brighter the scene, the narrower the aperture you can use, meaning a higher-numbered f-stop.** For wider apertures (lower-numbered f-stops), you should use a tripod to avoid camera shake and to ensure a sharp image. If you don't have a tripod and your camera has an image-stabilization feature, be sure to turn it on for wider apertures/lower f-stops.

✓ **When you use Aperture Priority the shutter speed adjusts automatically.** Because a wide aperture admits more light, the camera will choose a faster shutter speed. With a smaller aperture admitting less light, the shutter speed slows. A slower shutter speed may result in blurring of objects moving in the picture.

Compensating with Exposure Value

There is another way to adjust exposure in small increments. Formally, this is called *exposure compensation* using *exposure values*. More simply, you adjust the current exposure using a control labeled EV or EC. This control works in any manual mode.

If you're lucky, your camera's EV control works in Auto mode, in which case it is the simplest way to make a photo lighter or darker without resorting to any other manual mode. If I could, I'd put a big star by this tip.

The EV control increases or decreases exposure as you adjust the control in a positive or negative direction. Recall that for any f-stop (aperture), one f-stop higher admits half as much light and one f-stop lower admits twice as much light. Fortunately, EV adjustments are usually in fractions of an f-stop, typically 1/3.

Try these steps:

1. **Locate your EV control (or EC).**

2. **In Auto mode, look for a zero on-screen (0E, 0EV, or 0EC).**

 If you don't see this information on-screen, switch to Aperture Priority or Shutter Priority.

3. **Move the EV control left or right, watching the EV information on screen.**

 You should see the number change anywhere from -3 to +3 (three full f-stops darker or lighter). Moreover, you should see the scene darken or lighten as you make this change.

4. **Shoot a photo of the sky with some puffy clouds or some leaves dappled with sun and shadow.**

 Take at least three shots of the same scene adjusting EV from negative to zero to positive. Compare these shots on your computer screen later.

Your camera remembers the EV setting until you switch modes or turn off the camera. Don't forget to manually switch back to 0EV before you take other photos.

DSLRs, like SLRs before them, accept filters on their lenses for various effects. One of these filters is a polarizer that aligns light as it enters the lens. One of the effects of a polarizing filter is deeper blue skies. You may find a similar effect in using EV to slightly underexpose the sky. (Polarizers also neutralize hazy skies, which EV won't do.)

Hedging your bet with bracketing

Some people hesitate to use manual controls because there seem to be too many things to get just right or risk ruining the photo. Remember that even Auto mode can ruin a photo. By learning just some of your manual options, you can take a good photo under difficult circumstances.

Still, what if you're wrong about a particular manual setting? You may not know until it's too late. One way to hedge your bet on a particular setting is to have the camera automatically take additional photos with slightly different settings. This is called *bracketing*. With bracketing on, when you press the shutter, the camera will take at least three (maybe five) photos. One will be with your settings, and the others will be adjusted a little more or less. More or less what? Well, in Shutter Priority, a little slower for one or two exposures and a little faster for one or two. Similarly, in Aperture Priority, additional shots will be exposed with wider or narrower aperture settings.

Think of bracketing as using EV to take a darker and then a brighter photo. The camera makes the adjustments automatically and very quickly. And you can use bracketing and EV together.

There is a downside to bracketing, as well as any option that shoots extra photos automatically. You end up with multiple photos that are roughly similar. If you have a large memory card, the space consumed won't matter, but you have more photos to review later. Another potential negative to bracketing is the extra time the extra exposures take, albeit only fractions of a second, during which you can't take any other photos.

Follow these steps:

1. **Locate your camera's Bracketing control.**

 It may have an icon with a batch of frames stacked on the control and on-screen when the function is on.

 If Bracketing isn't available in Auto mode, switch to Shutter or Aperture priority.

2. **Compose a shot and adjust any settings.**

3. **Take your photo.**

 The camera will take two or more additional photos.

The aperture, shutter speed, ISO, and much more information about a photo are recorded with the photo. Nerds call this information *metadata*. Photographers refer to *EXIF* (Exchangeable Image File format). On a computer, you can see this information (see Chapter 8). You can see the settings you controlled manually and which settings the camera chose automatically.

Setting ISO

Before digital cameras, film was described as *fast* — very sensitive to light and fast to expose — or *slow* — less sensitive to light and slow to expose.

The standards for grading film's light sensitivity or *film speed* were established by the International Organization of Standards (ISO, an abbreviation taken from the French name of the organization). Although ISO is not a unit of measure, light sensitivity is graded in terms of ISO. Here, a bigger number indicates greater light sensitivity and faster exposure (and overexposure); a smaller number indicates less light sensitivity and slower exposure (or underexposure).

Although your digital camera doesn't use film, your camera's image sensor clearly is sensitive to light. And that sensitivity can be expressed as ISO.

Your camera has either a fixed ISO or chooses the ISO automatically based on conditions. You may be able to manually adjust the ISO. As you raise the ISO, you increase sensitivity — good for lower light. As you lower the ISO, you decrease sensitivity — good for normal or brighter light. Cameras often operate automatically around ISO 100 in most levels of daylight. ISO 1000 is very sensitive to light and might be appropriate for night shots with a tripod.

Vestiges of prior technology often carry forward into newer technology. What does clockwise mean anymore? Why do we still say that we dial our push-button phones? Likewise, ISO has been brought forward into the current age. This is not to say that ISO is archaic. ISO provides a transition from old to new.

The dark side of using high ISO film is the resulting texture of a photo. Exposures at higher ISO tend to be grainy, speckled, or uneven because the increased sensitivity of high ISO film comes from larger grains of silver halide. The smaller, finer grains of lower ISO film produce smoother images.

Although digital cameras aren't subject to the chemistry of film, high ISO still has problems. The increased sensitivity of a high ISO digital setting increases interference and degrades the sharpness of photos. This interference is called *noise*. Noise is especially noticeable as defects in enlargements. Higher

ISO may be noisier than low ISO settings, much as higher ISO film is grainier than low ISO film.

The practical significance of ISO is not merely that you may be able to shoot in low light. Higher ISO increases light sensitivity and that makes available narrower apertures (greater DOF) or faster shutter speeds than would be possible with lower ISO at low light. Settings that would underexpose a given ISO setting will adequately expose a higher ISO. An added benefit is that you may be able to shoot in low light without a tripod.

Figure 3-9 shows an unsuccessful photo of the moon using an ISO setting of 1000. You can see the blotchy colors around the moon that are considered noise.

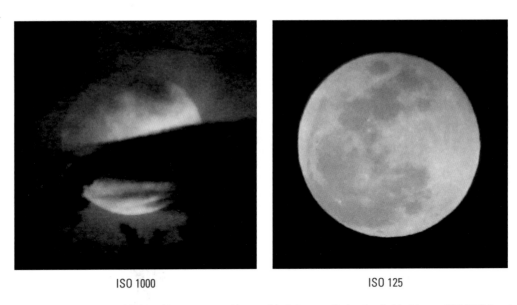

ISO 1000 ISO 125

Figure 3-9: A very high ISO (1000) increases problems with defects called noise (left). A lower ISO (125) has less noise.

See Chapter 4 for tips on photographing the moon.

Understandably, you want your photos to have good exposure — not too bright, not too dark. ISO, aperture, and shutter speed are interrelated in regard to exposure. You can achieve the same level of exposure with differ-ent combinations of these settings. One of those combinations might result in more or less DOF (aperture). Another might freeze or blur motion (shutter speed). Yet another combination might be more or less noisy, uneven, or grainy (ISO). The exposure might be the same in each of these instances, but your options are different.

In the various preset modes, such as Automatic or Night Sky, your camera selects an ISO setting according to the lighting in the shot, as well as the aperture and shutter speed.

Go ahead, change your ISO, if you have that option. Here are some things to think about as you play around with this setting:

- ✐ **Look around until you find the ISO option on your camera.** Because it's a less frequently adjusted setting, ISO may not be located with the other, more common options. (Basic cameras don't let you change the ISO setting.)

- ✐ **The lower the number of the ISO, the less sensitive your image sensor is to light.** A low ISO number results in a photo with very fine grain. An ISO setting of 100 is considered average, but a low ISO speed may not work in low-light scenarios. Normally, you want the lowest ISO setting possible for best quality, unless you want a grainy shot for creative reasons.

- ✐ **A high ISO number makes your image sensor more sensitive to light but may create a grainy, "noisy" image.** High ISO settings may be necessary in low-light situations, especially when you're using a faster shutter speed, a narrower aperture, or both — for example, when you're shooting a moving subject inside a building without using a flash.

- ✐ **As with the other settings, you should take several similar shots, varying just the ISO setting.** You may not be able to see any difference on your LCD. You're more likely to see differences on a computer screen.

Shooting in Manual mode

You can find ultimate control of your camera when you use Manual mode, if it is available. This mode enables you to set each of the options discussed so far (shutter speed, aperture, and ISO). Even if you can't juggle, you can use Manual mode.

When you use the semi-manual options, such as Shutter Priority, you select your desired shutter speed and the camera sets everything else based on that speed to produce a shot that is neither under- nor overexposed.

With Manual mode, you can override the adjustments the camera would make based on your semi-manual choices. For example, with Shutter Priority, as you increase shutter speed, you reduce the time for light to expose the image. Therefore, the camera increases aperture to let more light in — reducing the DOF in the process. (The camera could change ISO, instead of aperture, to suit conditions and your shutter speed.)

In Manual mode, however, you can increase shutter speed and reduce aperture at the same time, something the camera would not do as you adjust only one setting. Faster shutter speed with narrower aperture will underexpose most images and may create a dramatic effect. That would also produce greater DOF than if you set a fast shutter speed and the camera automatically opened the aperture. To avoid underexposure, you might also increase the ISO.

Continue to play with the various manual settings. Trial and error will teach you something about the synergy of these settings.

In Manual mode, the training wheels are off. Remember bracketing as a way to hedge your bet.

With the semi-manual modes, such as Aperture Priority, you select the mode on the dial. To change the aperture, you use a different control, perhaps a wheel, lever, or dial. You'd use the same control with Shutter Priority mode. However, in Manual mode, you can change multiple settings, so your camera provides a way to identify which setting you're changing at a given moment. Look for prompts on the LCD or EVF. The setting you are adjusting will be highlighted in some way — it might be larger or a different color from other settings onscreen. When in doubt, read the manual.

Figure 3-10 displays Manual mode — indicated by M in the upper-left corner — and other settings. The shutter speed is 125 and the aperture is f13.

Figure 3-10: Set your camera to Manual mode to take control of your settings.

Some of the buttons on your camera change function depending on mode or other settings. A common configuration on many cameras places four semi-circular buttons around a button. Each of the smaller buttons has a dedicated

function, such as Macro or Flash. In Manual mode, those buttons might move the selection highlight from one setting to the next. In Review mode, the same buttons might move you left and right through your photos.

The following steps walk you through turning on Manual mode and taking a photo using those settings:

1. **Set the Mode dial or button to M (Manual mode) on your camera.**

2. **In Manual mode, make all decisions:**

 a. *Set aperture, shutter speed, and ISO.*

 b. *As you watch the LCD or EVF, select aperture and change it.* You should see the scene turn darker or lighter. Your camera may display under or over exposure as an indicator on-screen.

 c. *Select shutter speed and change it, watching the exposure change.*

 This preview is not 100 percent accurate in predicting what you'll actually get, but you will at least see some effect of changes to settings.

 The first few times you use Manual mode, be sure to try it in a casual situation that isn't a once-in-a-lifetime event such as a birth or a wedding. Consider taking some duplicate shots in Automatic mode.

3. **Compose your shot in the viewfinder or LCD screen.**

4. **Press the shutter button halfway to give your camera a moment to establish the shot.**

5. **Press the shutter button the rest of the way to capture the image.**

If your camera has a Program mode (P), you can set shutter speed and aperture at the same time rather than controlling one while the camera controls the other. Program mode stands between Automatic mode (the camera decides everything) and Manual mode (you decide everything).

Using a Tripod

Back in the days when Abraham Lincoln posed for the great photojournalist Mathew B. Brady, the subject of a photograph had to hold still while the photographer worked magic under a black cloth, muttering incantations and mixing potions. ("Eye of silver, tail of halide. . .")

A century and a half later, cameras are nearly small enough to strap to the back of a fly. Many of our subjects are in motion, and so are we (the photographers). Some conditions, however, still require holding the camera more still than most people are capable of holding it without assistance.

Many of the settings discussed in the preceding section of this chapter increase the odds of blurring, especially in low light. Furthermore, under less-than-ideal conditions, the slightest motion of the camera can introduce blur. (Try holding your camera rock-steady as you lean over a wall to photograph the running of the bulls. Picture abstract blurs with horns.)

The slightest camera movement is even more significant when you use a zoom lens that's fully extended or you use any lens in low light.

To diminish the possibility of undesirable blurring, many cameras provide some means of image stabilization. The lens may be isolated from movement by gyroscopes or special materials. The image sensor may be programmed — it's a computer chip, after all — to detect vibration and subtract that vibration from the final image.

Cameras with an image-stabilization feature use it automatically. You may be able to turn it off, but you probably don't want to do that, except to experiment.

Despite the wonders of image stabilization, you may want to buy a tripod, the venerable tool of photography that even Mathew B. Brady would recognize after all these years.

Brady might be surprised by the variations in tripods, however. Large tripods range from two to six feet tall with legs that fold or telescope. You may be able to set such a tripod at different heights using a twist or catch locking mechanism. Some tripods have pivoting connections so that you can incline the camera up, down, or sideways. You may even be able to remove the tripod head to hang it under the tripod (like a pot of beans over a campfire) for macro shots.

When is a tripod not a tripod? When it's a *monopod*. As you would expect, a monopod has a single leg — it's a walking stick with a camera connection. (Look for a monopod at a sporting goods or outdoor store if you often take your camera hiking.) Don't try to balance a monopod like a unicycle. Brace the monopod with your body or another stable object. The monopod's advantage over a tripod is that it is easier and faster to use and to move. Monopods are recommended over tripods when running with bulls.

Everyone needs a small tripod, something pocket-sized, for sheer convenience. And another small tripod style you might want to consider consists of a beanbag with a tripod connection for a malleable but stable bundle. (A beanbag drapes over a rock nicely.) In a pinch, an actual bag of beans or rice may provide a stable platform for your camera. Have I convinced you yet that you need a tripod?

Tripods are also useful for self-portraits and for group shots that you want to join. Use the self-timer and try not to trip over the tripod as you run to get in the shot. I don't mean that only as a joke — some cameras actually come with both short and long self-timer settings for your safety. So be sure to choose the setting that gives you enough time to get safely into the shot. Tripods are especially handy for taking movies, where any movement can be very distracting.

If you need a tripod but don't have one handy, you can try placing the camera on something steady, such as a wall. Or, brace yourself against a solid object such as a tree or a large rock. Opinions differ about holding your breath as you click. (Seriously.) You could also increase the ISO to allow for a faster shutter speed or smaller aperture.

If you have a tripod, follow these steps to use it successfully:

1. **Attach your camera to the tripod by screwing the tripod screw into the mount under the camera body (see Figure 3-11).**

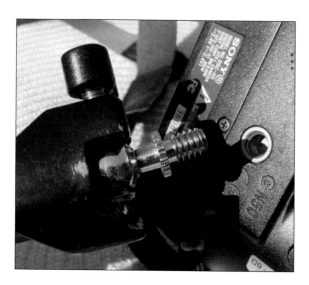

Figure 3-11: Most cameras have a receptacle for a tripod under the body.

Some tripods come equipped with a quick-connect plate that detaches from the tripod. If your tripod is so equipped, attach the plate to your camera ahead of time and use it to quickly attach and detach from the tripod.

2. **Establish the height of your tripod by adjusting the legs and neck of the tripod. Be sure to lock the legs and neck so that they don't slip. Get the height right to avoid straining your own neck as you compose the shot.**

3. **Adjust the head of the tripod until you have the exact angle you want for the camera.**

4. **Use the LCD screen and check the height and angle. Make any necessary adjustments.**

5. **If you're using a lens with an Image Stabilization or Vibration Reduction setting, you may want to turn that setting off when using a tripod (unless the lens also has a setting for detecting tripods).**

 Image Stabilization and Vibration Reduction settings enable you to hold a camera and decrease the incidence of camera shake. When you use a tripod, however, these settings may cause your photos to be blurry if the image-stabilization feature actually tries to compensate for movement or shake that doesn't exist. (Ironic, isn't it?) Check your owner's manual for suggestions on using tripods with image stabilization.

Tripods are especially vital for taking shots that require the shutter speed to be slower, thereby helping to eliminate camera shake. Slower shutter speeds, which enable you to use narrower aperture settings for increased DOF, are often used in low-light situations, such as bad weather, sunsets, and nighttime. You may also want to use a tripod when using a telephoto or an ultra-zoom lens.

Use the self-timer when shooting in low light with a tripod to avoid moving the camera as you press the shutter button. Some DSLRs accept a cable release mechanism for pressing the shutter release without touching the camera. (Very few cameras have wireless remote controls.)

Composing Better Shots

*O*ne of the great things about digital photography is that it doesn't require a lot of thought. You can simply point your camera and click the shutter. (Okay, you do have to remember to turn it on and remove the lens cap, if the camera doesn't do that automagically.)

A camera is like a computer. Wait, that's a good thing! A camera has capabilities that you can ignore as long as you like. When you start looking deeper, you find more and more that you can do with your camera.

Even if you're using the simplest point-and-shoot camera without any extra options, you still control the shot. You select the subject and frame it within your viewfinder.

In this chapter, you look through the lens to see something new. You also explore various ideas for composing a photo to maximize your subject and minimize distractions.

Seeing through the Lens

Focus is vital in photography. A picture in focus is sharp and clear. A picture with the subject out-of-focus is probably a dud.

One problem with focusing a camera is that you're focusing your eye on something right in front of your face (the EVF or LCD), whereas your camera is focusing on the subject (you hope). Putting a lens (and everything else) between your eye and the subject requires seeing things in a slightly different way. It may help to understand how cameras focus and what you can do to control that.

Nailing your focus

When you raise your eyes from this page to look across the room, you continuously focus on whatever you're looking at. You don't think about fixing focus, unless you just woke up.

Most cameras don't work the way your eyes do, unless you change an option in setup. You can think of camera focus as consisting of three parts: when to focus, where in the frame to focus, and the distance between you and the subject. Each of these three elements can be handled by the camera or by you through your camera's setup menu or other controls.

When to focus

Normally, your camera only focuses when you press the shutter button halfway. That's why you do that, to give the camera a moment to focus (as well as to set exposure). That standard method of automatic focus (Auto Focus, or AF) is fine for subjects that aren't moving much. You simply need to get used to the fraction of a second delay as the camera focuses. (DSLRs don't usually have this focus delay. Refer to Chapter 1 for more about the different types of cameras.) Your camera may call this One Shot AF or Single Shot AF.

For subjects that are moving, you may need another form of automatic focus: Continuous Auto Focus (CAF). If CAF is available, it appears in a setup menu or as you press the Focus button, if your camera has one. As the name implies, CAF constantly focuses, even when you are not pressing the shutter button. An advantage of CAF is the elimination of that brief delay for focusing, which is great for catching subjects in motion. A disadvantage of CAF is the drain on the batteries caused by the constant focusing. CAF may also have some associated noise as it constantly adjusts focus, and this may result in a modest increase in wear and tear on the mechanism.

Cameras with a Sport mode (often a runner or soccer player icon) may use CAF automatically.

Where in the frame to focus

But what is the camera actually focusing on? Does a camera recognize the subject of a photo? You may want to focus on that pretty bird in the tree, while the camera is automatically focusing on the twig in the foreground, blurring the bird. What determines the *focal point* (the part of the frame used

to focus)? Focal point sounds too small — think of this instead as the *focus area* that the camera uses to focus.

Your camera doesn't know what the subject of the photo is. Instead, your camera is set to focus on one or more areas within the frame. Standard AF uses a relatively wide area around the center of the frame to focus. You may see this as a rectangle or brackets on your EVF or LCD. (The rectangle or brackets may turn green when the subject is in focus.)

Your camera may let you choose Center Focus (CF). With CF, the focus area is reduced to more of a square than a broad rectangle. Use CF to reduce the area the camera focuses on, such as when you want to photograph one person in a crowd.

Some cameras feature Multipoint Focus (MF), in which the camera focuses on a number of areas (determined by the manufacturer, in most cases).

Some recent cameras have a variation on MF called *face detection,* as well as *smile detection.* These cameras are programmed to recognize faces and smiles. (Really!) Face detection draws a box around recognized faces, which the camera focuses on (among other areas, in most cases). With smile detection, the camera delays the shot until the subject smiles. Look for a smiley face icon on your camera's controls.

Hats, sunglasses, or odd angles may confuse face detection. Sometimes you'll see the face detection box around something that's not a face but has a pattern that fools the camera. (Don't worry about that unless you don't want the non-face in focus.)

The distance between you and the subject

Regardless of when or where the camera is focusing, how does it know that your subject is 6 feet and not 20 feet away? This is another task that the brain handles subconsciously, in most cases, but cameras are programmed to calculate.

Some cameras measure distance by using some form of range-finder based on optics, infrared (especially in low light), or sound (like a bat). This method is called *active autofocus.* Lasers were used until the first few subjects vanished in a puff of smoke. (Just kidding!)

Other cameras rely on *passive autofocus* methods known as phase detection or contrast measurement. Whereas active autofocus measures the distance to the subject, passive autofocus calculates the distance using analysis of light intensity differences at points on a sensor. The technical features of each method may be interesting, but for purposes of this chapter, any form of autofocus works.

The camera's calculation or measurement of how far away the subject is can be affected by low light or objects between the lens and the subject. So, that's where Manual Focus comes in. Look for a Focus button or menu item on your camera to switch between Auto Focus and Manual Focus. When you choose Manual Focus, you tell your camera how far away the subject is by using left (closer) and right (farther) controls while watching a scale on-screen with distances marked up to infinity. Some cameras and lenses use a focus ring around the lens, instead. Manual Focus takes the control away from the camera and leaves it to you to guess distances accurately.

Locking focus

Most of the time, the camera automatically focuses on as many things in the frame as it can, but it may not include your subject or you may not want irrelevant objects in focus. Look for indications on-screen of where the camera is focusing (usually one or more boxes or brackets). If you want to force the camera to focus on a particular object, you can lock the focus on that object.

In most cases, pressing the shutter button halfway locks the focus until you press all the way down or release the button, no matter how focus was determined by the camera. You might deliberately lock focus on a subject before moving the camera a little to one side or the other. This takes the subject out of the center of the frame but ensures that the subject is in focus. An off-center subject may be more interesting, as long as the subject is in focus.

Be certain you don't change the distance between you and the object you lock focus on, by moving more than a small turn of your body or by zooming in or out. Moving more than side-to-side guarantees the subject will be out of focus.

You don't have to change any settings to try this technique. If you also want to prevent the camera from focusing on other objects in the frame, set the Auto Focus option to Center Focus mode. If your camera has an option to select a single focus point, select it. (Check your camera's user manual to find out how.)

Figure 4-1 shows an off-center subject. For this photo, I pressed the shutter button halfway down to lock the focus with the subject in the center of the frame. Then I moved the camera to create a more interesting composition.

Locking focus on a subject can help you in situations where the camera might focus on the wrong thing. For example, when you're photographing a bird in a tree, the camera might focus on branches closer to you than the bird. To adjust for this, focus on an object the same distance from you as the bird, lock the focus, and move the camera to frame the bird. (This trick works on other subjects, too. It requires a good sense of distance, as does Manual Focus.)

Photo credit: Mark Justice Hinton

Figure 4-1: Lock the focus before you shoot an off-center subject.

Working with depth of field

No matter which mechanism your camera uses to focus — Auto Focus, Manual Focus, Center Focus, Multipoint Focus — there is always the issue of depth of field (DOF). DOF is covered in Chapter 3. You may recall that there is a range in front of the focal point (the area between the camera and the subject) and beyond or behind the subject that is in focus — that's the DOF.

Imagine three rows of volleyball players standing on bleachers. If the camera focuses on the middle row, will the players in the first and last row be in focus? They will be if there is sufficient DOF. If the DOF is shallow, the other rows will be out of focus. That may be just what you want if you like someone in the middle row.

Aperture directly affects DOF. If you are operating in any mode other than Aperture Priority, Program mode, or Manual mode, the aperture setting remains in the camera's control, along with the DOF. (See Chapter 3 if you need a refresher on how aperture affects DOF or to find out more about Program mode.) There is nothing wrong with letting the camera manage

settings. When you control the aperture and DOF settings, you may create photos that are different from what the camera would do automatically. Those photos may be better, but some surely will be worse as you experiment. You have to break a lot of eggs to photograph an omelet.

To play around with DOF, look in the early morning and late afternoon for natural spotlighting of bright objects in front of darker, shaded backgrounds.

Figure 4-2 shows an image of a coneflower with a very shallow depth of field, resulting in a blurred background (called *bokeh*).

Photo credit: Mark Justice Hinton

Figure 4-2: An image with a shallow depth of field.

Figure 4-3, on the other hand, shows Lily Pond in Colorado, with a very deep depth of field that results in near and far objects that look equally sharp.

If you want to create a shallow depth of field, use one of the techniques from the following list:

 ✓ **Shoot in Portrait mode.** Look for an icon of head and shoulders. This mode sets the camera to a larger aperture.

 ✓ **Set your camera to Aperture Priority (A or Av) mode, if that option is available.** Choose a wide aperture, which, ironically, is indicated by a lower f-stop number. For example, f2.8 is a larger aperture than f16. Try various aperture settings to create the DOF you're looking for. (See Chapter 3 if you need a refresher on setting the aperture.)

 ✓ **Zoom in to fill your frame with the subject.** The longer the focal length of your lens, the shallower the DOF.

 ✓ **Move close to your subject.** The closer you are, the shallower the DOF. A Macro shot has very little DOF.

With most non-DSLR cameras, you won't really see the DOF until you look at the picture afterward. DSLRs may have a Preview button that helps you see the DOF.

Photo credit: Mark Justice Hinton

Figure 4-3: An image with a deep depth of field.

In you want to create a deep DOF, try one of these techniques:

 ✓ **Shoot in Landscape mode.** Look for the mountain icon on your camera. This mode sets the camera to a narrower aperture.

 ✓ **Set your camera to Aperture Priority (A or Av) mode.** Choose a narrower aperture (larger number), such as f16 or f22. Experiment with settings to create the depth of field you want.

> ✔ **Use a wide-angle lens (or less zoom, unless the subject is very far away).** This increases the impact of a deep DOF.
>
> ✔ **Move farther away from your subject.** The farther away a subject is, the greater the DOF.

Keep in mind that DOF refers to how much area is *in focus* in front and in back of your subject. When you want to minimize a busy, distracting background and make your subject a strong focal point, use a shallow DOF, which blurs the background. When you want the entire image (from the foreground to the background) to be sharply in focus, use a deep DOF.

Compact P&S cameras inherently have greater DOF due to their small sensors and short lenses. That makes it harder to reduce DOF. Use the zoom and move close to your subject (fill the frame). You may achieve the desired effect, especially if there is some distance between the subject and the background.

Metering to evaluate scene brightness

For each photo you shoot, your camera evaluates the available light and analyzes the areas of light and dark within the frame. This analysis is called *metering* and comes from the traditional film technique that involves a hand-held or internal light meter. With a hand-held light meter, you can aim the meter at the part of the scene you want to use to determine the exposure (this is called *metering off* an object). Even though most nonprofessional camera owners don't use a hand-held meter, your camera has a built-in device that meters off all or part of the scene.

To control the exposure, especially in scenes with stark contrast between light and dark areas, consider how the camera determines the brightness of a scene. Imagine a marble statue surrounded by dark-green vegetation. If you meter off the statue, say, by moving close to it or zooming in, the camera adjusts for a bright scene and avoids overexposure. In the process, the greenery may be underexposed and dark, which is not necessarily bad. If you meter off the greenery, either by aiming away from the statue or by backing off so that the statue is a small part of the scene, the camera adjusts for a darker scene and avoids underexposure. In the process, the statue will probably be overexposed and bright.

All cameras use various metering methods. These methods define the way the image sensor in the camera measures the light in the shot and calculates the appropriate exposure for the image. DSLRs and other high-end cameras let you choose between methods.

Some of these metering methods are described in the following list:

- **Evaluative (also known as *matrix, multi-segment,* or *multi-zone*):** This method looks at the subject's position and brightness and the fore-ground, middle ground, and background lighting. Evaluative metering evaluates up to 100 percent of the scene and averages the lighting to determine the appropriate exposure.

 For most scenes, this is a sensible metering method, which is why evalu-ative metering is the standard method used by most cameras unless you choose otherwise. As you would expect, some cameras enable metering changes, and some do not.

- **Spot or partial:** This method of metering bases exposure on the light in the center of the frame (approximately 10 to 15 percent of the frame). You might choose spot metering for backlit scenes, in which the back-ground is much brighter than the subject. Doing so causes the camera to adjust to let in more light to properly expose the backlit subject. That, in turn, may overexpose the background. If you want a silhouette, you may want to meter off the bright background to cause the camera to under-expose the subject.

- **Center-weighted:** This method meters off the center, giving that infor-mation *weight* (emphasis or preference) and then meters the rest of the scene. This isn't quite an average because it is weighted toward the center metering, making this a cross between evaluative and spot meter-ing. This mode is good for complex lighting situations.

If your camera offers metering options, take a few minutes to explore them by following these steps:

1. **Put your camera in Manual (M) mode and press the Metering button or choose the setup menu.**

 Check your camera's user's manual if you don't see this function.

2. **Select from the available metering modes on the menu: evaluative (or multi), spot, or center-weighted.**

 See the descriptions in the preceding bullet list if you need help in choosing a mode.

3. **Take a few different shots from the same spot, looking for a variety of light and contrast.**

4. **Without moving from that spot, switch metering methods and take the same shots.**

The various effects you get from different metering methods can be very subtle on your camera's LCD. To really tell the difference among images, transfer the photos to your computer and compare them onscreen. (See Chapter 7 for help with reviewing your photos on your camera and on your computer.)

Composing the Photograph

So far, I've had you pretty fixated on technology — simply nailing down how to find and select the right setting for a particular shot. In this section, I help you snap up some technique (okay, bad pun). People have been taking and viewing photographs for ages, and you get to benefit from all they've learned.

The concept of *point-and-shoot* belies the amount of thought that precedes good *composition,* which is the conscious arrangement of elements in a scene. Along with juggling various mechanical settings — or using Automatic mode — consider improving the composition of your photograph by incorporating the suggestions discussed in this section. You find out how to place and enhance the subject, how to minimize distractions, and some ways to develop a particular mood for a shot. You may also see some photos that defy guidelines but are interesting, nonetheless.

Choosing your orientation

Most of the time, people hold a camera horizontally, the way it hangs from a strap or sits on a table. This is referred to as *landscape orientation.* The resulting photos will be wider than they are tall.

You may choose to rotate the camera 90 degrees left or right, holding the camera vertically. This is *portrait orientation.* The resulting photos will be taller than they are wide.

It may seem obvious from the names that landscape is suitable for pictures of, well, landscapes, and portrait orientation for pictures of people. Okay — it *is* obvious. Nevertheless, choosing the orientation of the camera is your first decision about composition. The orientation determines the emphasis of the picture — width, height, or depth — as well as the location of the thirds you are considering as you shoot.

Which perspective suits the subject? You might think portrait suits a person, but what if the scene around her is important? Consider landscape in that case. (Take shots in each orientation.) You'd have to think landscape orientation for a landscape scene, but what if you want to lead the eye up a valley or along a ridge you're standing on? Try portrait to emphasize the depth or length. (Take both.)

 One of the simplest edits is to *crop* a picture, which means that you save the part you want and throw the rest away. Cropped photos can be square or use other proportions than those of a standard print. See Chapter 9 for more about cropping and other types of editing.

Figure 4-4 shows two photographs of the same subject in different orientations.

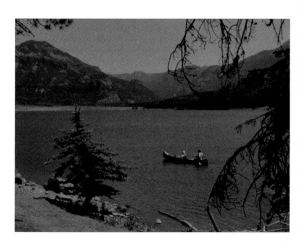 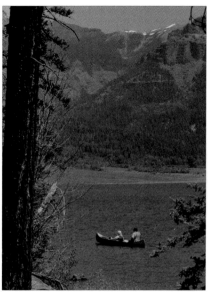

Photo credit: Mark Justice Hinton

Figure 4-4: Landscape (left) or portrait (right) orientation is your first composition decision.

You will probably use landscape orientation more often than portrait. However, experiment with portrait (vertical) landscapes and landscape (horizontal) portraits. Shoot the same photo both ways. Uncommon orientation can add freshness to a subject.

 For portrait orientation, I hold the camera with the grip at the top. It's easier to let the camera's weight hang than to hold it with the grip at the bottom.

 You're going to look at your photos on a screen, whether computer, TV, or photo frame. Screens are usually landscape. Portrait-oriented photos will have big, black borders on the left and right. Objects in the photo will be smaller than in a similar landscape shot because the height of the photo is reduced to fit the wider screen. In the worst case, some devices stretch the photo left and right, resulting in the top and bottom disappearing off-screen.

Finding a focal point

If a photo contains too many elements, the eye doesn't know where to look first. Beware the wandering eye. A focal point draws your viewer to a main point of interest within the image. One of the easiest compositional tasks is to find a clearly defined focal point.

Consider a city street corner with a lot of traffic signs, a couple of billboards, and dozens of people moving in every direction. That chaos might actually be the subject of a photo. But if the actual subject is a dog sitting by a lamppost, people looking at the photo may miss that point. (The *Where's Waldo?* series proves people enjoy hunting for the subject under some circumstances.)

A clear focal point should include only necessary elements that contribute to the compositional strength or emotional impact of your image, eliminating distractions. Here are a couple of suggestions:

- **Zoom in.** If you're photographing people or animals, try to get close to them by moving or using a zoom lens. (Using the zoom allows for more candid photos.)

- **Find an interesting subject.** If you're shooting outdoor scenes, give people something to focus on. Shots of mountains and beaches are fine, but how many are truly memorable? Throw in a climber scaling the mountain wall or a surfer wiping out on a wave and you elevate the visual impact to another level.

Elements that distract from your focal point, and which you should try to avoid, include too much background and random clutter and bystanders.

Figure 4-5 shows an off-center focal point (a sunflower seedling) emphasized by natural lighting.

Every guideline has exceptions. A field of flowers may not have a focal point but smells as sweet.

Reducing background clutter

Most people worry only about cutting off people's heads when they shoot. (Now that's a gruesome sentence!) However, including too many elements in their shots distracts from the focal point. Try to eliminate background clutter that adds nothing to the value of your shot.

Photo credit: Mark Justice Hinton

Figure 4-5: The focal point can be anywhere in the frame.

Here are a few tips for reducing unnecessary elements in your photo compositions:

- **Get close.** Fill your frame with your subject.

- **Move your camera, yourself, or your subject.** Try shooting a vertical or diagonal shot if the subject warrants it. If moving your camera isn't enough, move around your subject and try unexpected angles. Look for compositions that minimize or avoid distracting elements around your subject, such as poles, wires, fences, or bright lights.

- **Include only complementary background elements.** If your background elements are interesting and give context to your subject, include them. These elements can include props, landmarks, and natural components.

- **Try blurring an unavoidable, undesirable background.** Sometimes you can do this by using a wider aperture on your camera. This strategy makes the depth of field shallower so that your subject is sharp but the background isn't.

You can move around your subject, choosing the least distracting or most interesting background for your shot.

Following the Rule of Thirds

Very few photographic guidelines have been elevated to the status of a *rule*, but this section tells you about one of them. The Rule of Thirds divides the photo into horizontal thirds, vertical thirds, or a grid of nine squares (3 x 3).

For a very simple example of the effect of thirds, stand where you can see the horizon. Looking through the VF or using the LCD, position the horizon one-third up from the bottom of the frame. Shoot or take a mental picture. Move the camera slightly to position the horizon two-thirds up from the bottom. Which of these pictures is better depends on your intent and the subject. Either may be better than dividing the frame in half with the horizon.

Figure 4-6 shows a photo of a Canada goose overlaid with a grid. The Rule of Thirds suggests that the focal point should be at or near one of the four inter-sections around the middle of the picture, along one of the thirds — vertical, horizontal, or both. Placing the subject or focal point along the thirds makes it more likely to be noticed first and, some say, is subconsciously more pleasing.

Photo credit: Mark Justice Hinton

Figure 4-6: Position your subject by using the Rule of Thirds.

Remember, the Rule of Thirds is only a guideline. A very strict use of thirds would shift the goose's body down to the next intersection, but that would wreck the reflection.

Your camera may have an option to turn on gridlines. Some cameras don't show gridlines in Auto mode, but only in one of the manual modes.

To apply the Rule of Thirds to various shots, consider these examples:

- **In a scenic shot:** A low horizon creates a spacious feeling; a high horizon gives an intimate feeling.

- **In a portrait:** Try putting the face or eyes of the person along a vertical or horizontal third or at one of the four points of intersection.

If you have a camera with Auto Focus, lock the focus when you're moving from center because the Auto Focus sensor locks on to whatever is in the center of the viewfinder (unless you've manually chosen a different focus method). Center your subject in the viewfinder and apply slight pressure to the shutter release button to lock the focus. Then reposition your subject at an intersecting point and press the shutter release the rest of the way to take the photo.

Even the mighty Rule of Thirds has exceptions. You may choose to put your subject dead center, knowing that you expect to crop the picture later, either filling the frame with the subject or cropping with the subject off-center (and, more than likely, along one of the thirds).

Photography is fun. Editing is work.

Avoiding mergers

As you intently frame and compose your photo, you might fail to see a branch in the background that will seem to grow out of your friend's ear in the final photo. Such a gaffe is called a *merger.* Or, you might not notice that you're chopping off someone's hand or foot. This is known as a *border merger.*

Effects like these are common and amusing and, with luck, not too embarrassing. You can avoid mergers by thoroughly scanning the preview in the EVF or LCD and thinking about the background and foreground as much as you do about the subject. You may be able to avoid a problem with the background by moving your position or by reducing the depth of field (widening the aperture with a lower f-stop).

Figure 4-7 shows a border merger attacking a cheetah.

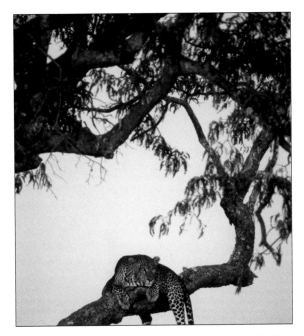

Photo credit: Corbis Digital Stock

Figure 4-7: Avoid border mergers.

With the best photo-editing software and enough time, it's easier to brush away a branch than to restore a severed limb.

Looking for balance

Even still photos can convey a sense of motion. A subject dead center may seem pinned or frozen in place. A subject along one of the thirds, looking or moving toward the center or away, creates tension between elements in the photo and the unseen world beyond the frame. You create balance in an image through the arrangement or placement of the elements in the image. Balance can be *symmetrical* (harmonious or formal) or *asymmetrical* (dynamic or informal). Think of balance in regard to color, shape, and contrast.

Imagine two photographs of a chessboard. In the first, all the pieces are lined up before the game begins. Shot from above or from the level of the board, the scene has a natural symmetry and balance among the pieces.

Now, the game is over. In a corner, two pieces stand over the fallen king — checkmate! The unbalanced image is part of the story.

The two photos in Figure 4-8 show very different approaches to the same subject (a church in Antigua, Guatemala) — starting with the orientation. The landscape photo on the left captures the symmetry and balance inherent in the architecture. The effect is formal and respectful. The portrait on the right intentionally unbalances the scene to draw the eye upward. The effect is more abstract and intimate.

Photo credit: Merri Rudd / Mark Justice Hinton

Figure 4-8: The symmetry and balance in a scene may convey formality or motion.

Although the examples mentioned are not from nature, balance, motion, and symmetry all apply to any scene. Refer to Figure 4-6, in which the reflection in the water creates balance. The placement and direction of the goose suggest she is about to swim out of the scene.

Finding leading lines

With some photos, your eye wanders haphazardly across the image, which isn't necessarily a bad thing. However, you may want to compose a stronger picture that leads the eye purposefully across the image.

Leading lines draw the eye into the picture. They add dimension and depth and can be actual lines or lines implied by the composition of elements.

To compose photos with leading lines, look for elements such as roads, fences, rivers, and bridges. Diagonal lines are dynamic. Curved lines are harmonious. Horizontal lines are peaceful. Vertical lines are active — or so some people say. Regardless of emotive quality, a line leads the eye.

The line of clouds in this photo of Chaco Canyon, New Mexico, shown in Figure 4-9, demonstrates how a leading line can direct your eye across an image. In Figure 4-9, the horizon (along the lower third) doesn't draw the eye left or right. The clouds lead the eye toward the lower right — and there's Waldo! This print may be too small for you to see the photographer's shadow in the lower-right corner. Such a shadow is generally regarded as a mistake. Here, it was intentional.

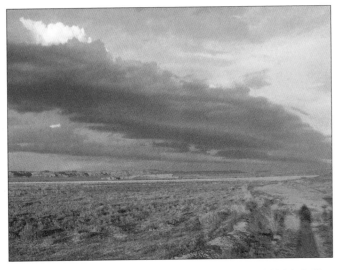

Photo credit: Mark Justice Hinton

Figure 4-9: Leading lines (the clouds, in this case) bring the eye into and across the image.

Keeping the horizon straight

For some reason, people expect horizons to be horizontal. (That must have something to do with the real world.) You can spoil a dramatic sunrise or sunset by too much tilt to the left or right. Try to keep a straight head on your shoulders or learn to compensate for your natural inclinations.

Figure 4-10 shows a whimsical self-portrait. The nearest horizontal line is perfectly level (and along one third, as is the foot). The real horizon is nearly along one third. Does it matter that it's not perfectly horizontal? If it were, then the shoreline wouldn't be. Sometimes, you have to make choices.

Figure 4-10: Keep major lines straight, when possible.

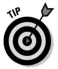

In Chapter 9, you use editing software to straighten a crooked picture.

If your camera has a viewfinder screen with a built-in grid for the purpose of helping you keep the horizon straight, use it.

Using a tripod can also help keep your horizons straight. And some tripods come with built-in bubble levels. Just make sure that the legs of your tripod are extended properly — equally on level ground, or lopsidedly on uneven ground — to make the camera level. (You can read more about using a tripod in Chapter 3.)

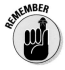

Once you know the rules, you can always break them. But it's much more fun to break the rules you know than to operate out of ignorance.

Framing the subject

The term *frame* is used to describe the image itself. You frame your subject, and the lines in the composition, such as the horizon or roads — as well as movement — extend beyond the frame. Inside this frame, you can further frame the subject by including elements around the foreground that surround the subject. Imagine a lake appearing flanked by trees or a shot through a doorway or window looking inside or looking outside.

Figure 4-11 shows a doorway in Chaco Canyon framing part of a room beyond within the frame of the photo. The doorway in this photo may violate the

Rule of Thirds because the right edge cuts the scene in half, unless you imagine the left-hand vertical third down the middle of the doorway. Showing more of the wall to the right would be more in line with the Rule of Thirds (one-third doorway, two-thirds wall).

Photo credit: Mark Justice Hinton

Figure 4-11: It can be fun to put frames within frames.

Here are a few more points to keep in mind about framing within a photo:

- **A frame welcomes you to an image, adds depth, and creates a point of reference.**

- **To compose photos with frames, use foreground elements to frame your subjects.** Elements such as tree branches, windows, and doorways can frame wide or long shots. Close-up shots can also be framed.

- **Decide whether to keep your framing elements sharply focused or soft.** Depending on the shot, sometimes sharply focused framing elements can distract from, rather than enhance, the focal point.

Creating a mood with distance

A memorable photograph often creates or conveys a mood. The subject is clearly significant, but light and distance also impart a mood.

Getting close to your subject may make the image personal, warm, and inviting. Avoid including excessive background elements, and intimately fill your frame with your subject, especially when photographing people.

Figure 4-12 shows the subject's joy in an odd find on the trail (a gastrolith). This photo illustrates the intimacy that comes with getting close to your subject.

You might even violate guidelines for framing and against mergers by getting exaggeratedly close to your subject. A close-up of a face, even just eyes, nose, and mouth, can be very interesting. A good zoom lens allows you to get especially close without aggravating your subject.

And just as shooting close can create a feeling of intimacy, shooting a subject with a lot of space around it can evoke a sense of loneliness or isolation (refer to Figure 4-9). It all depends on your intended message.

Use eye contact when photographing people. Remember that children, animals, and other height-challenged subjects aren't at the same eye level as adults. Try getting down on the ground, to their level, if necessary.

Photo credit: Mark Justice Hinton

Figure 4-12: Getting close to your subject affects the mood of the picture.

Using texture and shape

When composing your shot, look for interesting textures to add definition and for lines and shapes to create interest. Remember that textures and shapes are enhanced by the use of light and shadow. These elements come into play even more when you're shooting black-and-white images.

Figure 4-13 shows the effect of texture in an image. This photo of a rock wall in Chetro Ketl, New Mexico, emphasizes the natural texture of the stone plus the sculptural quality of the mason's work. This photo might be even more interesting in black and white.

Photo credit: Mark Justice Hinton

Figure 4-13: Using texture for added definition.

Check your camera's settings or refer to your user's guide to see whether your camera offers a black-and-white (B&W) setting. Alternatively, you can switch from color to B&W during editing.

5

Photographing People and Events

In This Chapter

▶ Photographing people
▶ Recording special events

*P*eople make great subjects for photographs. We want to preserve the time we spend with friends and family. Everybody enjoys seeing someone they know in photos. Who hasn't looked at a photo from just a few years ago and laughed over the fashions of the day or cried for a departed loved one. Every photo is a potential treasure.

Obvious opportunities for photographing people include birthdays, graduations, and weddings. Sometimes, a meal is all the occasion you need. With a compact P&S in your pocket or purse, you're ready.

Of course, not everyone wants to be in a photo. Be respectful of the camera shy, particularly people you don't know well. Sometimes, people feel too self-conscious to *pose* for the camera. Perhaps they'll join in a group photo, but don't press the matter.

In this chapter, I show you how to take the two classic people-pictures: the portrait and the group photo. A portrait can be formal or casual, up-close or in a setting, such a travel photo. Group photos call for some organization. Both types of photos often occur in the context of an event, such as a party or a game. A little preparation assures you'll be able to look back at this moment for years to come.

REMEMBER The advantage of digital photography is that you don't have to worry about the cost and time spent in film processing, so you can let your experimental and creative juices flow and take lots of pictures without worry or guilt. Just be sure to spend enough time with your camera before the big day to avoid unpleasant surprises. ("What lens cap?")

Capturing People

The best photographs tell a story or convey a mood. A photo can cause us to share even a stranger's joy or sorrow, or recall or imagine what it was like the day that photo was taken.

Photographs freeze a moment or an aspect of life. You may cringe at the sight years later; but more likely, everyone will delight in seeing how things used to be.

Taking a portrait

A portrait of one or two people can be very formal or casual. The subject of a portrait can fill the image or be framed by the immediate surroundings. And you can shoot a portrait in either portrait or landscape orientation.

The best portraits do more than merely capture an instant in a person's life — they reveal something unique or memorable about that person in that captured moment.

Don't worry about creating *art* — a candid snapshot can become a treasured keepsake. But if time and circumstance allow, invest some thought in the composition.

Figure 5-1 shows a candid portrait of a subject unaware of the photographer.

Photo credit: Merri Rudd

Figure 5-1: A candid portrait can become a treasured keepsake.

When you're shooting a portrait, the most important thing you can do is take care of your subject. Here are some suggestions on how to do just that:

- **If possible, photograph the person in a location where she feels comfortable.** Chat with her and make her feel relaxed.

- **To achieve the highest level of intimacy and engagement by viewers of the portrait, go for direct eye contact — that is, have your subject looking straight toward your lens.** If your subject is looking away from the camera, however (which can add mystery), decide whether you want to include any of the surroundings to show the person's point of view.

- **Sunglasses and hats shading the eyes can make or spoil the shot.** So think about whether you want your subject to remove them.

- **Try to include some context in a portrait, which means photographing the person in surroundings that speak to who she is.** For example, her profession, hobby, or personal life. Include tools of the trade or props, if appropriate.

- **If the person is posing, grab some candid shots when she isn't paying attention.** If you're posing her, have her turn slightly to the side, angle her shoulders, and lean in slightly toward the camera. Watch out for glare on eyeglasses.

- **For children, get down to their level, be patient, and take some candid shots.** Let children lose their shyness in play.

After making your subject comfortable, compose your photograph and choose your settings. Here are some things to consider before you shoot:

- **Incorporate general rules about composition.** Remember to move in close and use the Rule of Thirds for a great portrait. Place the eyes along an intersecting grid line and reduce background clutter unless it contributes to the shot in some way. See Chapter 4 for more composition pointers.

- **Use Portrait mode to keep your subject in focus while blurring the background.** Look on your camera for Portrait mode; it's usually indicated by an icon with a head on it. Some cameras also have a Portrait/ Landscape setting, which keeps both the subject and background in focus. (The icon may be a head in front of a triangular mountain symbol.)

- **Shoot a variety of shots.** Close-ups, medium shots, and even full body. Create a lot of images that you can choose from.

- **Shoot in optimal conditions:**

 - *Outside:* Shoot in natural light at a 45-degree angle to the sun. Overcast days create a soft, flattering light. Shooting right before sunset creates a soft, warm light. Avoid harsh midday sun at all

costs. People squint, and the sun causes nasty shadows across the face.

- *Inside:* Place people near a window, at a 45-degree angle to the light source. If you need to light the shadowed side of the face, place something reflective nearby, such as a light-colored cardboard or even a lamp (with or without a shade), placed at a 45-degree angle.

Soft lighting is the key with portraits. If you must use a flash, be sure to set Red-Eye Reduction mode. Red-Eye Reduction uses two flashes. Many people don't expect a second flash, so warn them to stay still through both flashes. (You can also correct red-eye in editing. See Chapter 9 for more about avoiding and fixing the problem of red-eye.)

✔ **Keep a low ISO (100 to 200) to minimize noise.** ISO settings refer to how sensitive the image sensor is to light. If you're using a slow shutter, use a tripod to ensure a sharp capture. If you're shooting in Manual mode and not using a tripod, set the shutter to around $\frac{1}{125}$ second.

If you're photographing someone you don't know — for example, someone you run into while on vacation — be sure to ask for the person's permission.

Getting the group

Photographing a group takes determination and cooperation. Teams are easy; families can be trickier. Don't even try to get everyone at the bus stop to pose together.

Take all the considerations of a portrait and multiply them by the number in a group. How many people will have their eyes closed? Will everyone look at the camera and smile at the same time? At the very least, be prepared to take extra pictures.

If your camera has smile detection, it may wait for smiles. Some cameras detect closed eyes and may take an extra picture or display a message on-screen. Look for a smiley face icon on the Mode dial or the LCD screen. Check your camera manual.

Sometimes, taking a great group shot is a matter of serendipity. Here are some tips:

✔ **Find the best location.** If possible, use props such as viewing stands, steps, picnic tables, trees, or other elements to arrange people.

✔ **Play director and tell people where and how to stand, sit, or position themselves.** Just be considerate of people's time and don't make them wait too long.

If you have an especially large group of people or active kids, ask for a volunteer to help with the directing.

✓ **Position people in a variety of poses.** Depending on the number of people, having some sit or kneel in front and others stand in back can work well. Stagger people in front and behind.

✓ **Have people get close, tilt their heads toward each other, and even touch.** Doing so often makes the shot more intimate and engaging. Figure 5-2 shows a group barely squeezed into a tent.

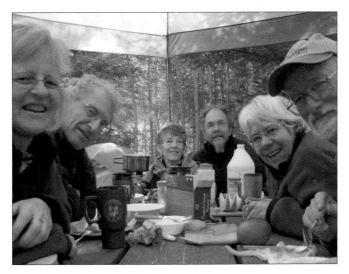

Photo credit: Mark Justice Hinton

Figure 5-2: Direct people how to fit within the frame.

Join the group by setting up the shot on a tripod and using the self-timer. Let everyone know what position you'll take when you join the group and make sure you'll fit in the frame. Make everyone hold positions until you check the photo.

✓ **When photographing really large groups, move higher and focus down on the group.** You can squeeze more people into the frame.

✓ **If a group of people is engaged in an activity, bring elements of the location or activity into the shot.** Activities, such as a game, give the photo context.

✓ **Get people to relax.** Use humor to get people to smile naturally. It's the next best thing to spontaneity.

Documenting Events

From time to time, you may find yourself taking photos in a structured, organized, or more constrained setting, such as a sporting event, wedding,

or group meal. The good thing about shooting a scheduled event is that you know in advance when and where people will be and what they are likely to be doing at a given moment.

The challenge of taking photos for an event, of course, is that most events restrict your movement and your freedom to use a flash or yell "Stop!" Think about the event ahead of time and recall similar events and the photos you took or have seen from these events. Plan ahead and remain flexible — remember, the unplanned photo is very often the most interesting.

During an event is not the time to wonder how a particular camera mode works or "what was the difference between aperture and shutter speed?" Do your homework and come prepared. Have lots of space on your memory card (or take spares) and some extra batteries. Practice changing batteries or cards as quickly as you can. You want to be free to think about composition, not mechanics.

Games, sports, or other events with quick action require specific preparation. Weddings, on the other hand, tend to unfold at a much slower pace. But remember that neither event offers the chance to pause or redo.

Some events don't allow you to use a flash. When you're shooting in low light without a flash, try moving to a higher ISO setting. Just be aware that this may add noise (defects) to your images.

Freezing action

One of the great benefits of digital *video* cameras is that you can relive every minute of a game or other event. Usually, there are moments that stand out above all the rest. In those moments may be found the best photos of the event.

Most digital cameras also shoot video. See Chapter 2.

How do you capture the bat meeting the ball, the goal, or the spike with a regular digital camera, however? With preparation, a fast shutter speed, and some luck.

Most cameras have a Sports mode that increases the shutter speed and adjusts all other settings automatically. (Look for an icon of a runner, or a ball.) Take advantage of Sports mode and remember it in other circumstances that require quick captures (such as photographing wildlife).

Here are some things to consider when you want to freeze the action in a shot:

> ✔ **Have a plan.** Know in advance what kinds of shots you want to get. Of course, being familiar with the event or sport helps you determine which shots would be most interesting to capture.

- ✔ **Position yourself in the best location to capture the action.** This location may vary as the game, activity, or time of day progresses. In general, keep the sun at your back.

- ✔ **Use a telephoto or zoom lens to help you get close to the action.**

 A monopod (similar to a tripod, but with only one leg) is useful when you're using long, heavy lenses. It's lightweight, letting you move it easily to chase action subjects.

- ✔ **Be in the right place at the right time.** Sometimes, timing is so critical that capturing that excellent shot means pushing the shutter just before the perfect moment. Take into account any delay between click and capture *(shutter lag)* your camera has.

- ✔ **Be aware of the background and elements around your focal point.** Unless they add context, keep them simple and nondistracting.

- ✔ **For most sports, shoot at a fast shutter speed (⅟₅₀₀ second or faster).** Set your camera to Shutter Priority mode so that if the light changes, the shutter speed stays the same and the aperture adjusts accordingly.

Figure 5-3 shows a frozen instant, full of the action of a martial arts demonstration.

Photo credit: Mark Justice Hinton

Figure 5-3: Be ready to freeze an instant.

When you're trying to keep up with a player on the move, give these settings and techniques a try:

- ✓ **Set your camera to continuous Auto Focus mode.** This mode gives you better capability to track a moving player.

- ✓ **Conversely, try Manual Focus mode.** Auto Focus may be fine for the subject you're capturing, but becoming comfortable with Manual Focus can help you get a shot when Auto Focus falls short.

- ✓ **Try panning.** Using a slower shutter speed, follow the action and press the shutter while still moving the camera. The moving subject remains in focus as other objects blur. This technique creates the illusion of movement in a photo.

Take some shots of the event preparations, the sidelines, the crowd, individual spectators caught up in the excitement, and the aftermath. Sometimes the most interesting and poignant shots aren't even part of the official action.

Photographing a birthday, graduation, or wedding

Many events that you attend are highly structured and choreographed, with multiple players performing scripts as beaming witnesses look on, often through tears of joy. These events mark transitions in people's lives, from youth to old age, from school to real life, from two into one. We want to preserve and treasure these moments forever.

But don't let the pressure of the special day get to you. Follow these tips:

- ✓ **Plan, prepare, know your camera, and stay flexible and alert to the moment.** Be prepared with charged batteries, memory cards, and other equipment, such as lenses and a tripod. Be ready to rumble.

- ✓ **Plan some of your pictures in advance.** Know when special moments will happen — blowing out candles on a cake, handing out diplomas, the big kiss.

- ✓ **Sometimes the best shots are the candid ones.** Someone adjusting a formal outfit, a friend or family member radiating pride, or someone goofing off.

- ✓ **Discretion is the key at a formal event.** No one wants to be haunted by some misbehavior caught on camera.

- ✓ **Scout out the best locations and vantage points for your photos.** Minimize the distraction you create for participants and guests. Stay out of the way — and out of the frame — of other photographers, if possible.

- ✓ **Shoot a few throwaway shots to test the lighting.** Use a flash only if it's allowed. If flash isn't allowed, open the aperture to a wide setting using

Aperture Priority or increase the ISO (as little as possible to reduce image problems).

✓ **Follow the rules of composition.** Get in close, eliminate background clutter, compose with the Rule of Thirds, shoot at angles, and find the light. (Also refer to the section "Getting the group," earlier in this chapter.)

Figure 5-4 shows the birthday boy blowing out his candles.

Photo credit: Merri Rudd

Figure 5-4: Anticipate candid moments.

Taking in food

Although we often wolf down food at the sink, at our desk, or in the car, a meal shared with others can be an event in itself. And most events feature food and drink. Food can be beautiful by its nature or its preparation. The satisfaction we experience from good food in good company can be the subject of good photographs.

You may want to photograph the food itself, the preparation, presentation and service, or the diners (with permission, of course).

When photographing food, consider the following:

✓ **Take time to set up a pleasing composition.** Think of the food in terms of color, shape, texture, line, and so on. If you have time and are involved with the preparation, set up alternative arrangements for your shot.

✓ **Use simple props.** When appropriate, props can help "set the stage" and give context to the food. Think of your setup as a still life.

 ✔ **Shoot it quickly.** Capturing food is all about getting the shot before the food starts to deteriorate or change temperature.

 ✔ **Get close to the food and shoot at plate level or higher.** One technique to try is to shoot with a Macro mode or special macro lens, focusing on one part of the dish and letting the surrounding elements blur. This technique provides a strong focal point while still maintaining the context.

Figure 5-5 uses a macro lens to emphasize the moment of celebration. Eat, drink, and be merry.

Photo credit: Merri Rudd

Figure 5-5: A macro lens is used here to emphasize the champagne.

Food stylists all have their secret tips for making food look great. You hear stories about using shaving cream instead of whipped cream, airbrushing food with paint, and so on. Additional appetizing tips are to brush vegetable oil on food to make it glisten and to spray water on bottles to make them look wet and cold.

6

Capturing Animals and Landscapes

Most people love looking at animals. Everybody loves a picture of a cuddly kitty or a playful puppy — well, maybe not everybody. And don't leave out birds and bugs (less popular, for some reason) — or plants, for that matter — all can capture the heart and imagination. There are countless ways to photograph the creatures we encounter at home, around town, and in the wild.

The land itself may be the most majestic subject you tackle. Under a big sky, acres of forest at the foot of mountain ranges call us home. Lakes, streams, and waterfalls speak to us — and to the wildlife you may want to photograph. Get out! You'll come home healthier and happier, with photos that will take you on vacation whenever you need it.

In this chapter, I show you how to capture animals, domestic and wild — figuratively, at least. Turn your camera on the vistas around you, even at night or in foul weather.

Capturing Animals in the Shot

Wild or tame, animals touch us all in some way. Some photos of animals can be staged, as you can stage portraits of humans. Your dog may sit on command. Your cat may ignore you and refuse to move out of the frame. The hamster's got no place to go on that wheel.

Figure 6-1 shows a portrait of a contemplative pet cat.

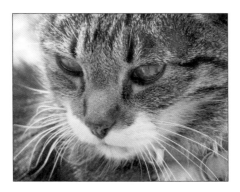

Photo credit: Mark Justice Hinton

Figure 6-1: Animal portraits can be as engaging as those of humans.

Photograph animals using these tips:

- **Be ready for unexpected movement.** Unless, of course, you're taking a photo of a pet rock or a Tamagochi. Take multiple shots in close, and then move back and take some more. Move in and out physically or with a zoom lens. Keep in mind that zooming in usually reduces the depth of field.

- **Spontaneous animal photos involve luck with the timing.** The first step with any spontaneous photo is to always have your camera ready. That means the lens cap is off and the camera is on anytime you might luck into a photo. You may even want to keep your hand on the trigger. This is the price of your art: eternal vigilance.

Figure 6-2 shows a flock of snow geese taking off. Be ready for the unexpected movement of animals.

To conserve battery power, your camera shuts down after a preset idle period. Using the setup menus, you may be able to make the idle period longer for readiness at the expense of power. You can also half-press the shutter periodically to keep the power on.

- **Improve your chances of getting a good, spontaneous shot by observing animal behavior.** What part of the fence do the birds favor? In which direction is that animal likely to move? Will it pause for a second? (It might, if you don't alarm it. Animals are curious, too.) When you know which way the butterfly will turn, you've reached *nerdvana*.

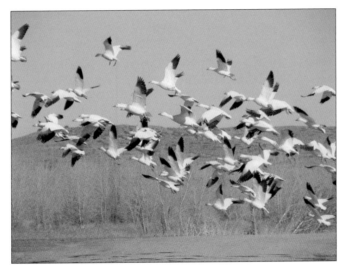

Photo credit: Mark Justice Hinton

Figure 6-2: Spontaneity happens, although some animal movements are predictable.

✏ **If possible, move the camera down to the animal's level.** For an intimate photo, capture the animal closely and at eye level. If you can't get close physically, use a zoom lens. Get your pet's attention by holding a treat or toy next to the camera.

✏ **Photograph the animal in a location it likes so that the animal is relaxed and feels comfortable.** A location that provides context adds to the ambience of the photo. A source of water usually draws wildlife.

✏ **Try to capture the animal's personality and charm.** Is your dog a live wire? Is your cat the ultimate couch potato? Is that skunk a little stinker? Whatever its personality, try to capture the special trait that defines the animal. And, as with portraits of people, often the candid, rather than posed, shot is the best. (And don't even think about posing that skunk.)

✏ **Be careful using a flash.** The flash may make the animal uncomfortable and even scare it. Try to capture the animal in natural light, if possible. Interestingly, whereas shots of people may incur red-eye from a flash, shots of animals usually incur *green-eye,* which may be harder to remove in editing.

Suppress the flash by choosing a No Flash option (the icon looks like lightning with a slash over it). Some cameras won't let you suppress the flash in Auto Mode, in which case you have to switch to a scene mode or

Manual mode. On some cameras, if you don't manually open or pop up the flash, it won't flash (making it easy to suppress the flash), whereas other cameras will open the flash automatically.

✔ **If the animal you're photographing has very dark or very light fur or feathers, slightly underexpose or overexpose the shot, respectively.** Doing so retains detail in the fur. See Chapter 3 for options that control exposure.

✔ **You may need to shoot with a fast shutter speed (check your camera's Manual mode capability) or in Sports mode.** These modes select a fast shutter for you.

✔ **Shoot in Continuous, or Burst, mode.** In Burst mode, the camera takes multiple photos while you hold down the shutter button. Cameras differ in how many photos are taken and the amount of time between photos. For subjects that move, especially animals and people at play, you're almost certain to capture at least one photo you like from the series. Burst mode may be wasted on a subject that isn't moving, although you may capture an important but subtle change in the subject. Look for a symbol of overlapping rectangles, suggesting multiple exposures, on a button or menu.

✔ **If you're shooting through glass at home, at the zoo, or from your car, find a clean spot and get as close to the glass as you can.** Make sure the camera isn't focusing on something on the glass. Suppress the flash when shooting toward glass to prevent a reflection (and temporary blindness).

Picturing Land, Sky, and Sea

Close at hand, few subjects are larger than the earth. We are tiny on the landscape and in the face of the extremes of weather. The environment is a subject of great power, impact — even threat — as well as stunning beauty.

The scale of the land, sky, and sea, and the quick changeability of the weather bring different challenges and opportunities to a photographer. Too often we race over the land, not even turning our faces toward the sun, wind, rain, or land around us. A key to photographing landscapes is to stop and be there in that place.

The great outdoors — and this includes urban settings — invites a sensitivity to scale and distance. Be ready for nighttime and bad weather, as either a subject or a challenge.

Shooting landscapes and vistas

Landscapes, including the sky and bodies of water, are great subjects for photography. One challenge is conveying great distance and space in the small frame of most photographs. In your landscapes, be sure to do the following:

✓ **Include objects with familiar scale — animals, people, dwellings, or vehicles.** You can enhance the depth of the seemingly infinite sky, for example, by including clouds, mountains, or even skyscrapers in your shot. Similarly, the vast sea might be only a puddle until you include a ship or a surfer.

Figure 6-3 uses a person to convey the scale of the scene. In this scene from Seedskadee, along the Green River in Wyoming (the name of the wildlife refuge alone makes it worth photographing), note the leading lines drawing the eye from the lower-left corner to the center-right of the shot.

Photo credit: Mark Justice Hinton

Figure 6-3: Include people, animals, or other recognizable objects for scale in vast scenes.

✔ **Take the time to get the composition just right.** Composition is the element that separates a memorable landscape shot from a mundane one. Check out the composition tips in Chapter 4. They explain how to use a focal point, the Rule of Thirds, framing, and leading lines.

✔ **Use a wide-angle lens to capture expansive vistas.** A zoom lens is a wide-angle lens when it's not extended. As you zoom toward telephoto, you sacrifice width and depth for the sake of getting close to the subject. For example, if you take two shots of a mountain peak — one using a wide-angle and the other zoomed in tight — each photo will show something different. Figure 6-4 shows the two Sandia Peak Tramway ("world's longest") cars passing in the Sandia Mountains on the edge of Albuquerque, New Mexico. The wide-angle version is very different "zoomed out," showing the context; its opposite, the telephoto shot, is zoomed in emphasizing a part of the whole.

Figure 6-4: This composite shows wide-angle (left) and zoomed photos (right) of the same landscape.

✔ **If one shot can't take in the entire scene — or, if you want a 360-degree view — try capturing the scene in several shots and then stitching them together later using a photo editor's Panorama feature.** Some cameras have a built-in Panorama function. (See Chapter 9 for tips and techniques on creating a panorama.)

✔ **Go for the maximum depth of field (see Chapters 3 and 4).** Use Aperture Priority to choose a small aperture setting and a slower shutter speed (unless you're working in very bright daylight). Many cameras have a Landscape mode that will set up your shot for maximum depth of field and set shutter speed automatically. Look for a symbol of triangle peaks on a button, the Mode dial, or a menu.

✔ **Use a tripod and self-timer or shutter release for the sharpest image, if the scene isn't bright.** If low light or night require a slow shutter speed, the slightest movement blurs the scene. If you use a zoom lens, any movement of the lens is more exaggerated.

✔ **If you're shooting water, include reflections of landscape features, animals, or people.** Moving in relation to the reflections may enhance them.

✔ **Shooting at dawn (and immediately afterward) and dusk (and just before) gives you soft, warm lighting.** Stormy skies make dramatic backdrops. If you have a boring sky, try a polarizing filter on a DSLR for added color and contrast, or keep the horizon line high to minimize the amount of sky in the shot.

The photo of a sunset in Figure 6-5 (taken at the Bosque del Apache National Wildlife Refuge in New Mexico) uses the setting sun reflected in water to create contrast and bathe the scene in warm color.

Photo credit: Mark Justice Hinton

Figure 6-5: Dusk provides warm, soft, yet dramatic lighting on any object, including water.

Working at night

Taking photos at night requires special settings to increase the aperture (letting in more light at one time), reduce the shutter speed (giving more time for exposure), and, possibly, increase the ISO (providing more sensitivity to exposure and a wider range of adjustments to aperture and shutter speed). Your camera may handle these settings effectively with a Night or Night Sky mode (look for a crescent moon or star symbol). You may choose to alter any or all of these settings manually.

You can change one setting manually and allow the camera to adjust the others by using Shutter Priority or Aperture Priority. You can change multiple settings with Program mode or Manual mode.

You may also need to set the focus manually if the light is too low for Auto Focus to work. To shoot the sky or horizon, set the focus to Infinity.

Figure 6-6 shows an urban landscape reflected in water. The camera's Night mode handled the exposure and focus nicely, although the color may not be true. Another shot taken of a different slice of the skyline is much warmer.

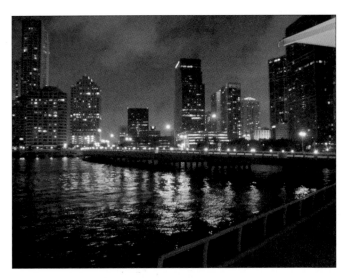

Photo credit: Mark Justice Hinton

Figure 6-6: Exposure and focus are challenges at night.

Here are some tips when shooting at night:

✔ **The camera needs a bigger, more open aperture (at least f2.8), reducing the depth of field. The shutter needs to stay open longer (¹⁄₃₀ second or longer).** Recall that objects in motion are more likely to blur at slower

shutter speeds. If you want to use a faster shutter speed, increase the ISO setting. Just keep in mind that the higher the ISO, the more noise your image may contain, lessening the sharpness of the image.

✍ **Use a tripod when taking photos with longer exposure.** Use a self-timer so that pressing the shutter button doesn't cause shakiness in your image.

✍ **Suppress the flash for more distant shots.** A flash helps only if your subject is directly in front of you and within range (typically 3 to 12 ft.).

✍ **Start shooting before dark. Try taking shots at dusk or soon after.** Capturing neon lighting is especially nice before it gets really dark and a little natural light is left.

Shooting the moon

The moon is a particularly captivating subject, waxing and waning as it transits the sky. The moon isn't necessarily any more difficult to photograph than other night-time subjects. There is, however, one important thing to remember about the moon: It's very bright when it's full. Another obvious pearl of wisdom, yet, when you shoot at night, you prepare for underexposure. When you shoot the moon, you get overexposure unless you choose your setting wisely. (Or have a terrific Full Moon mode.)

Although the moon is fascinating by itself, including the horizon, buildings, or other objects provides context and scale (see Figure 6-7). The moon looks largest at the horizon.

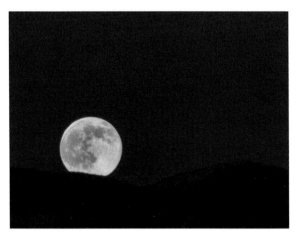

Photo credit: Mark Justice Hinton

Figure 6-7: The moon seems largest just as it rises.

Consider these other suggestions:

- **Use a tripod to eliminate all motion.** Shooting handheld can work, especially if you increase ISO to allow a faster shutter speed. Using a tripod also makes it easier to shoot multiple shots.

- **Turn off Image Stabilization (IS).** On a tripod, IS may be unnecessary, even interfering, and it may slow down the process of taking a picture. If your owner's manual doesn't say whether to use IS with a tripod, experiment with IS on and off and compare the results. The IS symbol is usually a waving hand on a button or menu.

- **Any movement of the camera will be a problem.** Use your short self-timer so you can press and release the camera.

- **Focus may be a problem on such a distant object at night.** Set Manual Focus to infinity. (Technically, the moon is only 250,000 miles away, not infinitely far.) Focus control may be through a button or menu item and may not be available in Auto or scene modes.

- **Get as close as you can.** Zoom all the way in unless some other feature fits the scene. (A long zoom exacerbates problems with camera movement. Another vote for the tripod.)

- **Because the moon is so bright, you don't need a particularly high ISO (avoiding the noise that is a common problem in low light), unless you're not using a tripod.** Use between 100 and 200 ISO on a tripod.

- **Try a shutter speed between 1/100 and 1/200 and an aperture above f/5.2.** The image on-screen should be a little dark.

 Your camera may have an option to *bracket* shots. This means that when you take one photo, the camera will take several, each with exposure settings lighter or darker than the settings you choose. Bracketing increases the odds that you'll get a photo under difficult exposure conditions.

The easiest way to avoid overexposing a moon shot is don't shoot at night. Seriously, the moon rises nearly full in late afternoon sunlight a few days before full and sets nearly full in the early morning light for a few days after full. Don't pin all your hopes on just a few minutes every 28.25 days. Check out www.sunrisesunset.com for sun and moon rising and setting times. If you own a GPS unit, it may list rising and setting times, as well.

Weathering the storm

Stormy weather might ruin your vacation or it might give you unusual and dramatic photographs. Even if rough weather doesn't inspire you, it shouldn't inhibit you if you need to get a particular shot.

✔ **Take advantage of bad weather's creative benefits.** Clouds diffuse the light and eliminate harsh shadows, making for nice landscapes and even portraits. Stormy skies create dramatic backdrops for landscape shots or singular objects, such as trees or barns. Rain enhances colors and adds texture and reflections on surfaces. If the scene is gray, include a spot of color. Dark objects and colors against white create exaggerated contrast.

Figure 6-8 shows a hiker in a storm in Conejos, Colorado. The hail may not be visible in a smaller print, but the light, the rain gear, and the hiker's posture speak volumes.

Photo credit: Mark Justice Hinton

Figure 6-8: Life isn't all sunny. Harsh conditions highlight strength and drama.

✔ **Use a wider aperture, slower shutter speed, a higher ISO or all three.** Bad weather usually means less light. A tripod keeps images sharp, especially for longer exposures. A self-timer can also be handy. In extremely cold weather, keep a spare battery or two warm in your pocket. Cold weather zaps battery life.

✔ **Snow and fog may confuse your camera's light meter, so play it safe and bracket your shots.** See the preceding section for an explanation on bracketing your shots.

✔ **Protect your equipment.** Keep your camera as dry as possible by tucking it inside your coat or shirt when you aren't shooting. Keep a soft, scratch-free cloth in your pocket to wipe off any water that gets on the camera. Going from extreme cold into a very warm environment can cause condensation to form in your equipment, so allow your equipment to warm up gradually. Finally, make sure all your equipment is dry before you put it away.

Figure 6-9 shows an urban scene transformed by snow.

Photo credit: Mark Justice Hinton

Figure 6-9: Ordinary objects look extraordinary in snow.

Part III
Managing and Editing Your Photos

The 5th Wave By Rich Tennant

"Hey— let's put scanned photos of ourselves through a ripple filter and see if we can make ourselves look weird."

In this part . . .

When you fill up your camera's memory card, then what? You'll want to move your photos from camera to computer for many reasons, including the convenience of viewing them on a large screen, and this part tells you how to do that. I also tell you about various ways to organize your photos for easy access later.

You can change any photo — for the better, with any luck — by editing it. With the special tools and adjustments available to you in photo-editing programs, you can draw more attention to the subject or fix exposure and color deficiencies, among other things.

Photo by Merri Rudd

7

Transferring Photos from Camera to Computer

*E*ventually, you'll want to transfer the photos from your camera to your computer so that you can edit, share, print, or simply store them. (And, it's definitely preferable to throwing the camera away because it's full.)

After you move the pictures to your computer, you can free up space on the camera for more photos . . . and the vicious cycle begins. That cycle never really ends, and it can eat up more and more of your computer's hard drive space. Photo files are typically megabytes in size. A few hundred photos can add up to a gigabyte of disk space in no time. Consider investing in an external hard drive that is larger than you can imagine using. Disk space, like closets and garages, seem to fill up when you aren't looking. An external hard drive is much more convenient than storing photos on DVDs or CDs, but you do have to think about creating a second copy — a backup — no matter where you store your photos.

With photos on your computer, you can enjoy all the effort you've made taking those pictures. The photos on your computer are instantly available for viewing individually, as slide shows, and as screen savers.

In this chapter, I show you how to transfer your photos from your camera to your hard drive. After those photos are on the hard drive, you'll surely need

to copy, move, delete, and rename those files. I show you how to do all this with Windows 7 Explorer; other operating systems work similarly.

Deleting Photos from Your Camera Manually

Despite your blossoming photographic skill, you'll eventually take some pictures that just aren't worth keeping. You can delete pictures directly from your camera's memory card to free up space for newer pictures. To delete photos directly from the camera, you don't need a computer or a cable.

Before I show you how to delete photos from your camera, let me make one suggestion: Don't do it! It's just too easy to delete the wrong picture. And you can't judge a picture completely on the tiny LCD. You need to see it on your large computer monitor. Perhaps the picture has details worth cropping (see Chapter 9). Perhaps you can improve the picture with other edits (make it lighter or darker, among other possibilities).

Get a memory card large enough to hold all the pictures you might take before you have a chance to move them to the computer. See Chapter 1 for more about memory cards and photo file sizes.

Now, just so you know how, because knowledge is a beautiful thing, here are the steps for deleting photos from the camera memory card. Take a couple of bad photos before you continue:

1. **Using the camera's LCD, switch to Preview mode.**

 Look for a button that shows a right-pointing triangle.

2. **In Preview mode, use the right- and left-arrow buttons to move through a display of your pictures.**

 You may be able to press the W (Wide) end of the Zoom rocker switch to see multiple photos at once.

3. **When you find a photo you don't want to keep, press your camera's Delete button (look for a trash can icon) or a Delete menu item on-screen, as shown in Figure 7-1.**

 Some cameras require confirmation of the delete instruction. Press OK if needed.

That wasn't so hard. Why the fuss? Many people delete a photo thinking they'll take a better one later — but they never do. Even a bad picture might be better than no picture at all. So transfer that photo to your computer, review it there, and think twice before dumping it.

To get rid of every photo on the camera in one step — are you sure you want to do this? — use the camera's setup menu to format or erase the memory

card. There is no Undo for formatting or erasing a memory card. So be very sure that this is what you want to do. Again, *you can't undo this!*

Figure 7-1: Your camera may have a Delete button or menu item.

Planning before You Copy Photos

Before you copy any photos to your computer, think about how you want to organize those files. Even if you're using a tool that automatically copies photos, you have to configure that tool to serve your sense of order.

It's important to recognize that your organizational style is unique and also likely to change over time. When you can't find that one picture you want most, you may have to let it go. But learn from that search as you copy more and more pictures to your computer, and continue to refine your photo organization. Consider what changes to your system will make it easier to find pictures the next time.

How you name the photo files and the folders they go into is very important for organizing and reorganizing photos. Think about whether you should include some descriptive text in the filename, such as *vacation* or *Colorado vacation.* And is it helpful to include some part of the date in the file or folder name?

An option called a *tag* offers a way for you to add descriptive categories to your photos, providing further means of organizing your files so that you can easily find them later with a simple search for specific tags. I cover tagging photos in Chapter 8.

Naming files

Your camera names each photo file as it creates it. That name usually includes a sequential or random number or the date and time. Your camera's setup menu may allow you to select the method used to name files. Options for naming files on the camera may include specifying whether the number in each filename is continuous, meaning it never resets. If that option is enabled, every file has a unique filename. If that option is disabled, numbering starts over with each new set of photos, resulting in duplicate filenames. This point may be irrelevant if you rename files as you copy them, but many professional photographers keep these camera-generated filenames and want them to be unique.

Filenames also include a three-letter file *extension* — the three additional letters that follow the period (.) in a filename. The extension is determined by the file format you select in the camera's setup menus. Most likely, your files are JPEGs with the file extension .jpg. If your camera creates files in the RAW format, the extension name depends on the camera.

If you use an automatic process to copy your photos from camera to disk, that process may rename those files according to options set within that program.

Which is a better filename: DSC0047.jpg or vacation.jpg? *Vacation* may seem to be the better choice if you take only one vacation and save only one photo from that trip. But think through the kind of overall file-naming scheme that might work best for you.

Figure 7-2 shows some photos as extra-large thumbnail images (or icons) on the right and folders on the left in Windows Explorer in Windows 7. The gap in the sequence of filenames under each photo is due to deletions. (***Note:*** The extension name (.jpg) is normally hidden in Windows.) The folder *path* appears at the top of the screen.

Libraries ▶ Pictures ▶ book

Using folders

How you name your individual photos is important, but you also want folders to hold specific photo files in an organized, logical way for easy access in the future.

The best way to organize groups of files is to create folders in which to store them. Some people also create folders within folders (called *subfolders*). Although you can create folders anytime, it is easiest to create folders during the process of copying photos from camera to disk.

Figure 7-2: The sequential, camera-generated filenames matter less in this organizational style than folders and tags.

A folder's name should help you recognize its contents as you shuffle madly through, looking for the vacation photos from three — or was it four? — years ago.

For example, you could have the following series of folders within folders:

```
Pictures
    2010
        Vacations
            South Pacific
                Hawaii
```

Or maybe this simpler structure makes more sense:

```
Pictures
    Hawaii
```

As you name folders, keep in mind how your computer displays folders: Generally, folders are sorted either by name or by the date modified, although other options are available.

Getting Pictures out of Your Camera

Most cameras can connect directly to a computer by using a USB cable and the ports on the camera and the computer. The port on your camera could be just about anywhere on the camera body, and it may be hidden by a small door or cover. Plug one end of the cable into the camera and the other end into the USB port on your computer (see Figure 7-3). Turn the camera power on, if necessary.

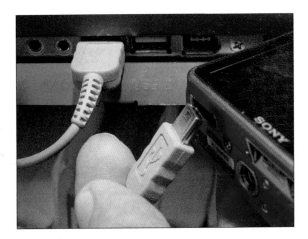

Figure 7-3: Connect camera and computer with a cable.

In most cases, the computer automatically recognizes the camera and begins copying photos from the camera to the computer.

If your computer doesn't recognize the camera and nothing happens automatically, you may need to install a *driver,* a program that tells the computer how to talk to hardware. Odds are that using a driver won't be necessary, though. If manually installing a driver does turn out to be necessary, you may find that a CD containing the driver software that came with your camera. Instead of using that CD, go to the camera manufacturer's Web site and download and install the latest driver for your specific camera model and your specific computer operating system (Windows, Macintosh, or Linux). (Again, this process probably happens automatically.)

When you travel, take the USB cable so that you can transfer photos from your camera to your laptop or a friend's computer.

Instead of plugging your camera into the computer, you can insert your camera memory card into a *card reader.* Many laptops have a built-in card reader slot that takes various card types, such as SD. If your computer doesn't have a built-in card reader, you can buy a separate device that plugs into your computer. Another option is to buy an adapter designed to convert a memory card into a flash drive. You remove the memory card from the camera and insert it into the card reader (or converter). Just like when you connect the camera directly, inserting a memory card in a card reader should start the copying process automatically.

Copying photos from your camera automatically

In most cases, connecting a camera to a computer automatically starts the copying of pictures from the camera to the computer.

Your camera may come with software for moving, organizing, and editing your pictures. Before you install more software, see what happens without that software. You may already have everything you need for basic tasks.

With the pictures safely on your computer, you can delete them from the camera without regret. In fact, the automatic copying process probably includes an option to automatically delete all pictures on the camera after the copying completes successfully. Take advantage of that automatic delete — it will save you time. If you intend to print from the card (directly to a printer or at a print service) or to use the card in a digital photo frame, then don't automatically delete photos from the card.

The following steps show you how to use the Import Pictures and Videos function in Windows 7 to transfer photos from your camera to your computer.

1. **Connect your camera or card reader to your computer by using a USB cable.**

 Alternatively, if your computer has a media card slot or you have a card reader, insert your card.

 The AutoPlay dialog box appears, as shown in Figure 7-4.

2. **Select the Import Pictures and Videos Using Windows option to import your images.**

 You may see additional import options if you have a photo organizer installed.

 To use the Open Folder to View Files function, see the next section, "Copying Photos from Your Camera Manually."

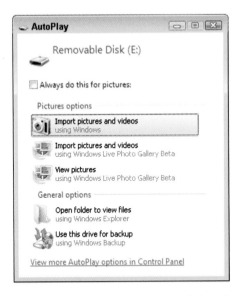

Figure 7-4: Windows may give you a choice of how to copy your photos.

If you have any photo management software installed, such as Windows Live Photo Gallery, that software may pop up instead of the AutoPlay options. Just click Cancel or exit that program for the purposes of these steps. If you prefer to use that software, follow that program's documentation for transferring your photos.

The Import Pictures and Videos dialog box appears (see Figure 7-5).

3. **(Optional) Add a tag for the photos.**

See Chapter 8 for information on tags and import settings.

4. **Click the Import button.**

Figure 7-5: The Import Pictures and Videos dialog box in Windows 7.

The dialog box displays a progress bar and the count of photos being copied.

5. **Click the Erase after Importing check box to automatically delete the photos from the camera (recommended).**

 Some people prefer to format the card in camera after the transfer.

 After the copying and erasing are done, Explorer opens automatically to a window like the one in Figure 7-6. The filenames (001, 002, and so forth) were determined by the import settings.

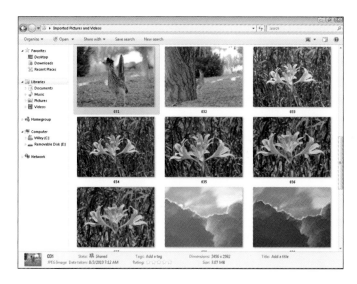

Figure 7-6: Recently imported photos.

Copying photos from your camera manually

Ideally, when you plug your camera into your computer with a USB cable, your computer automatically copies your pictures from the camera to your computer's hard drive. However, when your camera is attached to your computer, the camera's memory card is listed as a removable disk in Computer (or My Computer if you're using XP). You can browse that disk as you can any other, working your way into the folders to find the individual photo files. From there, you can copy, move, and delete files.

Avoid renaming files still on the camera because renaming them may interfere with the camera's automatic naming function.

The following steps show you how to use Windows Explorer in Windows 7 to transfer photos from your camera to your computer:

1. **Connect your camera to your computer by using a USB cable.**

 If your computer has a media card slot or you have a card reader, insert your card. If your camera has a docking station, plug it into your computer and place your camera in the dock.

 The Windows AutoPlay dialog box opens (refer to Figure 7-4).

2. **Choose the Open Folder to View Files command to launch Windows Explorer.**

 If nothing happens automatically, launch Windows Explorer manually by choosing Start⇨Computer.

3. **In Windows Explorer, select Computer to display all disks, including your camera or memory card. See Figure 7-7. Click or double-click the icon for the camera.**

Figure 7-7: Your memory card is just another disk.

4. **Select the camera folder containing your images.**

 If you see more than one folder, you may have to look in each one until you find your photos.

5. **Copy the photos you want.**

 Press Ctrl+A to select all the photos in the folder and then press Ctrl+C to copy.

6. **In the navigation bar on the left, select Pictures or choose Start⇨ Pictures.**

7. **Choose the folder where you want to save these photos:**

 • *An existing folder:* Open that folder.

 • *A new folder:* Click the New Folder button in the Explorer Command bar or choose Organize⇨New Folder. Type a name for your new folder and press Enter. Open the new folder.

8. **Press Ctrl+V to paste the photos into the folder.**

 Filenames remain the same as they are on the camera unless you manually rename the files.

Viewing Photos on Your Computer

When you have photos on your computer, you can view them and begin to work with them in various ways. In this section, I show you how Windows 7 handles photos. However, you may have a program installed that takes over these duties from Windows 7, such as Windows Live Photo Gallery (WLPG). See Chapter 8 for information on using WLPG to enjoy your photos.

Access your photo folder using Windows Explorer, the file manager in Windows 7. In Explorer, you can see your photos as thumbnails (or icons) of various sizes, as well as see some information about your photos. Explorer also enables you to copy, move, rename, and delete photos. (All of these tasks can also be performed using a photo organizing program, such as WLPG.)

You can explore your photos the following ways:

✔ **Choose a view:** Click the View button in the upper right of Explorer to change how you see your photos:

 • *Choose the size of the icons (thumbnails).* For best viewing, select Extra Large Icons from the list.

 • *Choose to see all the details.* Details lists files in rows and information such as filename, date, and size in columns.

✔ **Arrange your photos by date:** Click the button next to Arrange By and select Day from the list (see Figure 7-8). Your photos are arranged by date taken. Choose Arrange By⇨Folder if you wish to return to the original order.

✔ **View a photo full screen:** Click the photo once to select it. In the Command bar, click the triangle next to Open for a list of programs with which you can open this photo. Windows Photo Viewer is standard with Windows 7, as is Paint. If you want to open with the default photo program, you can double-click the photo or click the Open button, just not on the triangle.

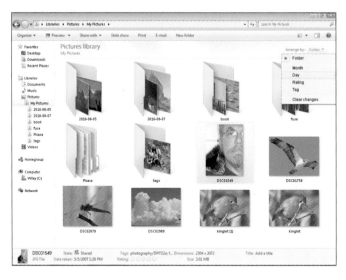

Figure 7-8: View and arrange your photos.

For information on using Windows 7, see *Windows 7 For Dummies* by Andy Rathbone or *Windows 7 For Seniors For Dummies,* by Mark Justice Hinton.

Renaming Photos

If you want to rename your photos (or any file) in Windows Explorer, follow these steps:

1. **In Explorer, select the files.**

 To select all, press Ctrl+A.

2. **With the mouse pointer over the first file, right-click and choose Rename.**

3. **Type the new filename in the highlighted box and press Enter.**

 If you see an extension name following a period, do not change that part of the filename. You may not be able to open your photo if you do.

 Windows renames all the selected files using the name you type followed by a number in parentheses.

Backing Up Your Photos

You move your photos from your camera to your computer. Now all your eggs are in one basket. I doubt it's news to you that something could go wrong. You may delete or mis-edit the only copy you have of a beloved

photo. That file may become corrupted and unusable. I'm not trying to scare you, but something could make your computer disappear. (Not any particular keystroke that I know of.)

The more important your photos are to you, the more you need duplicates — backups. You can back up your entire computer or just the pictures that matter. You can use the software that comes with your computer. Check the main system menu or search your computer for *backup.* Free alternatives also exist. Search the Web for *backup software review.*

A backup program has many benefits, including automatic scheduling (daily, weekly, and so on) or archiving (keeping multiple copies of the same file as it changes). Such backup features take time to understand and configure. That is time well spent, but beyond the scope of this book. You should include all your irreplaceable files in a good backup plan.

In Chapter 9, I show you how to edit your photos using Windows Live Photo Gallery (WLPG). All photo editors allow you to undo some edits before you save the file. Some editors enable you to revert to the original, even after saving. The safest thing is to create backups before you begin editing. Backing up may save you from all kinds of missteps, goofs, surprises, and disasters. The assurance of a backup will make you feel freer to experiment and learn.

Whether you intend to back up photos for peace of mind or simply to copy them to take them to another computer, follow these steps:

1. **Insert a flash drive (a thumb-sized device) into a USB port on your computer.**

 These steps also work with a memory card or external hard drive.

 If Windows automatically opens a list of available programs, close that window. If Windows starts some program, exit that program.

2. **Select the photos you intend to copy using Explorer.**

 One way to select multiple files individually is to hold down the Ctrl key as you select each file. To select all, press Ctrl+A.

3. **Right-click and choose Send To⇨*your device name.***

 The device you inserted in Step 1 appears near the bottom of the list with a letter (D: or higher). See Figure 7-9.

 The next time you want to copy photos, if you want to copy only those photos you haven't copied before (makes sense), arrange the photos by date taken. See the earlier section, "Viewing Photos on Your Computer," for the steps.

 To copy photos to a DVD or CD, click the Burn button in the Command bar.

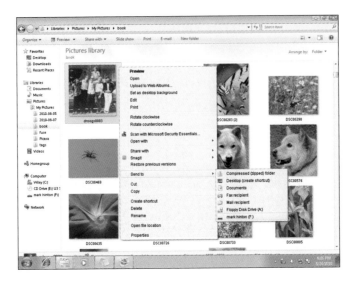

Figure 7-9: Use the Send To function to copy photos to other disks.

Deleting Photos from Your Computer

You will want to get rid of some photos on your computer.

Before you delete not-too-great photos, turn to Chapter 9. You may be able to fix a photo.

If you find photos that must go, follow these steps:

1. **Select the photos you intend to delete.**

2. **Press the Delete key or right-click and choose Delete.**

3. **If a confirmation dialog box appears, click OK.**

If you change your mind immediately, press Ctrl+Z or right-click and choose Undo Delete.

If you want to restore a photo (or any file) you deleted, open the Recycle Bin from the desktop. Locate the file. Right-click and choose Restore.

8

Organizing and Finding
Your Photos

*A*s you add more photos to your computer, you need a photo organizing program to help you manage those files. A photo organizer enables you to label or categorize — *tag* — photos, rate or flag them, and find photos by criteria, such as date taken.

Tags are just one example of *metadata,* which is the data that describes a file. Other metadata includes the date the picture was taken and all the exposure data (ISO, aperture, shutter speed). Much of this metadata is created and changed automatically in the camera. Tags, titles, captions, descriptions, *author* (the curious term for the photographer), and copyright are some of the metadata that you can add and change anytime if you have the right tools, such as those discussed in the section "Choosing a Photo Organizer."

The examples in this chapter feature Windows Live Photo Gallery (WLPG) — a free program available to any Windows user — although the concepts and terminology in this chapter may apply to any photo organizer.

In this chapter, you get an overview of WLPG and use it to import photos from your camera and view photos in various ways. You use WLPG to add metadata, especially tags, to your photos and to use metadata to find your photos no matter where they are on your computer.

Choosing a Photo Organizer

Most photo organizers allow you to browse photos from anywhere on the system, regardless of the specific folders those photos are in, as if you are looking at one huge photo album. Those photos can be sorted and grouped by date taken, date modified, file or image size, location, tags, and more.

Photo organizers make it easy to add tags, ratings, and captions to your photos. Photo organizers typically are also editors and include tools for basic editing, including cropping, brightness, and contrast adjustments. (See Chapter 9 for more about editing your photos.)

Photo organizers also provide tools for printing, e-mailing, and uploading your photos to the Web.

Here are three of the available photo organizers:

- **Windows Live Photo Gallery (WLPG):** WLPG displays all the photos and movies in the Pictures and Videos folders by default, as well as any subfolders under those locations. You can add other folders from any location on your computer.

- **Picasa:** Picasa is an organizer and editor from Google. You can download it from www.picasa.com. See Chapter 14 for some tips on using Picasa.

- **iPhoto:** The Mac includes iPhoto as the photo organizer and editor in the iLife suite. If your Mac didn't come with iPhoto, you can download it from www.apple.com.

Installing WLPG

You may already have WLPG installed on your computer. If so, skip to the next section. If you don't have WLPG, follow these steps to install it:

1. **Browse to the Windows Live Essentials Web site at http://get. live.com.**

2. **Click the Download Now button.**

3. **If you see a dialog box with buttons to Run, Save, or Cancel, click Save.**

 If you don't see this dialog box, your browser automatically downloads the file to your default Downloads folder. Find the downloaded file and select it to run.

4. **Click Run.**

5. **Click the Yes button if you see a User Account Control dialog box**.

 The installer runs for a moment before displaying a Select Programs to Install dialog box, as shown in Figure 8-1.

6. **Deselect everything except Photo Gallery and Movie Maker and click the Install button.**

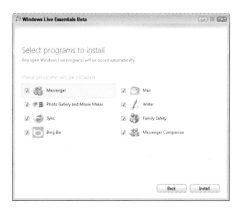

Figure 8-1: Install Windows Live Photo Gallery and Movie Maker.

 A dialog box displays progress installing the programs.

7. **When the installation process completes, click the Close button.**

8. **Choose Start⇨All Programs⇨Windows Live Photo Gallery to start the program.**

 The first time you run WLPG, a dialog box asks about handling various file types, including JPEG.

9. **Select the Don't Show Me This Again check box and click the Yes button.**

 The WLPG Gallery view appears. See the next section, "Getting the Overview" to find out more about WLPG.

Getting the Overview

The first things you may notice in Windows Live Photo Gallery are the large thumbnails of your photos. This opening screen is the *Gallery* view (see Figure 8-2). Use Gallery to view or work with more than one photo at once.

Quick Access toolbar

File tab tabs Ribbon

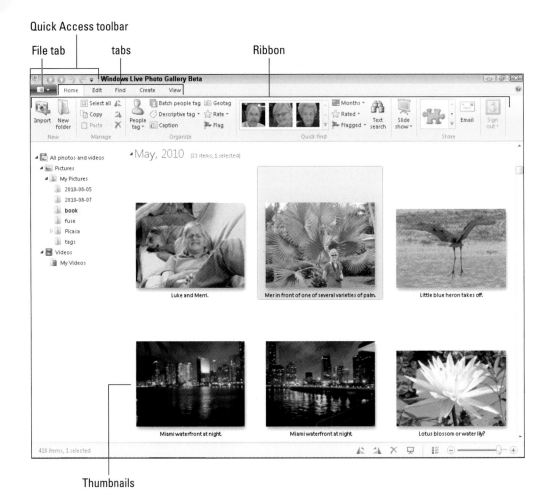

Thumbnails

Figure 8-2: Gallery view shows multiple photos as thumbnails.

Here are some items to take note of:

- **Ribbon:** Across the top of the screen is the *Ribbon* common to many
 Windows 7 programs, including Microsoft Office. The Ribbon organizes
 single-click functions as buttons on tabs: Home, Edit, Find, Create, and
 View. Click any of these tabs to switch between them.

- **Tabs:** Each tab is further divided into sections or groups, whose labels
 appear under the section. The Home tab consists of these sections: New,
 Manage, Tab and Caption, Quick Find, Share, and a couple of buttons
 in sections that don't have labels (Slide Show and Sign In). As you click
 other tabs, notice the sections in each tab.

- **File button:** The first tab, immediately left of Home, doesn't have a label, just an icon. This is the File button. Click the File button to see a menu of file-related functions.

- **The Quick Access toolbar:** The tiny buttons above the Ribbon in the title bar comprise the Quick Access toolbar. The buttons on this toolbar are: Back (preceding view), Forward (next view, if you have gone back at least once), Undo, and Redo. Click the last button to add other functions to the toolbar.

- **Navigation bar:** Down the left side of the screen is the folder tree, or *navigation bar* — a list of folders included in WLPG, starting with All Photos and Videos, under which you see Pictures, My Pictures, and Videos, and any folders you have created under those folders.

- **Status bar:** Across the bottom of the screen, the status bar displays the number of items (photos and videos) in Photo Gallery. If any photos are selected, the number selected appears next. (When you start Photo Gallery, the first photo is automatically selected.) At some point, you may notice a small clock icon next to the number selected. If you hover the mouse pointer over that clock, a pop-up message reports how many thumbnails are being generated and how many face detections are being processed (more on that later).

 At the far-right end of the status bar, these buttons appear, all of which are discussed in later sections: rotate left, rotate right, delete, slide show, view details / view thumbnails, and zoom out and in.

- **Tag and Caption pane:** Along the right side of the screen, you may see the Tag and Caption pane, which I discuss in "Tagging Photos."

Importing Photos with WLPG

If you have some shots in your camera (if not, take a couple now), copy them into Windows Live Photo Gallery. WLPG calls this process *importing;* many people call this *downloading.*

Follow these steps to copy photos from camera to computer with WLPG:

1. **Connect your camera to the computer by cable or insert your memory card in the card reader.**

 Windows 7 displays the AutoPlay dialog box (unless AutoPlay has been configured to run a specific program).

2. **Click Import Pictures and Videos Using Windows Live Photo Gallery.**

 If you always want to use WLPG, select the Always Do This for Pictures check box.

The Import Photos and Videos dialog box appears, indicating how many photos and videos are on the memory card. You have two choices (see Figure 8-3):

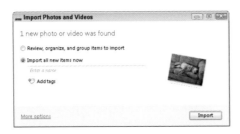

Figure 8-3: Choose how to import these photos.

- *Review, Organize, and Group Items to Import* enables you to import photos very selectively (I'll stop adding "and videos" now). If you had photos from two unrelated events, say a wedding and a birthday, you could use this option to handle the two groups of photos differently. It is so easy to rearrange photos after importing that I never use this option.

- *Import All New Items Now* does what it says. I use this option all the time. "New" means that if you import photos without erasing them from the card, then take more photos, the old photos on the card won't be copied again.

3. **Select Import All New Items Now.**

4. **(Optional) In the box below the option, type text that you want to appear in every name of every file to be imported.**

 For example, "wedding" or "birthday," if every photo imported has something in common. Often, I have shots taken over days in various locations with nothing in common, in which case, I leave this box empty. The filenames and folder names that are created during importing derive from More Options, the text you type here, and the tags you enter.

5. **Click the Import button.**

 The Import Photos and Videos dialog box displays progress in importing files.

6. Select the Erase After Importing option to clear your camera card of files.

When importing completes, Gallery view appears with your newly imported photos. In Figure 8-4, the photos are in a folder automatically named 2010-08-27 001 (based on the Import Options, which I show you how to set in the next section).

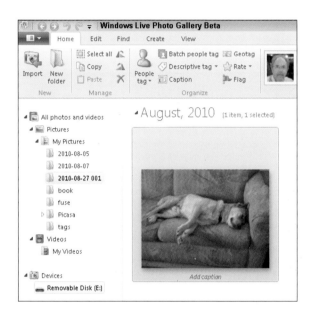

Figure 8-4: Newly imported photos.

Your camera or memory card appears under Devices (refer to Figure 8-4). Another way to import is to click on your device.

Setting import options

You can probably get by importing your photos with the default importing options that Windows Live Photo Gallery sets for you. But you can make a lot of tweaks so your photos import exactly the way you'd like.

Choose File➪Options. Click the Import tab of the Options dialog box. Next to Settings For, select Cameras (may already be selected), as shown in Figure 8-5.

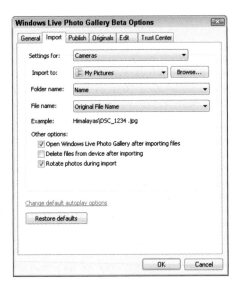

Figure 8-5: Use Import Options to control the naming of files and folders.

Here are the importing options:

 ✔ **Import To:** Specify a main folder on your computer into which to copy your pictures. The default option of My Pictures is a good choice for most people; click the Browse button to select a different folder.

 ✔ **Folder Name:** Create a new subfolder under the main folder each time you copy photos from your camera. Doing so helps you keep photos separated into smaller groups, which may make your photos easier to find, review, and manage. On the other hand, if you copy photos to your computer once a week, you'll have at least 52 folders in a year, more with certain options. How many folders are too many? Photo Gallery offers various ways to name new folders. Most of these methods prompt you for some text that will become part of the folder name. Several options also use the date on which you actually copy the files as part of the folder name. Other options use the date the photos were taken, instead.

 Here's the breakdown:

 • *None:* I put the last choice first because I use it. This option copies your photos into the main folder selected in Import To and not into a subfolder. If you take a lot of pictures, this option does not help you organize your photos. If you don't do anything, you end up with one huge folder stuffed with photos you've taken over the

years — the digital equivalent of the old shoe box full of prints and negatives. However, it is easy to make a new folder in WLPG (a button is on the Home tab) and drag and drop photos into any folders. It's some work, but you get the exact organization you want.

- *Name:* This option just uses the text you enter and ignores the date you copy the photos or the dates the photos were taken. However, you can enter date information manually as part of the text, such as **Colorado Vacation 2010** or **2010 Vacation** (the sorting is different). I recommend this option unless you feel strongly about including dates in the name. (Photo Gallery makes it very easy to find photos by date without including the date in folder or file names.)

- *Date Imported + Name:* With this option, the date you copy (import) files from the camera to the computer will be the first part of the folder name and the second part will be any text you enter when you copy your photos. For example, if you copy photos on **9-14-2010** and enter **birthday** when you are prompted, all of the photos will be in a folder named **2010-09-14 birthday**.

- *Date Taken + Name:* This option creates folders using the date the photos were taken plus text you enter when you copy the photos. If photos taken on more than one day are on the camera, separate folders will be created for each day. For example, if you take photos on **5-18-2010** and **5-19-2010** and copy those photos on 5-20, entering **birthday** at the prompt, you'll have two new folders named **2010-05-18 birthday** and **2010-05-19 birthday** (and 5-20 is irrelevant).

- *Date Taken Range + Name:* This option also uses the date taken and text you enter. However, photos from multiple days, such as your vacation, are copied to one new folder with the date range in the name. For example, if you take photos on **5-18-2010** and **5-19-2010** and copy those photos on 5-20, entering **Colorado vacation** at the prompt, you'll have one new folder named **2010-05-18 – 2010-05-19 Colorado vacation**.

- *Name + Date Imported:* This option puts the text you enter first, followed by the date you copy the files to the computer, such as **birthday 2010-05-20**.

- *Name + Date Taken:* This option puts the text you enter first, followed by the date the photos were taken. Multiple days create multiple folders, each with the same text in front, such as **Colorado vacation 2010-05-18** and **Colorado vacation 2010-05-19**.

- *Name + Date Taken Range:* This option puts the text you enter first, followed by the range of dates the photos were taken. Multiple days are all placed in one folder, such as **Colorado vacation 2010-05-18 – 2010-05-19**.

✏ **File Name:** Specify how Photo Gallery should name individual photos as Photo Gallery copies them from the camera into folders on your computer.

- *Name:* The Name option uses the same text you entered for the folder name, if any. Each photo has a unique number, starting with 001 (for example, **birthday 001**, **birthday 002**, and so forth). I recommend this option for most people.

- *Original File Name:* This option uses the name your camera gives to each photo, which is usually letters and numbers, often the sequence number for the photo (for example, **DSC00047** or **PB000047**). I use this option because I'm more interested in other information about the photos. See the later sections "Using and Changing File Information" and "Tagging Photos."

- *Original File Name (Preserve Folders):* This option uses the in-camera filename and copies folders you have created on the camera's memory card. I don't recommend this for most people because of the extra work to create folders on the memory card.

- *Name + Date Taken:* This option uses the text you enter and the date the photo was taken plus a serial number (for example, **birthday 2010-09-14 001**).

- *Date Taken + Name:* This option uses the date the photo was taken followed by the text you enter and a serial number, such as **2010-09-14 birthday 001**.

You never have to go through these options again unless you change your mind about naming photos as they are imported. However, you should consider the Other options on the Import tab (refer to Figure 8-5):

✏ **Open Windows Live Photo Gallery After Importing Files:** Check this box to start Photo Gallery automatically after you import photos.

✏ **Delete Files from Device After Importing:** Select this option to have Photo Gallery delete photos from the camera memory card after Photo Gallery successfully copies those photos to your computer. This is a sensible option to keep from filling up your camera's memory card and to spare you from having to manually delete those photos on the card.

✏ **Rotate Photos During Import:** If you turn your camera 90 degrees vertically when you take photos, you'll want to rotate those photos to stand up correctly. Select this option to let Photo Gallery try to rotate only those photos that need rotation. This option depends on information the camera provides, so it often doesn't work. You can manually rotate photos anytime, as I show you in Chapter 9.

✏ **Change Default AutoPlay Options:** This link opens a dialog box to choose what happens when you connect your camera to your computer, if Photo Gallery doesn't automatically copy your photos. Locate

the Pictures option to choose the Import Pictures and Videos using Windows Live Photo Gallery option.

✓ **Restore Defaults:** This button puts all options back the way they were when you installed the program. You shouldn't need this unless you want to start over.

After you have made your changes to the Import options, remember to click OK.

Viewing Photos

When you select the Pictures folder in the navigation bar on the left, WLPG presents all of your photos as one long continuous display, regardless of what folders the photos are in. There are many useful options for viewing and arranging your photos.

There is always more than one way to do something. I show you the mouse-method and a keystroke in parentheses.

In the lower-right corner of WLPG, at the end of the status bar, the Zoom slider appears between Minus (-) and Plus (+) buttons. Click the Minus button a few times to see the thumbnails of your photos shrink. Click the Plus button to increase the size of the thumbnails. You can also click and drag the slider or click either side of the slider to change sizes.

To the left of the Zoom slider in the status bar is a button that toggles between two functions (Ctrl+0 – zero):

✓ **View Details** displays smaller thumbnails with some file information for each photo: filename, date taken, file size, dimensions, rating, and caption.

✓ **View Thumbnails** displays the thumbnails. You can see more information for a photo by hovering the mouse pointer over that photo. You can also display more info using options on the View tab (coming up).

To the left of the Details / Thumbnails toggle is the Slide Show button (F12). Click it and sit back. You deserve a break. To stop the show, press the Esc key.

The remaining buttons in the status bar are covered in Chapter 9.

Click the View tab for more functions. Here are the sections:

✓ **Show Details:** Click each button to see the information displayed below each photo: Rating, Caption, All Details, File Name, File Size, Date Taken, Image Size, and Date Modified. See Figure 8-6.

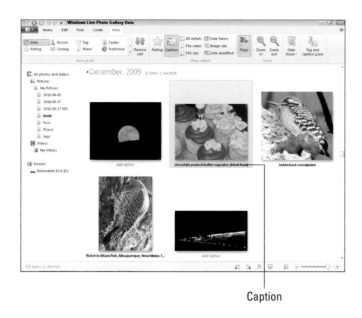

Caption

Figure 8-6: Use the View tab to display information.

WLPG has some redundancy between tabs, the status bar, and menus. For example, the Show Details section contains Thumbnails and All Details buttons. These two buttons switch between Details and Thumbnails just like the status bar buttons.

✔ **Zoom:** The Zoom In and Out buttons do the same thing as the Plus and Minus buttons in the status bar.

✔ **Arrange List:** The Date button sorts photos by date taken, grouped by month taken (refer to Figure 8-6). Newer photos sort first and older photos are down the screen. Click the Reverse Sort button to reverse that — oldest first, newer as you scroll down through the Gallery.

 Headings appear between groups of photos. In Figure 8-6, December, 2009 is the heading. The number of items in a group appears in the heading, as well as the number selected, if any. Click the heading to select all items under that particular heading.

Gallery view shows you more than one picture at once. Double-click a photo to open it in File view (see Figure 8-7). In File view, a photo fills most of the screen. The Home tab doesn't appear in File view.

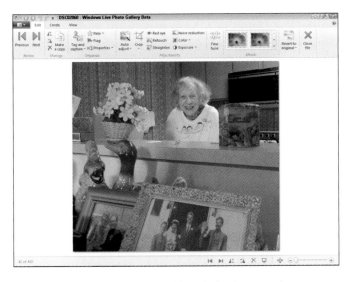

Figure 8-7: Use File view to work with a single photo at a time.

Although you can perform functions in either view, each view is better suited for certain functions. File view is ideal for editing a photo. See Chapter 9 for information on editing.

You can browse files one at a time in File view by pressing the right or left arrow keys on the keyboard. Click the Close File button at the end of the Edit tab to return to Gallery view (or press the Esc key).

Earlier versions of Photo Gallery had a Back to Gallery button, but the current version does not. More importantly, in earlier versions, if you clicked the Exit button in File view, you returned to Gallery view. In the current version, Exit closes Photo Gallery completely.

Using and Changing File Information

Every photo has information associated with it, such as date taken, date modified, and exposure information. In WLPG, you can easily see and change much of this *metadata*. WLPG writes the data into each JPEG according to general standards. Exchangeable Image File Format (EXIF) is one standard for photo data. International Press Telecommunications Council (IPTC) is another metadata standard for photos.

Some programs record this data separately from the photo in a database or in a file sometimes called a "sidecar" (Extensible Metadata Platform [XMP] is one standard). The problem with such separate data is that when the photo is copied, the data may not stay with it.

Although you can add metadata using the Home tab, open the Tag and Caption pane first so you can see the data that is already associated with a photo. On the Edit tab, click the Tag and Caption pane to display that pane on the right side of the screen (press Ctrl+I to toggle display) as shown in Figure 8-8.

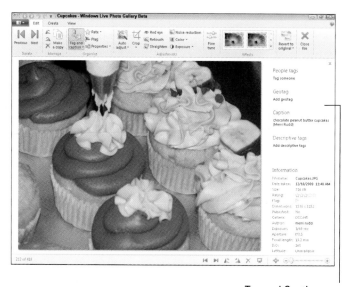

Tag and Caption pane

Figure 8-8: The Tag and Caption pane on the right shows information for the selected photo.

To see all the metadata associated with a photo, place the mouse pointer over the very faint line above Information. When the mouse pointer becomes a double-headed arrow pointing up and down, click and drag up until you see all data, ending with Longitude.

Any of this data may be missing, blank, or labeled "unavailable." You can change some of this data by clicking it. For example, enter your name for Author. In the following list, I denote the information you can change with an asterisk.

Consider the following groups of information, although this is not the order on screen:

- ✔ **About the file itself:** Filename*, Date Taken* (with time*), (File) Size, Dimensions (width x height in pixels).

- ✔ **The three factors in exposure:** Exposure is actually the shutter speed used. Aperture is the size of the lens opening. ISO is the light sensitivity rating. This may be useful in learning what settings work or don't. See Chapter 3 for information on exposure.

- ✔ **Miscellaneous information:** Camera is your camera model. Author* is the photographer's name. Focal length ranges from the wide angle to the telephoto length of your zoom lens. Longitude and Latitude are the geographical coordinates where the shot was taken. (Few cameras record this automatically, so I drag the Information area down just enough to hide these two items.)

The preceding information is collected automatically, for the most part, and Author is the only item you may want to change for every photo you take.

You can see and change some of this data for multiple files by selecting more than one file at once. Ctrl+click each photo or click the small check box in the upper-left corner of each photo. Be careful about making changes without realizing which files you selected.

You can also add the following information. (It's not automatic.) You may only want to add it to your most important or favorite photos. Consider adding it to photos you e-mail or post on the Web (as well as your Authorship).

- ✔ **Caption:** Type a few words or a sentence to describe the photo. In Figure 8-8, the caption is "chocolate peanut butter cupcakes (Merri Rudd)." In the Tag and Caption pane, click under Caption and type the text you want with a given photo. Or click the Caption button in the Tag and Caption section of the Home tab. Press Enter to finish.

- ✔ **Rating:** Rate your best photos, at least, because you can find photos based on rating (or most of the information in this section). In Figure 8-8, the rating is three out of five stars. (This is subjective. No one has to see your ratings.) Click the stars under Information or click the Rate button in the Tag and Caption section of the Home tab.

 If you see Add a Caption under a photo, you can click that. If you see stars under a photo, you can click them.

- ✔ **Flag:** Use this to identify photos you want to find easily. Click the flag under Information; the flag in the upper-right corner of any photo; or the Flag button in the Tag and Caption section of the Home tab to add or remove a flag.

See the later section, "Finding Photos," to search using any of the information in this section.

On a 12-day trip, I took 2,300 photos. No one wants to see 2,300 photos. I looked at all of them and deleted as many as I could. (It's hard!) Of the remaining, I rated the most promising 400 photos with three stars. My beloved is a fantastic editor (text and photos). She looked at the 400 and bumped 130 to four stars. Those are the ones I showed to other people — and even that may seem like a lot, but they were the best of the bunch. In the end, only five photos got five stars. Use ratings to identify your best or favorite photos. Those are the ones to share with friends and family.

Tagging Photos

Imagine that you've just gotten back from vacation with dozens, or even hundreds, of photos. You copy these photos to your computer's hard drive and into a folder created especially for those pictures. Some of those photos are of flowers (or birds) and some include your significant other.

The next vacation comes and goes, and the process repeats. Now you can go to the folder for either of those vacations and relive the restful or exciting moments.

But what if you want to see only the pictures of your significant other from both vacations? Or photos of all the flowers, regardless of where you photographed them? This is where tags come in. You apply tags to your photos; then, after you have them tagged, you can view all the photos with a given tag regardless of the folder location. For this example, you could apply one simple tag — flowers — and later display all your photos, almost as though you're looking at a separate photo album of just flowers.

Tags do not replace filenames or folder names, but they do provide a flexible way to categorize photos regardless of filename or folder location. One photo can be tagged multiple ways, putting that one photo into multiple categories.

Tags can have subtags (or *hierarchy*), such as

```
Flowers
    roses
                    red
                  yellow
            sunflowers
```

(It doesn't matter whether you capitalize tags or use plurals. The tag **flower** is okay.)

WLPG supports three categories of tags:

✔ **Descriptive tags** can be anything: the names of objects, moods, people, and locations. Figure 8-9 shows some of the descriptive tags I use in WLPG.

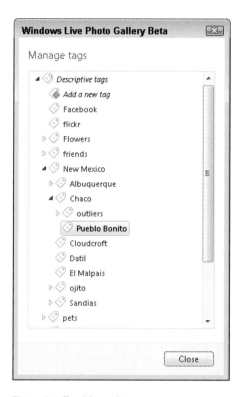

Figure 8-9: Tag hierarchy.

✔ **People tags** are, of course, for people, although you can use descriptive tags for that purpose, if you prefer. WLPG provides face recognition to quickly identify every photo containing a particular person.

✔ **Geotags** identify locations. Photos that are geotagged can appear on a map.

For geotagging, the current version of WLPG requires you to enter a location name. Microsoft's free Photo Info tool from `www.microsoft.com/downloads/` lets you drop photos on a map or a GPS file to tag photos with precise coordinates.

Adding descriptive tags

Follow these steps to tag a photo with a descriptive tag:

1. **In Gallery view, select one of your photos.**

 You can add the same tags to a group of photos by selecting them before the next step. You can tag a single photo in File view, as well.

2. **Click the Descriptive Tag button in the Organize section of the Home tab or select Add Descriptive Tags in the Tag and Caption pane.**

3. **In the tag box, begin typing your tag.**

 If the tag already exists, matching tags appear automatically below the box, in which case, you can highlight a tag to select it (see Figure 8-10). Tags can have spaces; avoid most symbols and punctuation.

4. **Press the Enter key, or click outside of the Tag and Caption pane.**

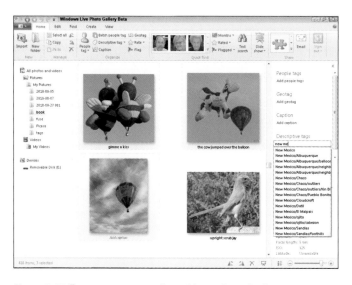

Figure 8-10: Type new tags or select old tags from the list.

5. **Repeat Step 4 to add more tags one at a time.**

 You can add as many tags as you need.

 You have to add descriptive tags to photos yourself. The software you use to copy photos from your camera to your computer may enable you to add tags as the files are copied. You can add and remove tags later, but don't wait too long. Just a little discipline in early organization pays dividends later. For one thing, you won't have to try to remember just where in the world you snapped that photo.

To remove a descriptive tag, hover over the tag in the Tag and Caption pane. Click the small "x" that appears near the tag. Confirm that you want to delete this tag from this photo. This action does not delete that tag from other photos.

To delete a tag from all photos or to rename a tag, click the triangle next to the Descriptive Tag button on the Home tab. Select Manage Tags (refer to Figure 8-9). Right-click a tag and choose Delete or Rename. You cannot undo deleting a tag. Yes, you can create it again, but you also have to re-tag all the photos that previously had the tag.

Display descriptive tags in the navigation bar to make it easy to see all photos using a tag. Choose File⇨Options⇨General. Under the Navigation Pane heading, select Show Descriptive Tags. You may also want to select Show Date Taken to make it easy to see all photos taken on selected dates. Although you can use Find for tags and dates, having both in the navigation bar is convenient.

Adding people tags

You tag people several ways, including using descriptive tags.

- **Identify a photo featuring a person:** Click the People Tag button on the Home tab or click Add People Tags in the Tag and Caption pane. A list of previously used names, if any, appears. Select a name or type a new one. This does not connect the name and a face.

- **Identify a face in a photo:** Double-click the photo to open in File view. Now, the People Tag button enables you to tag a face. See Figure 8-11. Move the mouse pointer over a face. Click on a face (or click and drag a box around the face). In the box that opens, select a name or type a new one.

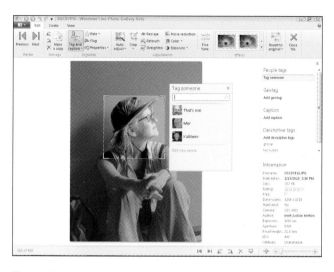

Figure 8-11: Connect a face with a name.

Adding geotags

To geotag the location where a photo was taken, follow these steps:

1. **In Gallery or File view, click the Geotag button in the Home or Edit tab.**

 A box opens under Geotag in the Tag and Caption pane.

2. **Begin typing the location.**

 Matching locations appear in a list below the geotag, as shown in Figure 8-12. At this time, it isn't possible to enter a location for which no match pops up, such as a spot in the woods. Enter the nearest matching location.

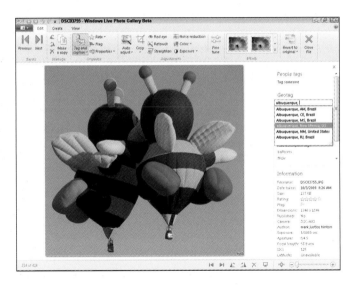

Figure 8-12: WLPG geotags use matching location names.

Finding Photos

As your collection of photographs grows, you will find yourself searching for photos from time to time. Although that may be as easy as selecting a particular folder, odds are you'll come to appreciate some of the many search functions Windows Live Photo Gallery provides.

Search results may vary depending on which folder you select in the navigation bar. Selecting All Photos and Videos is the broadest search with the

most results. Consider selecting a subfolder, if narrowing the search to that folder (and folders under it) returns just the photos you want.

Start with the Quick Find section of the Home tab (see Figure 8-13).

Figure 8-13: The Quick Find section of the Home tab.

Quick Find provides the following functions:

- ✔ **People:** Select any of the thumbnails of the most frequently found faces to find photos of that person. (Scroll to other faces with the tiny triangle or expand the choices using the triangle with a line over it.)

- ✔ **Months:** Click the Months button for a list of years (in descending order) and months (ascending) in which you took photos. Note that at the end of the list, you can find photos for a given month from any year (all May photos, for example).

- ✔ **Rated:** Click the Rated button for a list of ratings from five stars down to Not Rated. Searching for ratings less than five stars usually includes "and higher."

- ✔ **Flagged:** Click the Flagged button to find all photos you have flagged. Click the triangle on the button to select Not Flagged, although that is likely to be the vast majority of your photos.

You see the value of rating and flagging photos so you can find them quickly. See the section "Tagging Photos" to find out how to rate and flag photos.

Notice Flag in the Tag and Caption pane and Flagged in the Quick Find section, as well as Rate and Rated. The former are for adding a flag or rating, and the latter are for finding photos with a flag or rating.

Each time you use Quick Find, a search banner (see Figure 8-14) appears between your photos and the Ribbon that recapitulates what you searched for and where. Clicking the X for the banner closes it, undoing the search. Click the pushpin if you want the search banner to stay on the screen.

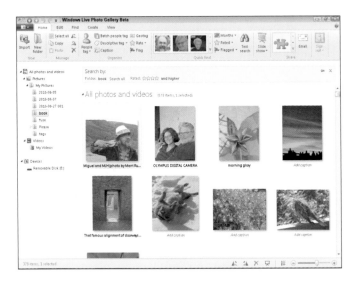

Figure 8-14: The search banner shows information about the search.

Here's how to find photos:

1. **In Gallery view, click All Photos and Videos in the navigation bar.**

 Note the number of items in the status bar.

2. **Click the Months button in the Quick Find section of the Home tab. Select any month.**

 Note the search banner and the number of items.

 The search banner indicates if you are searching in a folder. You can broaden that search by clicking the Search All link.

3. **Click the Rated button and "1 Star" (the single gold star).**

 If you don't have any rated photos in the selected month, you may not see any results. Note both search criteria in the search banner.

 As you add search criteria this way, you narrow your results to photos matching criterion one AND criterion two, and so on.

4. **(Optional) To cancel a search criteria in the search banner, hover the mouse pointer over the criteria you want to delete. Click the small x.**

5. **Close the search banner to return to browsing all photos and videos.**

You can do a lot with the Quick Find functions. For more functions, click the Find tab (see Figure 8-15). The following list offers more refined searches than Quick Find:

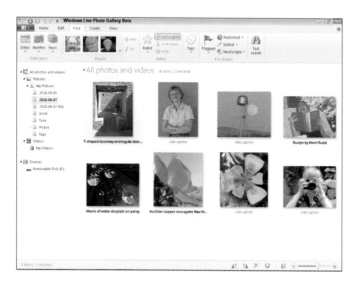

Figure 8-15: Use the Find tab for multiple search criteria.

✔ **Date Taken:** In addition to Months, Dates lets you zero in on photos taken on a specific date. Years lets you see a whole year's worth of photos.

WLPG may not realize when you intend to start a new search. Close the search banner to start from scratch. Make sure the appropriate folder (or All Photos and Videos) is selected in the navigation bar as you start each new search.

✔ **People:** You can select a face to find all photos of one person. Here, you can search for a photo containing one person and another (using the + And button) or for photos containing one person or another (using the / Or button) between selecting people.

✔ **Rated:** You can search for a specific rating. Additional buttons let you determine "And Higher," "And Lower," or exactly "Equal Only."

✔ **Tags:** The Tags button lists all the tags you have used. The first section lists your Most Used Tags (followed by a count of photos with each tag). The next section is an alphabetical list of all tags. At the bottom of the

list, Not Tagged finds photos without tags. Show Tag Hierarchy pops up a window containing all your tags.

Use the Not Tagged option to find untagged photos. Tag these! Tags are good, but that's only true if you use them.

✓ **Flagged:** Click the upper part of the button to find Flagged photos. Click the lower part for the option to find photos Not Flagged (the majority).

✓ **Search:** This function opens a box in the search banner. You can type text that might appear anywhere in the photo's metadata (filename, caption, author, tags, and people). This freeform search can be handy.

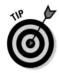

You can add most functions on the Ribbon to the Quick Access toolbar. Right-click a button and choose Add to Quick Access Toolbar. The button appears in the toolbar. To remove it, right-click the button and choose Remove from the Quick Access Toolbar.

9

Fixing Your Photos

*N*ow that you've been taking photos with your digital camera for a while, you may not always be thrilled with the outcome and may even wonder, "Can this photo be saved?" The answer is often "Yes" — even for photos you might at first consider deleting.

In this chapter, you work with several tools to fix or improve your photos. A photo that isn't exposed correctly can be fixed. A photo with composition problems — the subject isn't emphasized or something else in the frame distracts — can be improved. An array of adjustments can take a photo from okay to "wow."

The examples in this chapter feature Windows Live Photo Gallery (WLPG), a free program available to any Windows user. The concepts and terminology in this chapter apply to any photo editor. See the sidebar "Checking out photo editors," to find which photo editors are available.

Editing a photo presents an opportunity to consider what you could have done differently when shooting. Look for tips in each section that suggest how you might avoid a specific problem when taking a picture so that you can save time later on editing.

Checking out photo editors

Most computers come with a preinstalled tool for organizing and editing photographs. All photo editors provide the basic editing capabilities covered in this chapter. Some let you make some mind-blowing adjustments.

Photo editors also enable you to convert photo files to other file formats. Your camera may use the RAW format, but you wouldn't e-mail a RAW file to a friend — JPEG is preferable for sharing. Just keep in mind that this process requires extra work and more disk space than simply storing everything as JPEGs.

Some cameras include editing software on a CD or make it available from the manufacturer's Web site. You can also download free and for-a-fee photo-editing software. In most cases, the more editing features a program includes, the more it costs and the more effort you have to put in to learn to use the extra features.

Here are some of the most popular free photo editors:

- **Windows Live Photo Gallery (WLPG):** WLPG is a Windows-based program, and the one I choose to use in this book. Download WLPG from http://get.live.com.

- **Picasa:** Google's photo organizer and editor is a little flashier than WLPG. See Chapter 14 for tips on using Picasa on your computer and on the Web. Get the program from http://picasa.google.com.

- **Windows Paint:** Paint is included with all versions of Windows but isn't available for downloading from the Web. It's a basic

editor, so it might be your editor of last resort. You can use Paint for some editing.

- **IrfanView:** IrfanView is a wildly popular shareware program for image editing and conversion. It provides tools for editing, converting formats, optimizing for the Web, and batch processing multiple photos. Download it from www.irfanview.com.

- **GIMP:** GIMP is the favorite image editor for Linux, but a Windows version is also available. GIMP has a highly customizable interface, letting you choose which tools to show or hide. Download it from www.gimp.org.

- **Paint.NET:** Not to be confused with Windows Paint, Paint.NET is a powerful photo editor with an active online community supporting and extending the program. Download it from www.getpaint.net.

- **iPhoto:** iPhoto is the Mac editor included with the iLife suite. Download it from www.apple.com.

- **Web-based editors:** Instead of downloading and installing a program to edit your photos, you can upload your photos to a Web-based editor. Several of these services are available, and many provide free basic editing. These include: www.picnik.com (used by Flickr; see Chapter 10) and www.photoshop.com/tools/.

See the section "Extending Your Editing Power" for information on powerful but paid-for photo editors.

Working with Windows Live Photo Gallery

For all the editing tricks I show you in this chapter, I use Windows Live Photo Gallery (WLPG). See Chapter 8 for how to download and start using it. As you start to use Windows Live Photo Gallery (see Figure 9-1), keep these points in mind:

✔ **Gallery view:** WLPG starts in Gallery view with folders down the left side of the screen and thumbnails on the right. The first photo is selected automatically. Double-clicking any photo shows just that one photo in File view. To switch to Gallery view, click the Close File button on the far right end of the Ribbon.

✔ **Editing tools:** What tools are available to you depends on whether you are in Gallery or File view; which tab of the Ribbon you are using; and whether any files are selected.

If you can't find a function covered in this chapter, you may be on the wrong tab or in the wrong view.

Some functions appear in more than one place, including the Ribbon, the Quick Access toolbar, and the status bar at the bottom of the screen. You can also right-click for a context menu. And some functions have keyboard shortcuts. Whatever works.

✔ **Automatic saves:** Changes you make are saved automatically whenever you move from one photo to the next or from File to Gallery view. Unlike most programs, WLPG doesn't have the Save and Save As commands. See the later section "Undoing, redoing, and reverting."

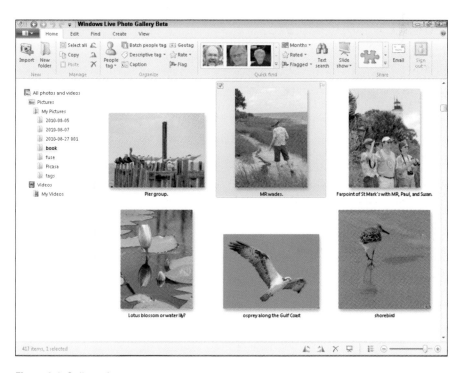

Figure 9-1: Gallery view.

See Chapter 8 for an overview of Windows Live Photo Gallery and how to use WLPG to organize and find photos.

Selecting photos to edit

Edit photos in two ways:

✔ **One photo at a time in File view:** If you double-click a thumbnail, you select the photo and switch to File view (see Figure 9-2). File view starts with the Edit tab selected. (The Home tab doesn't appear in File view.) Click the Close File button at the end of the Edit tab to return to Gallery view.

You can also edit one photo by single-clicking its thumbnail in Gallery view. However, File view provides you with the most tools on the Edit tab.

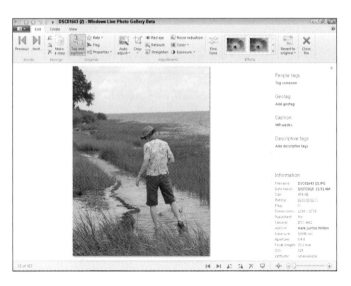

Figure 9-2: File view.

✔ **Multiple photos at a time** *(batch editing):* Apply one change to two or more photos at the same time in Gallery view. For example, you might want to delete or rename a group of photos with one command. Single-click the first photo you intend to edit. For additional photos, click the small check box in the upper-left corner of each photo. If you click anywhere else on a photo, all photos except that one are no longer selected. Watch the left side of the status bar at the bottom of the screen for the number of photos selected.

To select every photo under a particular group heading in Gallery view, click that heading.

To see each photo in a selected batch in File view, right-click one of the selected photos and choose Preview Photos. Click the Previous and Next buttons (or the left and right keys) to move through each of the selected photos. Even with a group of files selected, the changes you make in File view apply to only the one photo you see. You can batch edit only in Gallery view.

Ctrl+A selects all photos showing in Gallery view. You probably don't want to do this to all the photos you have. However, you may want to use WLPG's Find functions (see Chapter 8) to find some of your photos before editing all of those photos as a batch.

Making a copy of a photo

WLPG automatically saves the changes you make to a photo. That's a helpful timesaver in most cases. However, if you want to keep the original photo and also have the edited version, you need to make a copy before you edit the photo. Follow these steps:

1. **In Gallery view, double-click a photo.**

2. **In File view, click the Make a Copy button in the Manage section of the Edit tab.**

 See Figure 9-3.

Figure 9-3: The Make a Copy button.

The Make a Copy button appears only on the Edit tab in File view.

3. **In the Make a Copy dialog box, choose a location and type a name or accept the default name *original filename* (2).**

 I recommend accepting the default, to remind you of the connection to the original.

4. **(Optional) Change the file type of the copy.**

5. **Click the Save button.**

 You are still working on the original photo, not the copy. When you return to Gallery view, the copy you created may appear after all other photos in the group you are viewing until you sort your photos.

Don't overuse Make a Copy. You probably don't need two copies of every photo you take.

To copy more than one file at a time, use the standard two-step process for copying files: In Gallery view, select the photos you intend to copy. Click the Copy button in the Manage section of the Home or Edit tabs (or press Ctrl+C). Select a folder in the navigation pane on the left. Click the Paste button (or press Ctrl+V). If you paste the copies in a different folder, they have the original filenames. If you paste the copies in the same folder as the originals, the copies have Copy appended to the original names.

Undoing, redoing, and reverting

As you make changes to a photo, you can undo those changes so long as you don't leave that photo to view another or return to Gallery view — doing either saves your changes automatically. If you make ten changes, you can undo each of those changes one at a time — again, until you leave the photo. If you undo one change — or ten — you can also redo each change.

If you make changes and leave the photo to look at another photo, to return to Gallery view, or exit WLPG, your changes are saved automatically.

If you want the original photo back before the most recently saved changes, you can revert to the original. When you revert a photo, you lose all changes made since the last time the photo was automatically saved.

Follow these steps to undo and redo changes made to a photo:

1. **Double-click a photo in Gallery view.**

 Unless you have previously edited this photo, the Revert to Original button on the far right end of the Edit tab is grayed out (unavailable).

2. **Click the Auto Adjust button in the Adjustments section.**

 WLPG makes some automatic changes. (More on this in the "Adjusting Your Photos" section.)

3. **To undo a change, click the Undo button in the Quick Access toolbar.**

 Your latest change is undone. If you made more than one change, you can repeat this step until you've undone all the changes you'd like to undo. (So long as you don't leave this photo for another or for Gallery view.)

4. **To redo your changes, click the Redo button in the Quick Access toolbar.**

 Your most recently undone change is redone. If you undo more than one change, you can repeat this step until you've redone all the changes you'd like. (So long as you don't leave this photo for another or for Gallery view.)

5. **Click the Close File button on the far right.**

 The text "Saving" appears briefly.

6. **In Gallery view, double-click that same photo.**

 Notice the Revert to Original button is not grayed out (it is available), but Undo and Redo are grayed out (they are unavailable until you make new changes).

7. **To revert to the original photo, click the Revert to Original button.**

8. **In the Revert to Original dialog box, click the Revert button.**

If you like the changes you made to a photo but you also want the original back, make a copy of the changed photo before reverting. In this case, the copy includes the changes and the original does not.

To make revert possible, WLPG hides the original photo in a backup location. If you move the photo to another computer, you can't revert on the new computer.

Deleting and Undeleting Photos

Follow these steps to delete one or many — not too many — photos:

1. **In Gallery view, click an expendable photo.**

 Look at the number of photos selected at the left end of the status bar: Does it say "1 selected" or more? It is easy to select more photos than you intend to. If the message says more than one photo is selected, click again anywhere except the check box on the photo you intend to delete. (The check box adds and removes photos from a group selection.)

 You can delete photos from File view, too. Delete removes only the one photo on your screen at that time.

 To delete more than one photo at once, select more than one.

2. **Delete your photo.**

 Delete buttons appear in several places:

 - The Home tab in the Manage section

 - The Edit tab in the Manage section

 - Near the right end of the status bar

Not surprisingly, you can press the Delete key, as well. You can even right-click the photo and choose Delete. Whether you see a dialog box to confirm the deletion depends on the confirmation setting for your Recycle Bin. Be careful deleting.

Often there are multiple ways to do something. One way of doing things is easier or makes more sense to one person, another way to another person. Knowing more than one way gives you options and keeps you from getting bored. However, I won't list six ways to do everything. (Did someone just sigh in relief?)

Unfortunately, Undo and Revert don't work here. To undelete a photo (or any file), open the Recycle Bin from the desktop or Windows Explorer. Right-click the photo you want to undelete and choose Restore. Exit the Recycle Bin.

To disable the confirmation message, right-click an empty place in the Recycle Bin and choose Properties. Unselect the Display Delete Confirmation Dialog option if you don't want a confirmation message in Photo Gallery or in Windows Explorer.

Your restored photo may appear at the end of the group of photos you are browsing until you sort your photos.

Renaming Photos

Your camera names files automatically. Importing photos with WLPG may rename those files automatically. To manually rename files, follow these steps:

1. **In Gallery view, select one or more photos to rename.**

2. **On the Edit tab, click Rename in the File Details section.**

 The current name of the first selected file appears highlighted in the Tag and Caption pane on the right side of the screen under the Information heading. (See Chapter 8 for information on the Tag and Caption pane.)

3. **Type a new filename and press Enter.**

Oddly, if you rename multiple files, WLPG adds (1) to the second, (2) to the third, and so forth. If you include (1) in the first filename, the second file is "your file (1) (1)," and so forth. So, rename files one at a time, live with WLPG's numbering oddity, or rename groups of files using Explorer, instead.

Rotating Photos

When you take a photo, you can hold your camera in one of two orientations: *landscape,* for which you hold the camera normally (as it hangs from your

neck strap), and *portrait,* for which you rotate the camera body 90 degrees vertically for a shot that is taller than it is wide. (Okay, you can hold your camera at any wacky angle you like, but landscape and portrait are the conventional angles. Other angles may be brilliant or disturbing.) Stored in the camera, all pictures have landscape orientation, even portraits.

When you copy portrait-oriented photos, WLPG may automatically rotate them vertically, as they should be. (Otherwise, that portrait is on its side.) If WLPG doesn't rotate a photo correctly, you can do so with the following steps:

1. **In Gallery view, select one or more photos to rotate.**

 Or open a photo in File view.

2. **Click one of the Rotate buttons in the Manage section of the Home or Edit tab (see Figure 9-4):**

 - *Rotate Left* turns the photo(s) 90 degrees counterclockwise each time you click the button. Four times brings you back to the original orientation.

 - *Rotate Right* turns the photo 90 degrees clockwise each time you click the button.

The Rotate buttons also appear at the right end of the status bar. Or press Ctrl+, (include the comma) for Rotate Left and Ctrl+. (include the period) for Rotate Right.

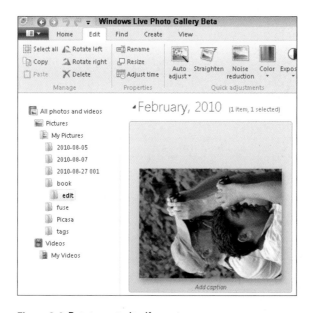

Figure 9-4: Rotate portraits, if necessary.

Resizing Photos

Your multi-megapixel camera produces high-resolution photos, and you can print high-resolution photos as large prints. (Chapter 12 discusses printing your photos.) You can also crop high-resolution photos and still have reasonable resolution in the remaining area. Cropping is covered later in this chapter.

These high-resolution photos are big files — sometimes many megabytes. They are also big in area — bigger than most computer screens — and you want big photos for printing and editing.

You can view your photo or thumbnails at various sizes without making any changes to the actual overall dimensions of your photos. Therefore, I don't think you will resize photos very often.

If you want to resize your photos, follow these steps:

1. **In Gallery view, select one or more photos to resize.**

2. **On the Edit tab, click the Resize button.**

 The Resize dialog box appears, as shown in Figure 9-5.

3. **Resize your photos in one of two ways:**

 • Select a size from the drop-down list.

 • Enter a number of pixels under Maximum dimensions.

 Both options apply your selection to the long edge of the photo (the width of landscapes and the height of portraits).

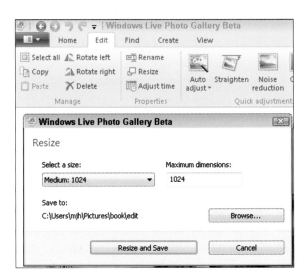

Figure 9-5: Resize one or more selected photos.

4. (Optional) Click the Browse button to change the location of the resized photo.

Resize does not change the original photo. Instead, it creates a resized file with the original name followed by the width and height.

5. Click the Resize and Save button.

The resized versions may appear after the other photos in the group you are browsing.

If you're concerned about the large amount of space photos take up on disk, you're better off deleting bad photos than resizing good ones. If size matters for all of your photos, you can change camera settings to create smaller files in camera. (I don't recommend that.)

Adjusting Your Photos

Although you can use some of the functions in this section on a group of selected files in Gallery view, most often you'll make these changes to one photo at a time in File view, so you can see the changes more easily.

The batch-processing capability in Gallery view becomes more useful as you get familiar with how each tool works in File view. Perform the steps in this section using the Edit tab in File view (see Figure 9-6). If you see the Home tab, you're in Gallery view, so double-click a photo to edit.

As you make changes to your photos, you can always undo, redo, and revert your changes. See the earlier section, "Undoing, redoing, and reverting." If you want a copy of your photo before you make changes, see the section, "Making a copy of a photo."

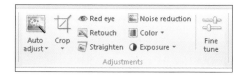

Figure 9-6: The Edit functions.

Auto adjust

WLPG can automatically adjust some aspects of a photo. Only you can determine how successful the automatic changes are. However, it's easy to undo if you don't like the changes. Further, it may make sense to use Auto Adjust and then make a few manual adjustments after that. Follow these steps:

1. **In Gallery view, double-click a photo to edit it in File view.**

2. **Click the top half of the Auto Adjust button (the icon portion).**

 WLPG adjusts the photo according to default settings. You may notice a change.

3. **Click Undo, reversing Auto Adjust.**

4. **Click the bottom half of the button (the text portion) of the Auto Adjust button.**

 A menu appears with options to auto adjust (just what the top half of the button does) and to change settings.

5. **Select Settings from the menu.**

 The Options dialog box opens on the Edit tab. WLPG automatically adjusts any combination of four aspects of photos: Straighten, Noise Reduction, Color, and Exposure. Each of these settings is explained under its own heading later in this section. For now, accept the defaults. (Later, you may want to change these.)

6. **Click OK.**

 The lower section of the Options dialog box controls JPEG quality (amount of compression). I recommend the highest setting for the slider (100%).

7. **If you aren't going to make any other changes to this photo and intend to return to Gallery view, click the Close File button on the right to keep any changes you haven't undone or undo all changes.**

If you find that the majority of your photos need changes to exposure, color, or noise, you may need to adjust camera settings discussed in Chapter 2.

Crop

You may want to emphasize one portion of a photo or eliminate an out-of-focus or otherwise distracting element from a photo. *Cropping* is the term for selecting a portion of a photo to save while deleting the rest of the photo.

Appropriate cropping is subjective, as are many of the edits you make to your photos. *Tight* cropping brings the edges of the image close to the subject, showing very little of the background or surrounding scene. *Loose* cropping shows more of the surroundings with the subject smaller within the frame.

Cropping can change the shape of the photo — for example, turning a landscape shot into a vertical portrait or changing the usual rectangular shot into a square. There are vast variations in cropping.

The mood or visual impact of a photo changes with different cropping. You may want to undo and recrop or crop different copies of one original to see the difference.

For e-mail and the Web, tight cropping has two benefits:

- It puts clear emphasis on the subject.
- It results in a smaller file size.

If you crop a very small area of a photo or start with a low-resolution original, your cropped image may be too blurred or jagged to be useful.

To crop a photo, follow these steps:

1. **In File view, click the top half of the Crop button (the icon portion, which looks like two overlapping right angles).**

 The cropping box appears over the photo (see Figure 9-7).

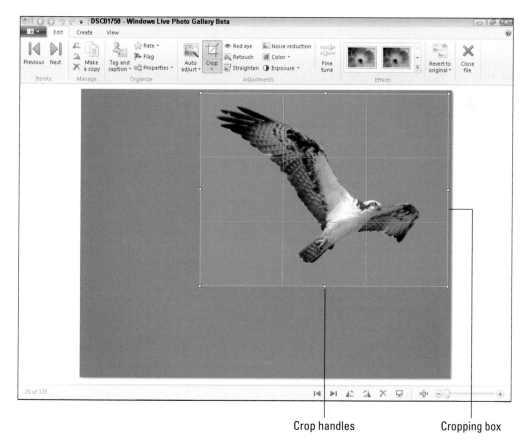

Crop handles Cropping box

Figure 9-7: An osprey with the crop box repositioned over the bird.

2. **To accept the cropping without any further adjustment, click the top half of the Crop button (the icon portion) again.**

 The area outside the cropping box is gone and the remaining portion of the photo fills more of the screen.

3. **Click the Crop icon again.**

 The full photo reappears. (No need to undo, unless you do something other than crop between Steps 2 and 3.)

4. **Move and resize the cropping box any way you like:**

 • *Move the cropping box to another area:* With your mouse pointer over the middle of the cropping box, click and drag over the area of the photo you want to crop.

 • *Move one side of the area:* Move the mouse pointer over one of the small boxes (handles) in the middle of the top, bottom, left, or right sides. Click and drag to move just that one side.

 • *Move two sides of the area:* Move the mouse pointer over one of the handles (small boxes) in the corners. Click and drag to move two sides.

 The crop box displays gridlines for applying the Rule of Thirds (see Chapter 4). Your camera may display a similar grid to help with composition. You may want to put the most important part of a photo along one of these lines or where the lines cross.

5. **Click the Crop icon to finish (or press Enter).**

 The area outside the cropping box is gone and the remaining portion of the photo fills more of the screen (see Figure 9-8).

6. **To return to Gallery view, click the Close File button to keep any changes you haven't undone or undo all changes.**

To set cropping options, click the Crop icon in File view to get the cropping box to appear. Click the bottom half of the Crop button (the text half). Four options appear on a menu. (If any of these are grayed out — unavailable — click the Crop icon again. The cropping box must show on-screen to use all of these options.) You can dictate how the Crop icon and its tools work:

✔ **Apply Crop** is just like clicking the icon a second time or pressing Enter.

✔ **Proportion** lets you restrict the dimensions of the cropping box.

 • *Custom:* Free-form, choose your own proportion.

 • *Original:* Follow whatever proportions your original photo has.

 • *4:3:* Good for printing the photo.

 • *16:9:* Good for displaying your photos on an HDTV or an HD photo frame.

 • *Square:* It just looks cool, like a Polaroid print.

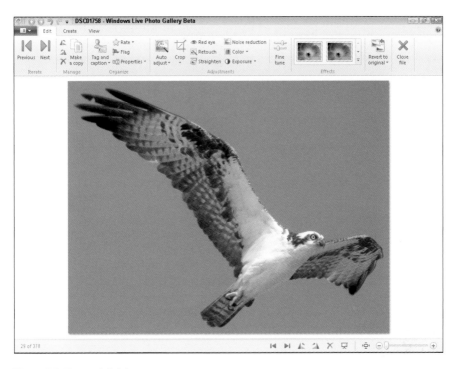

Figure 9-8: Cropped tightly.

Any choice other than Custom removes the side handles (not the corners) because you have restricted the adjustment you can make. (I almost exclusively use Custom, but I rarely print photos.)

✔ **Rotate Frame** flips the cropping box 90 degrees. A horizontal box becomes vertical and vice versa. (You can choose rotate again to flip it back.) This does not rotate the photo. This is another way to resize or reshape the cropping box.

✔ **Cancel Crop** speaks for itself.

For cropping, you can't have too many pixels. Buy a camera with high resolution (the more megapixels, the better) and set the resolution to the highest level to maximize your cropping options. The uncropped file, on the other hand, is huge and takes more hard drive space to store and more processing time to copy.

To avoid cropping, take close-ups. Get closer to your subject by moving in or by using a zoom lens. For extreme close-ups, use your camera's Macro mode. You're likely to get the most details with a close macro shot. Take a few wide-angle shots, as well. You can crop a wide shot, but you can't widen a close shot.

Red-eye

Red-eye is the reflection of a flash off the back of a subject's eyes. With human subjects you see a red reflection, whereas animal subjects produce green-eye or yellow-eye. Red-eye is a consequence of having the flash too close to the lens on most cameras. The small distance between the lens and the flash creates a small angle in the travel of light from the flash to the back of the eye and back to the lens.

Red-eye is most common in close-ups or portraits shot in low light. It is more likely to occur if the subject is looking directly at the camera.

To fix red-eye, WLPG turns selected pixels (dots) from red to black, which is why it's important not to include red that actually belongs in the photo.

Red-eye removal may be easier if you zoom in with the Zoom slider to the right end of the status bar (or press the + key) and click and drag the photo to get close to the problem areas *before* you start. If you need to move the photo *after* you start, hold down the Alt key as you click and drag.

To remove red-eye, follow these steps:

1. **In File view, click the Red Eye button.**

2. **Move the mouse pointer close to the red-eye (see Figure 9-9).**

3. **Click and drag the crosshairs over the red-eye, keeping the area you highlight as small as appropriate.**

 As soon as you release the left mouse button, the change is applied.

4. **Repeat for each red-eye in the photo.**

5. **Click the Red Eye button a second time or press the Esc key to turn off Red Eye correction.**

6. **To return to Gallery view, click the Close File button to keep any changes you haven't undone or undo all changes.**

Your camera may have a red-eye reduction function. Usually, this involves two flashes. The first flash contracts the subject's pupil, reducing or eliminating red-eye. The second flash is used for the actual photograph. (Some people find this double flash confusing or irritating.) Most non-DSLRs have a fixed flash that cannot be moved. If you can point or remove your flash, try to bounce the flash off the ceiling, wall, or nearby reflective surface. Low-tech solutions include turning up room lights (even removing lamp shades). Also consider having the subject look away slightly. Finally, you can shoot without a flash, but this creates exposure problems with low light.

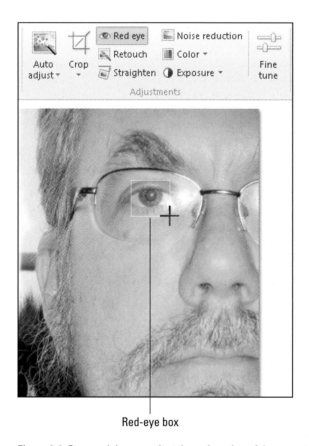

Red-eye box

Figure 9-9: Drag and drop over just the red portion of the eye.

The Web-based editor Picnik has a tool for fixing animals' green eye. See Chapter 10.

Retouch

Retouch can remove blemishes and entire objects from a photo. To do so, WLPG clones pixels from around the area that you select and replaces the pixels inside the area with the clones. When it works well, the retouched area looks just like the area around it. This function works best with small areas that are surrounded by a relatively consistent background.

Retouch may be easier if you zoom in with the Zoom slider to the right end of the status bar (or press the + key) and click and drag the photo to get close

to the problem areas *before* you start. If you need to move the photo *after* you start, hold down the Alt key as you click and drag.

To retouch, follow these steps:

1. **In File view, click the Retouch button.**

2. **Move the mouse pointer close to the area you are trying to remove or to make more consistent with the surrounding area.**

3. **Click and drag the crosshairs over the problem area.**

 As soon as you release the left mouse button, the change is applied. Figure 9-10 shows before (left) and after (right), in which I removed part of a twig with Retouch.

Figure 9-10: Retouch can remove distractions.

If retouching the entire problem area at once doesn't look right, undo, and try a smaller area.

4. **Repeat for each blemish or other problem in the photo.**

5. **Click the Retouch button a second time or press the Esc key to turn off Retouch.**

 In between retouching multiple areas, you may want to see the full photo. Click the Actual Size button left of the Zoom slider or press Ctrl+0 (zero).

6. **To return to Gallery view, click the Close File button to keep any changes you haven't undone or undo all changes.**

When you take a photo, pay close attention to more than just the subject. Is anything in the foreground or background distracting, particularly something between the camera and the subject or behind the subject in such a way it looks like it is coming out of the subject? You may be able to avoid problems instead of having to touch them up in editing.

Straighten

Sometimes a photo is tilted just a little, perhaps because of the way you stood as you took it, or a short leg on a tripod, or something you didn't notice at the time you took the photo. If the subject of a photo seems odd because of a tilt, you can straighten the photo. (See the "Rotating Photos" section if the photo is off by 90 degrees.)

You can improve on reality with this (and other edits). Perhaps that lamp post really does lean a few degrees. Straighten it, if the original seems wrong.

Straighten is included in Auto Adjust by default. I prefer to decide when to straighten a photo, so I uncheck this option in Settings for Auto Adjust. See the "Auto adjust" section.

To straighten a photo, follow these steps:

1. **In File view, click the Straighten button.**

 WLPG rotates the photo just enough to place major lines horizontally or vertically. In the process, a small area along the edges of the photo may be cropped to prevent blank space caused by the adjustment.

2. **Click the Fine Tune button to expose four headings in a pane on the right. Click the Straighten Photo heading (see Figure 9-11).**

 A grid appears over the photo to help you line up objects and major lines, such as the horizon or the edge of a wall.

3. **Drag the slider left and right to tip the photo in each direction until the photo looks straight.**

 In Figure 9-11, dragging the slider a little to the left will fix the photo.

4. **To return to Gallery view, click the Close File button to keep any changes you haven't undone or undo all changes.**

Avoid this problem by observing major lines in the scene you are photographing. Do you see a tilt? Can you fix that tilt by turning the camera or moving relative to the subject? Your camera may have an option to display a grid to help you with alignment.

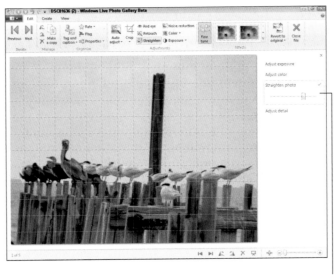

Straighten your photo.

Figure 9-11: Drag the slider to make major lines vertical and horizontal.

Noise reduction and sharpening

Some photos have a rough, grainy texture or seemingly random spots of out-of-place color defects or *artifacts*. These are symptoms of *noise,* which is a term for electrical interference. Several factors contribute to noise, including the type of image sensor and its size, as well as the image resolution. Even photon distribution and cosmic rays can play a role — seriously! For that matter, dust on the lens or the sensor may look like noise, too.

Noise may become a problem when you print enlargements or crop a small area. For normal screen viewing, noise may be unnoticeable or ignorable.

The factor most relevant to the amount of noise in a photo at the moment you shoot is ISO, which is not an acronym but a term used to describe light sensitivity. In very bright conditions, ISO can be low. As the scene gets darker, ISO may need to increase in order to capture any light at all. See Chapter 3 for information on setting ISO and other factors of exposure. As ISO increases, so does susceptibility to noise. (I'm not saying noise never occurs at low ISO.)

One way to minimize noise is to use a low ISO, which is easy when you shoot outdoors on a bright day. If you use Auto mode in low light or any of the low-light-related scene modes, such as Night, your camera is likely to increase the

ISO. The range of possible ISO depends on your camera, but from 100 to at least 800 is common on high-end P&S (point-and-shoots). Some DSLRs (digital single lens reflexes) range up to 12800 ISO. ISO above 400 may have problems with noise, depending on the camera.

WLPG pairs another function with Noise Reduction: Sharpen. Noise reduction attempts to eliminate odd pixels by making them match surrounding pixels. A bright pixel in the middle of darkness is made darker; a dark pixel in the middle of light is made lighter. Sharpen also makes pixels lighter or darker. However, Sharpen changes pixels along boundaries between light and dark to intensify the border between areas. As you drag the Sharpen slider right, you intensify borders and boundaries between light and dark pixels. This sharpens those borders. The effect may be to make part of the photo appear more in focus — sharper — although focus is not really changing. Anyway, zoom in on a detailed, complex, or patterned area of the photo and slowly drag Sharpen to the right. A little goes a long way and even a little too much looks bad.

Sharpening a photo may make a photo appear more in focus, but it may also sharpen noise, which is to say make the noise worse. Photo-nerds argue over whether to sharpen or reduce noise first. I buy the argument to reduce noise first, or you'll sharpen those defects. The order of these functions under Adjust Detail may indicate Windows Live Photo Gallery sees it the other way around. Experiment to see what you like.

To reduce noise in a photo, follow these steps:

1. **Double-click a photo with a grainy texture or odd spots (probably taken in low light).**

2. **Zoom in on a problem area and click the Noise Reduction button on the Edit tab.**

 Although you're zooming in to see the affected area, noise reduction is applied to the entire photo.

3. **(Optional) To see what's happened, undo and redo.**

4. **Click the Fine Tune button to reveal additional tools on the right side of the window.**

5. **Click the Adjust Detail heading.**

 The panel opens to expose three tools, and WLPG automatically zooms in on your photo.

6. **Click and drag the photo to see a patterned, complex, or problem area.**

 Figure 9-12 shows noise in a dark scene using ISO 400.

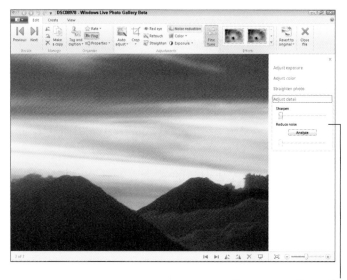

Sharpen or reduce noise.

Figure 9-12: Noise may appear as flecks or defects.

7. **Click and drag the Sharpen slider to the right.**

 As you do so, notice the effect Sharpen has on borders and lines. You may also see defects appear.

8. **Click the Analyze button under Reduce Noise.**

 You may not notice a change.

9. **To manually adjust noise, drag the slider left or right.**

 If you don't notice improvement, undo your changes.

10. **To return to Gallery view, click the Close File button to keep any changes you haven't undone or undo all changes.**

In normal to bright light, let the camera set ISO. Experiment with shots in low light using any Scene modes that seem appropriate. If experience tells you that noise is a problem in low light (and it isn't always), you may be able to manually set the ISO to 400 or less, but then you will probably have to use a flash or a tripod. Some people have found that reducing the image resolution reduces noise. This goes against the general view that more pixels are better, but in this case, fewer pixels mean less interference, or so some say. Take several shots with the same settings but different resolutions to test this theory.

Color

How green was the grass? How blue was the sky? Whether an image captures the true color or not, you can shift color and change the overall dominant color. A deft adjustment of color may make the picture more vivid. The wrong adjustment can show people and scenery in unnatural colors.

All colors on a computer screen are composed of three constituent colors in varying degrees: red, green, and blue (RGB). WLPG enables you to adjust three properties of color:

- **Temperature:** Higher is redder and warmer; lower is bluer and cooler.

- **Tint:** Tint is an adjustment to the effect caused by different light sources. For example, incandescent light bulbs cast a yellowish light, whereas fluorescent lights cast a bluish light. Use higher and lower tint to shift colors.

- **Saturation:** Saturated colors are rich and vibrant; less saturated colors are paler and flatter. Unsaturated colors are shades of gray.

To adjust color in a photo, follow these steps:

1. **In File view, click the main part of the Color button to automatically adjust color.**

2. **Click the triangle at the right end of Color to display icons to tweak the color properties in preset ways.**

 Hover over the icons that pop up for text describing how each changes the exposure.

3. **Click the Fine Tune button to reveal additional tools on the right side of the window.**

4. **Click the Adjust Color heading to expand that panel (see Figure 9-13).**

5. **Drag sliders for each of the color properties.**

 Left is less or lower; right is more or higher.

6. **To get to Gallery view, click the Close File button to keep any changes you haven't undone or undo all changes**.

Your camera may have more than one color mode. Some cameras have a Normal mode and a Vivid mode that intensifies saturation. You can affect the tint by using a flash indoors. Your camera may have a white-balance control you can set to match the light source, such as incandescent or fluorescent, and this changes the tint. These options may be in your camera's setup menu.

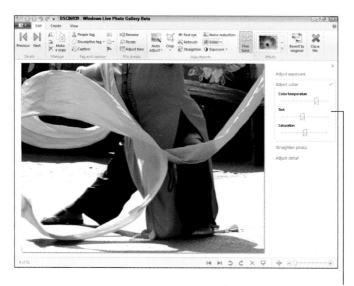

Adjust the color in your photo.

Figure 9-13: Use the sliders to adjust three color properties.

Exposure

Despite your best efforts — or your camera's best efforts — some of your photos may come out too dark or too light. Use WLPG to adjust the following four properties of exposure:

- ✓ **Brightness:** Brighten a too-dark photo or tone down one that is too bright. Push the brightness too light, and some areas wash out to white. Push the brightness too dark, and other areas fade to black.

 Adjust the brightness to adjust the mood of a picture. A little darker may make the photo more dramatic; less dark may make it seem less ominous.

- ✓ **Contrast:** Contrast is the difference between light and dark areas of the photo. A high-contrast image looks sharp — maybe too sharp. A low-contrast image looks softer and more muted.

- ✓ **Shadows:** This property refers to those pixels closer to black than to white. You may be able to lighten or darken these pixels separately from the lighter ones.

- ✓ **Highlights:** This property refers to those pixels closer to white than to black. You may be able to lighten or darken these pixels separately from the darker ones.

Adjusting brightness affects every pixel. Using shadows or highlights adjusts only those pixels that are darker or lighter, respectively. Shadows and highlights are more selective than overall brightness or contrast.

Adjust the exposure of a photo with the following steps:

1. **In File view, click the main part of the Exposure button to automatically adjust exposure.**

2. **Click the triangle at the right end of Exposure to display icons to tweak the exposure properties in preset ways.**

 Hover over the icons that pop up for text describing how each changes the exposure.

 You can try different exposure adjustments. These changes are not cumulative, so you don't need to undo one change before trying another.

3. **Click the Fine Tune button to reveal additional tools on the right side of the window.**

4. **Click the Adjust Exposure heading to expand that panel.**

5. **Use the four sliders to adjust each property:**

 • *Brightness:* Slide left to make the entire exposure darker; slide right to make it brighter.

 • *Contrast:* Slide left to reduce the difference between dark and bright pixels (making the picture softer); slide right to increase the difference between dark and bright pixels (making the picture harsher).

 • *Shadows:* Slide left to make dark pixels darker; slide right to make dark pixels brighter. Figure 9-14 shows a scene that was originally too dark; adjusting the shadows made it better.

 • *Highlights:* Slide left to make light pixels darker; slide right to make light pixels brighter.

 As you experiment with these sliders, undo in between attempts.

6. **To return to Gallery view, click the Close File button on the right to keep any changes you haven't undone or undo all changes.**

The Adjust Exposure panel also displays a *histogram* for hardcore left-brain adjustments. (Adjustments *using* your analytical, number-crunching left-brain, not *to* your left-brain.) A histogram is a graphic display of pixel distribution from dark to light (left to right). A black photo has a histogram with a vertical line along the left edge because all of its pixels are dark. A white photo has a vertical line along the right edge because all of its pixels are light.

The histogram in Figure 9-14 indicates that most of this photo is gray (the background). Your camera may have a histogram display that either appears live as you compose or displays after the photo is taken.

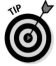

While taking photos, you may avoid exposure problems by adjusting your camera settings. When in doubt, use the camera's Automatic mode. Try different scene modes with a little imagination. For example, Beach mode might be perfect for shooting a snowy scene; both beaches and snowy landscapes are very bright. If your camera has Exposure Compensation (EC), use it as an easy way to shift exposure brighter or darker. When in doubt about manual settings, use your camera's *bracketing* function. Look for a menu or button for Bracket. Bracketing causes the camera to automatically take two to four extra photos with minor adjustments to whatever exposure setting you have manually chosen. You end up with a lot of near-duplicates but also improved odds that one will please you or be fixable.

Adjust exposure.

Figure 9-14: Adjust exposure if the photo is too light or too dark.

If you continually over- or underexpose photos, some deeper setting in your camera's setup menu may be causing the problem. Look for an option to reset all settings or take the batteries out to force a reset.

Applying Effects

You can access additional functions from the Effects section of the Edit tab of the Ribbon (see Figure 9-15).

Expand section

Figure 9-15: The Effects section of the Edit tab.

The following six effects are available:

- ✓ **Black and White (B&W):** As you expect, this turns a color photo into a B&W one.

- ✓ **Sepia Tone:** Adds a golden or silver hue to B&W, somewhat like a very old photo.

- ✓ **Cyan Tone:** Turns the overall tone to a purplish blue.

- ✓ **Orange Filter:** Turns the photo B&W, but adjusts some colors differently from the B&W effect.

- ✓ **Yellow Filter:** As with the Orange Filter, this one turns the photo B&W but converts some colors differently.

- ✓ **Red Filter:** Ditto. You may see no difference between the filters unless the original photo had a tint, such as interior shots under incandescent or florescent lighting.

Only four effects show at once in the Effects section. Click the tiny down arrow next to the last effect to scroll down to the other effects, or click the triangle with a line over it to expand the Effects section temporarily to show all.

Creating Something New

The functions in this section all appear on the Create tab of the Ribbon (see Figure 9-16). Use these functions to create new photos out of old ones, such

as a panorama, which involves combining multiple shots into one. Other functions make it easy to share your photos through e-mail and publishing to Flickr, Facebook, and other Web sites.

Figure 9-16: The Create tab.

If these options appear grayed out (unavailable), select a photo.

Using your photo as your desktop picture

Click the Set as Desktop button to make the selected photo your desktop background (formerly, wallpaper). Unfortunately, you can't simply undo this. You can easily make a different photo your desktop background, but WLPG doesn't help you go back to your original background.

Windows 7 has some wonderful desktop backgrounds. Better still, if you use Windows 7's options, you can have your background change automatically to show any number of your photos, instead of just one. Right-click the desktop and choose Personalize⇨Desktop Background⇨Pictures Library (or Top Rated Pictures, if you use ratings).

Setting a screen saver

A screen saver changes your screen after you stop using your keyboard or mouse for some minutes. Although a screen saver does nothing to save your screen, it does provide some entertainment.

The screen saver is different from the Slide Show function on the Home and View tabs in WLPG (see Chapter 8). You start a slide show manually, and it runs only if WLPG is running. The screen saver starts automatically, whether WLPG is running or not.

Follow these steps to configure the screen saver:

1. **Choose File⇨Screen Saver Settings.**

 The Screen Saver Settings dialog box opens.

2. **Select Windows Live Photo Gallery, if it is not already selected.**

 A separate Photos screen saver has fewer options than the Windows Live Photo Gallery screen saver.

3. Click the Settings button.

The Settings dialog box opens (see Figure 9-17) with options to limit photos displayed to those with a particular tag or those with a particular (or higher) rating. The Settings dialog box also has options for how the photos display (theme) and how long each photo is on-screen (speed), as well as an option to shuffle the photos randomly.

4. Make your selections and click the Save button to return to Screen Saver Settings.

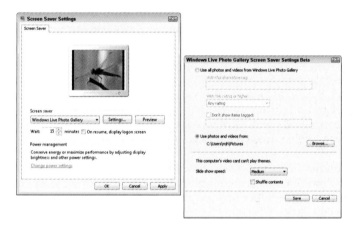

Figure 9-17: Screen saver settings.

5. (Optional) Test the settings by clicking the Preview button. Move the mouse to end the preview.

6. Click OK to close the dialog box and return to WLPG.

Making a panorama

A panorama is an extra-wide photo created from two or more photos. A wide landscape, such as a mountain range, may be a suitable subject for a panorama because a single photo cannot capture the sweep and grandeur of the scene.

Panoramas require planning as you take your photos. You need to shoot two or more photos that overlap enough (roughly 20 percent, but less overlap may work). Follow these steps that start with your camera and end at your computer:

1. In the field, stand in a spot you won't move from as you take pictures.

2. **Look through the viewfinder and practice without taking any shots.**

 Slowly move from left to right (the reverse works, as does panning vertically, as for a tall building). Keep your camera as level as possible as you move. (Using a tripod may help, but you can hand-hold these shots.)

3. **Take the photo at the left edge of the scene.**

4. **Move the camera slightly to the right, keeping part of what was on the right of the first photo on the left of the second photo to take the second photo.**

 You want these two photos to overlap 10 to 30 percent.

5. **Move the camera slightly to the right, leaving enough overlap with the second photo to take the next photo.**

6. **Repeat until you're done taking photos.**

 It is possible to include dozens of photos in a panorama, but start with three or four.

 Some cameras have a Panorama mode on the Mode dial or through a menu. In some cases, a guide appears on-screen to prompt your movements or show the recommended amount of overlap. In some cameras, you press the shutter only once, and then pan slowly as the camera captures the full scene, until the camera tells you to stop.

7. **At your computer, import your photos into WLPG (see Chapter 8).**

8. **Select all the photos you took for the panorama.**

 Don't include any other photos.

9. **On the Create tab, click the Panorama button.**

 A dialog box pops up to display a progress bar and indicate Stitching Panoramic Photo.

 When the processing ends, a Save dialog box opens automatically (before you see the results). WLPG appends the word Stich to the original filename of the first photo in the group you selected.

10. **Accept the name WLPG gives your panorama, or change the name, file type, or location. Then click the Save button.**

 The progress dialog box indicates saving. The dialog box closes automatically when processing is done. Your panorama opens in File view.

The resulting panorama may have an uneven black border as a result of the process (see Figure 9-18). Most people crop the photo to eliminate the border. (I like the border.)

Consider using a *panorama* tag to help you quickly find just your *panos* (as the cool kids call them). See Chapter 8 for information on tagging.

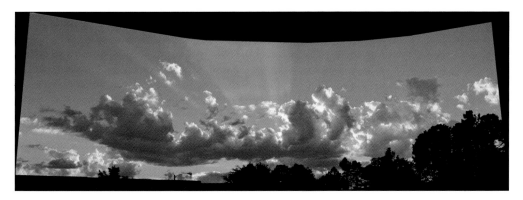

Figure 9-18: A panorama stitched from six photos.

You may notice some distortion in the resulting photo, especially in photos of large buildings or scenes you were too close to as you took your shots. There are programs for dealing with distortion or more complex composites. One of these is Microsoft Image Composite (ICE), available for free from http://research.microsoft.com.

In the field, take a normal wide-angle shot of the scene you intend to create a panorama from. That may help you select the individual photos to stitch, and it may show you whether a panorama is so different from a normal shot. If the panorama is important to you, take several groups of shots. For example, divide the scene into three shots, then six shots, in case one group produces better results than the other.

Photo Fuse

When you take a photo of a group of people, at least one person likely will have eyes closed or be yawning. Unfortunately, when you take a second photo, someone else becomes the problem. The Photo Fuse function lets you pick the best face for anyone from a series of photos.

Although you can use Photo Fuse for pictures other than group photos, plan to take advantage of Photo Fuse by shooting more than one photo of any gathering of two or more people.

Consider the three old friends in Figure 9-19. There are nine different expressions among them. With Photo Fuse, copy a head (or other area) from one photo and fuse it with another, making a new photo combining the best of the others.

This function works best when you have two or three photos. Larger numbers of photos and people are possible, but start small. The poses should be as similar as possible, where people haven't moved about.

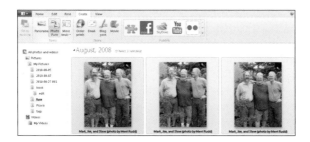

Figure 9-19: Three photos with nine expressions.

Follow these steps:

1. **In Gallery view, select the photos you intend to fuse.**

2. **On the Create tab, click the Photo Fuse button.**

 A dialog box pops up to show progress. The Photo Fuse tab appears with the first of your photos. A box highlights an area of the photo. Sometimes, the location of that box doesn't make sense.

3. **(Optional) Drag the box to place it over one face. Drag the handles to resize the box.**

 Experiment with how large or small to make the highlight box. You can replace any area of the photo, not just faces.

 When you place the box over someone's face, that person's face from each of the photos you previously selected appears in a box with a scroll bar under "Which do you like best?"

4. **Click the face you want and it becomes part of the photo, unless it already was.**

 Not every face needs to be replaced. In one step, I've replaced grinning Mark with taciturn Mark from the second photo.

5. **Repeat as needed (you can redo any part you've already done).**

 In Figure 9-20, I'm about to choose the Steve who is looking at the camera from the third photo. (This photo will combine Mark from #2, Jim from #1, and Steve from #3.)

6. **When you are done, click Save if you want to keep your results.**

 If you don't click Save, when you click Cancel, WLPG asks if you want to save. In the File Save dialog box, WLPG appends the word Fuse to the original filename of the first photo in the group you selected.

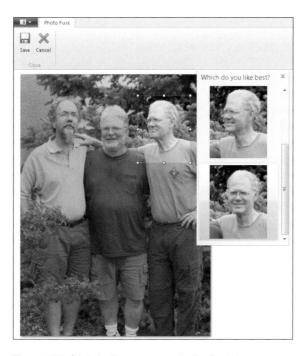

Figure 9-20: Click the face you want in the final photo.

7. **Accept the name WLPG gives your fused photo, or change the name, file type, or location. Then click the Save button.**

 You return to Gallery view automatically. The fused photo may not appear with the selected photos until you sort.

E-mailing your photos

Now that your photos are perfect, you want to share them with friends and family. WLPG has a function for sending selected photos by e-mail. However, that function requires you use an e-mail program that is installed on your computer, such as Windows Live Mail.

If you use Web-based e-mail that you access through a browser, such as Gmail, this option will not work for you. Web-based e-mail enables you to upload photos as attachments or insert photos into e-mail, but not using WLPG.

More tools

The More Tools button on the Create tab lets you access other tools that WLPG recognizes.

These two functions appear:

✔ **Open With:** Click this for a list of other photo-editing tools installed on your computer, including Paint, and an option to choose installed programs you want to use with WLPG.

✔ **Download More Photo Tools:** Click this to open a Web page that lists some additional programs you may want to use.

If you have installed the following Microsoft programs, they also appear under More Tools:

✔ **Pro Photo Tools** lets you edit metadata (extra information), including geographical information. See Chapter 8.

✔ **Photosynth** takes the idea of panorama and sharing to an amazing level in which huge scenes, even entire city blocks, are presented from huge assemblies of individually uploaded photos.

✔ **Image Composite Editor** is a powerful panorama creator and tweaker.

✔ **AutoCollage** creates a single photo collage layering multiple photos. A 30-day trial version is available.

Follow these steps to send a photo by e-mail:

1. **In Gallery view, select the photo you want to e-mail.**

 For a single photo, this also works in File view. To e-mail multiple photos, you must be in Gallery view.

2. **Click the Email button on the Home or Create tabs (refer to Figure 9-16).**

 The Preparing Files dialog box appears (see Figure 9-21).

3. **Select the photo size you want.**

 If the photo is just for e-mail, use Medium or smaller. If the recipient will print the photo, choose Original, which is full size. Note the estimated file size, which determines how long it will take to upload and download this photo.

4. **Click the Attach button.**

 Your e-mail program starts, and a new compose message window appears with your resized photos attached (these are copies and the originals are unaltered).

5. **Compose and send your message.**

Figure 9-21: Select a size for the photos you attach to e-mail.

Uploading photos to a blog

A blog (Weblog) is a Web site that features frequent, usually brief updates (*posts* or *entries*) organized with the most recent update at the top of the page and older updates in reverse chronological order down the page. A photo blog … well, it's a blog that emphasizes photos. You can get started blogging for free in a matter of seconds at www.blogger.com or www.wordpress.com.

Once you have a blog, you want Windows Live Writer, a great tool for creating blog posts. Live Writer works with almost any blog and gives you a Microsoft Word–like composing screen. Get Live Writer for free from http://get.live.com. (Writer is an option in the installer used for Windows Live Photo Gallery.)

In Live Writer, choose File⇨Options⇨Accounts⇨Add to enter your blog account information.

So, now that you have a blog and you have Live Writer, you can use WLPG to select photos for a new blog entry. That's actually cooler than it sounds. Trust me.

To create a new blog entry with a single photo, follow these steps:

1. **Select the photo in Gallery view.**

 For a single photo, you can also be in File view.

2. **On the Create tab, click Blog Post (refer to Figure 9-16).**

 Live Writer starts and a new entry appears with a small thumbnail of your photo (see Figure 9-22). The details of using Live Writer are beyond this book, but you can select the photo to resize the thumbnail and do many other good things.

3. **When you're ready to post, click Live Writer's Publish button.**

Figure 9-22: Select photos in WLPG to use in a Live Writer blog post.

You can also create a blog post with more than one photo in it. Do this:

1. **In Gallery view, select a group of photos.**

 Multiple photos can't be sent to Live Writer from File view.

2. **On the Create tab, click Blog Post.**

 The Insert Pictures dialog box opens (from Live Writer, not WLPG).

3. **If you selected three or more photos, choose how you want your photos to appear:**

 • *Inline Pictures* creates a thumbnail for each photo in succession within one new blog post.

 • *Photo Album* creates a single collage thumbnail of your photos that links to albums on Windows Live SkyDrive.

 If you selected one or two photos, thumbnails appear inline automatically without this dialog box appearing.

 Live Writer starts and a new entry appears with one or more thumbnails or a single thumbnail for a photo album. You can resize the thumbnails and do many other good things.

4. **When you're ready to post, click Live Writer's Publish button.**

Creating a movie

You have many options to share your photos and videos, including by e-mail, on a blog, or on a Web site. You may want to create a movie (or video) to show your photos and videos online or to send to someone as a DVD.

By creating a movie out of photos and videos, you can include fancy transitions, such as fading in and out, play music, and display titles between photos.

In order to create a movie, you need to install Windows Live Movie Maker. Get Live Movie Maker for free from `http://get.live.com`. (Live Movie Maker is an option in the installer used for Windows Live Photo Gallery.)

Follow these steps to make a movie from your photos:

1. **In Gallery view, select the photos and videos you intend to include in the new movie.**

2. **Click Movie on the Create tab (refer to Figure 9-16).**

 Windows Live Movie Maker (WLMM) starts with your selected photos and videos. WLMM has a Ribbon similar to WLPG. Thorough coverage of WLMM is beyond this chapter.

3. **Click the Play button under the largest thumbnail to see your movie as is without further work.**

 As each photo "plays," it appears on the left and a vertical bar sweeps over the corresponding thumbnail to indicate the transition time for that photo.

 Watch the movie full screen by clicking the Full Screen button under the preview or by clicking Preview Full Screen on the View tab. Press Esc to return to the main window.

4. **Click the Save Movie button on the Home tab.**

 Use the Recommended Setting for a project in the works. If you are done, you can use other formats, including Burn a DVD.

Whether you save the file or not, you can publish your movie on Facebook or YouTube by clicking the appropriate button in the Share section of the Home tab. The first time you do this, you need to enter account information for the site you will use.

Uploading to social sharing sites

The Publish section of the Create and Home tabs provides single-click uploading to popular photo-sharing sites, such as Flickr, Facebook, Picasa, and YouTube. To use these functions, select the photos or videos you intend to upload and click the button for the site you want to use. For each of these, you have to enter account information the first time. Subsequently, when you click a button for an established account, a dialog box prompts you for whatever information the site requires (for example, album name), then uploads everything. When the process ends, click the View Photos button to open the site in your browser.

See Chapter 10 for full details on using Flickr, Chapter 11 for information on Facebook, and Chapter 14 for information on Picasa.

Extending Your Editing Power

This chapter discusses some of the great enhancements you can make to your photos using Windows Live Photo Gallery. If you want to invest money and some time in learning to use it, however, a more powerful photo editor enables you to make amazing adjustments to every aspect of an image. Powerful editors offer more tools to apply changes semi-automatically or completely manually, down to individual pixels.

Simple tools allow you to crop any rectangular area. Powerful tools may enable other shapes, such as circular or freehand.

Basic tools let you adjust exposure for the entire image. More powerful editing tools enable exposure adjustment to selected areas or even down to the pixel level. You can brighten the subject and not the background, for example, or vice versa.

Here are three of the most popular advanced editors:

- **Adobe Photoshop (www.adobe.com/photoshop):** Photoshop is one of the top commercial, professional graphics-editing programs.
- **Adobe Photoshop Elements (www.adobe.com/elements):** This is a simpler and less expensive consumer version of Photoshop.
- **Adobe Photoshop Lightroom (www.adobe.com):** Lightroom is a powerful, professional organizer and editor.

If your editing needs exceed the capabilities of WLPG, you may want to invest in more powerful tools. The time you invest in the steps in this chapter will still be useful as you learn more complex programs.

For more information on editing photographs, see *Digital Photography For Dummies,* 6th Edition, by Julie Adair King and Serge Timacheff (Wiley Publishing), and *Photoshop Elements 8 For Dummies,* by Barbara Obermeier and Ted Padova (Wiley Publishing).

Part IV
Sharing Your Photos

The 5th Wave By Rich Tennant

"These are the parts of our life that aren't on Flickr."

In this part . . .

A photo buried in a folder on a hard drive is no better than if it were stuck in a shoebox in the back of your closet. Your photos want to be seen. You want people to see them. (Admit it!) E-mail is a great way to share a couple of photos, but not an entire vacation's worth. What other choices do you have?

In Chapter 10, use Flickr to share your photos on the Web. Flickr may be the most popular photo sharing service. Unless that's Facebook, which you use in Chapter 11.

With so many other ways to show your photos, you may not print many of your photos, but there will be some that call for it. Should you print at home or through a service? Chapter 12 covers both options.

10

Sharing Photos on Flickr

*O*dds are that you want people to see the photos you take — at least, the best ones. Sharing photos is half the fun of photography. The easiest way to share photos with family, friends, and the world is to upload those photos to the Web. After your photos are on the Web, people can see them whenever — and as often — as they want.

Flickr (owned by Yahoo!) is a popular photo-sharing service on the Web. (Flickr also supports short video clips up to 90 seconds.) Photo-enthusiasts flock to Flickr for fine photos. (Say that fast five times.) This chapter is about using Flickr to share your photos and videos.

A note on behalf of your friends and loved ones before you begin: Have mercy. Limit the photos you share. You don't have to create art, but share your best photos or those photos that are special, even if they aren't great. I know how hard this is, but your friends and family will appreciate limiting how many photos you share.

Before you show any photos, make any edits that will make those photos better — especially cropping to emphasize the subject. See Chapter 9 for information about editing. With a little effort, you can turn 100 so-so vacation photos into 20 fabulous shots everyone will enjoy seeing.

Flickr does not replace photo-organizing software on your computer. You need to be able to find your photos on your own machine. Someday, you may immediately upload your pictures to the Web and never keep a local copy. Until then, organize before you upload. See Chapter 8 for suggestions on organizing your photos.

Choosing a Photo-Sharing Service

Although Flickr is the focus of this chapter, other comparable services are available. Each service has its strengths and weaknesses. Photo-sharing services enable you to easily upload photos, to categorize your photos with tags, and to organize your photos into online albums or galleries. Choose from one of these popular services, each of which has free accounts:

- **Flickr** (www.flickr.com): Flickr has a large and active community worldwide. It sets the standard against which other services are judged and is a good choice for most people.

- **Microsoft Live Photos** (http://photos.live.com): This is a part of Microsoft's online suite of services, including search, blogging, and e-mail. Although Microsoft wants you to use this Web site with Windows Live Photo Gallery (WLPG), you don't have to.

- **Picasa Web Albums** (http://picasaweb.google.com): This is part of Google's online suite of services, including search and e-mail. Picasa is a free photo organizer and editor you can install on your computer. You can use the Web site or the editor without using both.

For viewing, organizing, and editing photos on my computer, I prefer Windows Live Photo Gallery to Picasa, but I know photographers who feel the other way. It's your choice.

- **Facebook, MySpace, and others:** Many people have accounts with social-networking sites. Most of these sites have places for photos and videos. Such sites can be great for staying current with the daily activities of family and friends around the world. See Chapter 11 for information on uploading photos to Facebook.

Each of these services enables photo uploading using your Web browser. You can also upload to each using Windows Live Photo Gallery and other photo organizers.

Many photo printing services, such as www.shutterfly.com, enable you to share your photos online, as well. This may be an especially attractive option if you want to allow others to order prints or photobooks and pay for their own prints from your photos. See Chapter 12 for information about photo printing services.

Exploring Flickr

Flickr is more than a photo host. Flickr enables members to interact. Explore Flickr to see what kinds of photos other people are posting. In the process, you discover more about Flickr and the people who love it. Look for like-minded folks and groups. You may use any of the following methods to react to other people's photos and anyone may use the same to react to your photos.

- **Mark a photo as a favorite by clicking the Favorite star above a photo on an individual photo page.** (You won't see this option on your own photos, but other people will.) See your favorites by clicking the Favorites link near the top of most pages or by choosing You⇨Your Favorites.

- **Add a photo to a gallery, which is a collection of other people's photos you like.** On the photo page, choose Actions⇨Add to a Gallery. Create a new gallery or select an existing one. You can add only 18 photos to one gallery; make new galleries as you need them. Galleries are a tribute and a way to introduce your friends to other photos.

- **Comment on photos, sets, and collections.** Use the Comment box below Add Your Comment. Click the Post Comment button to save your comment. Through comments, Flickr members encourage each other and let each other know these photos are noticed and appreciated.

Add comments to other members' pictures and they'll return the favor. Commenting and *favoriting* are part of the social aspect of Flickr. Activity in the form of comments and favorites raises a photo's rank and *interestingness*. (Flickr uses lots of words that vex editors.) Flickr automatically displays public photos with a high interestingness rating on its own home page.

- **Visit and join groups to discover photos and share similar photos.** See the section "Sharing photos with Flickr groups."

Uploading Photos to Flickr

Photostream is the term Flickr uses to describe all your photos. You add photos to your photostream by uploading them from your computer to your Flickr account. There are several ways to upload. In the next sections, you find out how to upload photos using your browser and Windows Live Photo Gallery.

Uploading with your browser

There are several ways to upload photos to Flickr. Using your browser is convenient for a few photos at a time, but less so for large numbers of photos.

Follow these steps to upload to Flickr using your browser:

1. **Sign into Flickr and choose You⇨Upload Photos and Videos.**

2. **Choose the photos you want to upload:**

 How you go about this step depends on whether you have Adobe Flash installed (you can install Flash using a button on-screen or from www. adobe.com).

 If you don't have Flash installed in your browser, you see the Basic Uploader in Figure 10-1.

 a. Click the Browse button to the right of item number 1.

 b. Navigate to your photo, click your photo to select it, and click the Open button. The filename of the selected photo appears next to item number 1.

 c. Repeat up to six photos or videos for uploading at once.

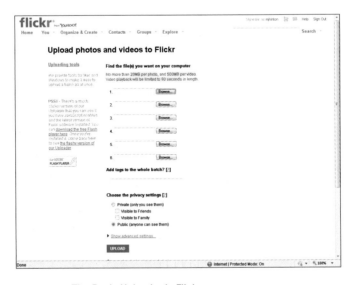

Figure 10-1: The Basic Uploader in Flickr.

If you have Flash installed, you see the screen in Figure 10-2.

a. *Click the Choose Photos and Videos link.*

b. *In the Select Files dialog box, navigate to the folder containing your photo, click your photo to select it, and click the Open button.* The name of your photo appears in a box on the Upload to Flickr screen.

c. *To upload more photos at once, click the Add More link and repeat the steps.*

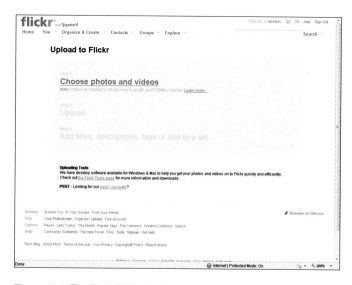

Figure 10-2: The Flash Uploader in Flickr.

3. **Select one of the options under Set Privacy:**

 - *Public* (recommended) allows anyone to view these photos.

 - *Private* limits who can view these photos to your contacts (discussed later). You can further restrict viewing privilege to Friends and/or Family (subsets of your Contacts).

Although Flickr's privacy options are good, no security is flawless, especially when it's a service whose primary purpose is to share photos with other people. If you want absolute privacy, stay off the Web (or lurk anonymously).

4. **After you have selected one or more files to upload, click the Upload Photos and Videos button.**

 A progress bar appears on-screen as files are uploaded.

5. Click the Add a Description link if you see one.

The Basic Uploader in Step 2 goes straight to Step 6.

The Describe This Upload screen appears with your photo(s) and options for describing each photo or video you upload. See Figure 10-3.

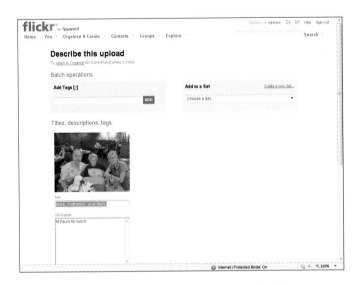

Figure 10-3: Add some text to your photos as you upload them.

6. Add tags to all photos uploaded.

Separately, you can add these photos to a set. Tags and sets are described later in this chapter.

For each individual file, you can type:

- *Title:* Usually a few words or blank. The filename may appear.

- *Description:* Can be as long as you like to describe the scene.

- *Tags*: See "Using tags with Flickr," later in this chapter.

7. Click the Save button to save your text.

Your most recently uploaded photo always appears first on your Flickr photostream page. Photos uploaded earlier move down the page and onto other pages, eventually. See Figure 10-4.

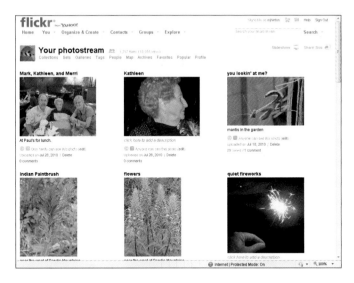

Figure 10-4: Your latest photos appear first.

 Flickr displays some metadata from photos, such as date taken. Some metadata is recorded automatically by digital cameras. You can add or change some metadata, such as title and tags, using a photo organizing program, such as Windows Live Photo Gallery. See Chapter 8.

Uploading with Windows Live Photo Gallery

Although uploading to Flickr through the browser isn't difficult, you may prefer to use Windows Live Photo Gallery instead. Photo Gallery makes it easier to find the photos you intend to upload than the file upload dialog box the browser uses.

 Use tags in Photo Gallery to help you. Tag photos you intend to upload — *upload* comes to mind as a logical tag. You may also want a *flickr* tag for those photos you have already uploaded to Flickr (and delete the *upload* tag from those photos you have finished uploading). Be sure to add any other tags you want Flickr members to see (see "Using tags with Flickr").

Follow these steps to upload photos with Photo Gallery:

1. **Start Photo Gallery (see Chapter 8).**

2. **Choose the photos you intend to upload to Flickr.**

 Use the check box in the upper-left corner of each photo to select it.

3. On the Home tab of the Ribbon, click the Flickr button in the Share section.

Look for blue and red dots on the button, as shown in Figure 10-5. If necessary, you can scroll through buttons for other services or click the Create tab to see more share functions at once.

Flickr button

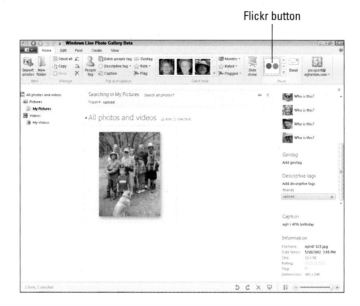

Figure 10-5: Flickr appears in the Share section of the Home tab and the Create tab.

4. Click the Authorize button to authorize the connection.

The first time you upload to Flickr with Photo Gallery, you have to authorize the Photo Gallery to connect to your Flickr account.

Your browser opens to a page at Flickr that indicates Windows Live Photo Gallery wants to link to your Flickr account. Note there are two Next buttons.

5. Click the right-hand Next button to approve the connection.

Another Web page appears, listing what you are authorizing.

6. Click the OK, I'll Authorize It button.

One more page indicates you were successful. Close your browser.

7. Back in Photo Gallery, click the Next button to continue.

In the future, you'll go straight from Step 3 to Step 8.

The Publish on Flickr dialog box appears.

8. **(Optional) Tell Flickr how to upload your photos:**

 - *Photo set:* Assign the photos you are uploading to a set, Flickr's version of a photo album. See the section "Organizing sets" for more info.

 - *Photo size:* Choose a smaller size than the original to avoid exceeding the upload limit Flickr places on free accounts. The 800 pixels option is a good choice.

9. **Select access permissions (privacy): public (anyone) or private.**

 Private can be limited to just you, to any contact, to contacts you identify as family, or contacts you identify as friends.

10. **Click the Publish button after making your choices.**

 While your photos are uploading, a dialog box pops up to show progress. Don't click Stop unless you change your mind about uploading.

11. **When uploading is complete, click the View Photos button to open Flickr in your browser.**

 The Describe This Upload page displays, as shown in Figure 10-6.

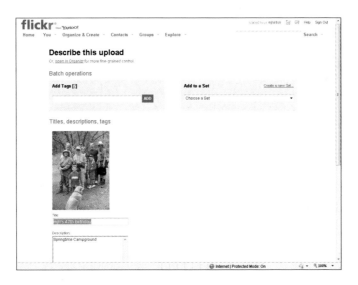

Figure 10-6: Describe the photos you uploaded.

12. **(Optional) Under Batch Operations, add tags to all photos uploaded.**

 Separately, you can add these photos to a set. Tags and sets are described later in this chapter.

For each individual file, you can type:

- *Title:* Usually a few words or blank. The filename may appear.

- *Description:* Can be as long as you like to describe the scene.

- *Tags:* See "Using tags with Flickr."

13. **Click the Save button to save your text.**

Your most recently uploaded photo always appears first on your Flickr photostream page. Photos uploaded earlier move down the page and onto other pages, eventually. Refer to Figure 10-4.

Getting Your Photos Organized on Flickr

After you upload photos to Flickr, take time to organize your photos. Doing so makes it easier for people to find your photos, especially as your collection grows to more pages. Choose a layout for your Flickr home page and group related photos using tags and *sets* (albums).

Choosing a layout in Flickr

Your most recently uploaded photos display first on your Flickr page, and older photos appear farther down and on other pages. This reverse chronological organization of photos is also called a *photo blog*.

By default, Flickr displays small thumbnails of your photos and videos in rows and columns, as shown in Figure 10-7. Each thumbnail has space for a title and a description. Almost every item on this page — all photos and most text — can be clicked for more options or information.

You can select a different layout for your Flickr home page. From the home page, click the Change the Layout of This Page link near the bottom of the page. Three layout options use small images and three other layout options use medium-sized images. You can also include thumbnail links for your sets or collections.

Figure 10-8 shows the medium layout with sets on the side. (See the section "Organizing sets.") The medium layouts show off nicely your five most recently uploaded pictures (only one of which shows in the figure because they are so much larger than the small thumbnails). The small layouts show more pictures at one time. Regardless of your home page layout, subsequent pages use small thumbnails.

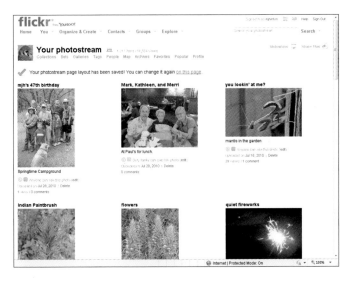

Figure 10-7: The default arrangement of small thumbnails.

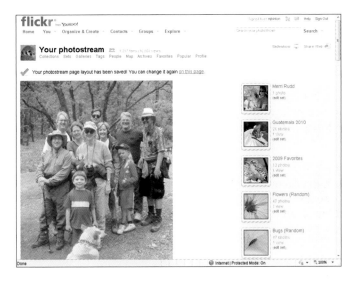

Figure 10-8: Larger but fewer thumbnails.

Using tags with Flickr

During uploading or anytime after, you can tag photos individually or in groups. Tags provide categories for photos. Tags can be unique to you, but many tags are also used by other *Flickrers*. (Okay, I made that up. Flickr members aren't actually called *Flickrers*, but maybe they should be.) Anyone can

use tags to search for photos within your account or across all of Flickr. Your tags also create album-like groups. For example, www.flickr.com/photos/ mjhinton/tags/birds/ shows all my (mjhinton's) photos with *birds* as a tag, whereas www.flickr.com/photos/tags/birds/ shows everyone's photos that are tagged with *birds*.

It takes a while to get used to tagging photos, and it's fine to change your mind over time about what tags to use. The tags you add to your photos when you use Windows Live Photo Gallery (see Chapter 8) and some other photo organizers carry over to Flickr automatically.

Follow these steps to add tags to your photos:

1. **Click one of the photo thumbnails in your photostream.**

 A larger version of the photo appears on a photo page, which contains much information and many options.

2. **Scroll down the page until you see the Tags heading on the right.**

 If this photo already has any tags, those appear below the heading (see Figure 10-9).

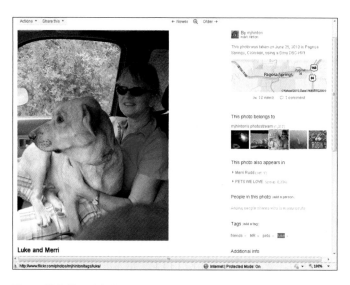

Figure 10-9: Tags label or categorize photos.

3. **Click the Add a Tag link and enter a tag (or tags) in the box that appears.**

To enter more than one tag at once, separate tags using spaces. To add a tag that has a space in it, such as "*my friends,*" surround the tag with quotation marks. Otherwise, *my friends* becomes two tags: *my* and *friends.*

Other Flickr members may find your photos as they search for specific tags you have used or text you use in your titles and descriptions. Think of the text you would use to search for these photos. That text should be in the title, description, or tags for your photos.

4. Click the Add button.

The added tag appears below the Tags heading.

To delete a tag, click the small x that appears to the right of the tag when you hover the mouse pointer over a tag. Click OK in the confirmation dialog box. Deleting a tag from one photo does not remove that tag from any other photos that use it.

To see all your photos with a specific tag, click a tag on a photo. Figure 10-10 shows the page that appears after clicking the tag *bugs* anywhere it appears in my photostream.

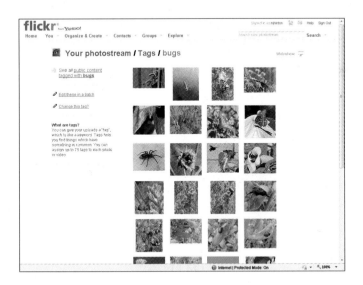

Figure 10-10: All of my photos tagged *bugs.*

There are two other kinds of tags: *people tags* and *geotags.* As you would expect, people tags identify people, whereas geotags identify places. Although you can use regular tags for people and places, use these special tag types for enhanced features, such as facial recognition and mapping,

respectively. Though you can add these tags in Flickr, see Chapter 8 for information on adding people tags and geotags in Windows Live Photo Gallery. Using WLPG, these tags become part of the original photo before you upload to Flickr or elsewhere.

Organizing sets

You can add photos to one or more *sets* during uploading or any time after. Think of a *set* as an album-like grouping. One photo can appear in any number of sets (and have any number of tags, as well). Sets display as thumbnails or larger photos with titles and descriptions. Free accounts are limited to three sets. Pro accounts can have an unlimited number of sets.

Follow these steps to add a photo to a set after you have uploaded it:

1. **Click one of the photo thumbnails in your photostream.**

 A larger version of the photo appears on a photo page.

2. **To add this photo to a set, choose Actions⇨Add to a Set.**

 See Figure 10-11. If you're creating a new set, go to Step 3. If you're adding this photo to an existing set, skip to Step 5.

Figure 10-11: Add a photo to a set.

3. **For a new set, click the Create a New Set button.**

4. **Type a title and description for the set and click the Create Set button.**

 See Figure 10-12.

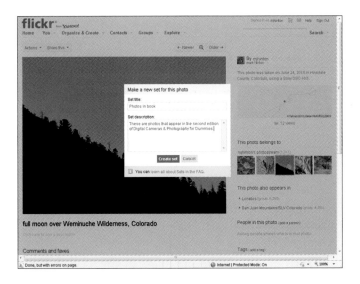

Figure 10-12: Create sets for albums of photos.

5. **Select an existing set from the window.**

 If you have many sets, you can search for the sets you want.

 A green check mark appears next to the set name.

6. **Repeat Step 5 to add this photo to other existing sets.** Remove a photo from a set by clicking the small x to the right of the group name.

7. **Click the Done button when you are (done, that is).**

 On the right side of the photo page, the sets you selected appear under the heading "This Photo Also Appears In."

See your sets by clicking the Sets link under Your Photostream or by choosing You⇨Your Sets. See the section "Choosing a layout in Flickr" for information on making your sets appear on the first page of your photostream.

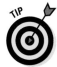

If you have multiple related sets, you can use collections to group those sets together.

Sharing Photos

You put photos on Flickr so other people will see them. Rather than wait for the world to come knocking on your door, let people know your photos are out there. Send links to friends and contribute your photos to groups of similar photos. Keep up with the people you meet on Flickr and on which of your photos people most like.

Sharing with family and friends

When you have pictures on Flickr, you can easily share those pictures with family and friends. Follow these steps to share pictures with people you know:

1. **Click the You menu item at the top of the screen.**

 This is your Flickr home page and the top of your photostream (all of your photos). The photos you most recently uploaded always appear on this page.

 As with any Web page address, you can simply copy the address in the browser address bar and paste that address into an e-mail.

2. **To send friends and family a link to any page on Flickr, click Share This in the upper-right corner of the photostream screen or above a photo on the photo page.**

 A dialog box appears, as shown in Figure 10-13.

Figure 10-13: Flickr will e-mail a link to your friends.

3. **Enter e-mail addresses separated by commas in the first box of the dialog box.**

 If you have marked any of your photos as private, you can send a guest pass to allow your family and friends who are not Flickr members to view those private photos (except those marked only for you).

4. **(Optional) Click the Add a Message link to enter a personal message and type a message.**

 If you just want the link for this page to paste into your own e-mail message, click the Grab the Link link.

5. **Click the Send button.**

On an individual photo page, you find two more specialty options:

- ✔ **Grab the HTML** provides HTML code to make this picture appear on a Web page. This is useful if you use a Web page code editor.

- ✔ **Blog It** displays blogs you have set up under You⇨Your Account⇨ Sharing & Extending⇨Your Blogs⇨Edit.

Sharing photos with Flickr groups

Groups make Flickr a social network through which you meet people who share an interest in photography or specific subjects. You don't have to participate in the social aspects of Flickr, but many people enjoy the interaction. Contributing your photos to Flickr groups after you upload is a good way to put your photos in front of more people.

Follow these steps to add your photos to a group:

1. **Choose Groups⇨Search for a Group to search for a Flickr group.**

 Most groups involve a subject as a theme, such as particular animals or locations. Figure 10-14 shows the results for groups about New Mexico.

 Choose Groups⇨Create a New Group to create your own group.

2. **Browse the photos of a group you are considering joining and look for information about the group requirements or limitations.**

 For example, some groups ask members to comment on other photos whenever they submit new photos. Some groups limit the number of photos you can submit each day. Some groups require an invitation or are completely private.

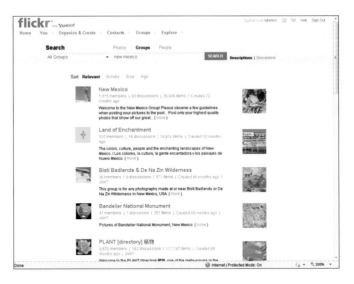

Figure 10-14: Join groups to meet people who share your interests.

3. **If membership is open and you agree to that group's requirements, click the Join This Group link under the group's name.**

 As people comment on your photos, explore their profiles and note the groups they have joined. This is an easy way to find new groups.

4. **To submit one of your photos to a group after you have joined, browse your photostream and click on the photo you intend to share.**

5. **Above the photo on the photo page, choose Actions⇨Add to Group.**

 A list of groups you have joined appears.

6. **Select the name of the group you are submitting to.**

 The groups you have joined appear in a new pop-up window.

7. **Click any group.**

 You can submit a photo to more than one group by repeating this process. Remove a photo from a group by clicking the small x to the right of the group name.

 Your submitted photo appears with other photos on the group's pages. Any changes you make to title, description, or tags are visible anywhere your photo appears.

On the page for individual photos you have submitted to groups, the group names appear to the right of the photo. You can click the group name to visit

the group. You can click the x that appears next to the group name to withdraw the photo from that group.

See all of the groups you have joined by clicking on Groups in the top menu.

Adding Flickr contacts

As you explore Flickr, or as people comment on your photos, you can add other Flickr members as contacts. A Flickr contact is someone you add to your contacts list, a kind of address book for Flickr members. Your contacts appear under the Contacts menu, making it easy to keep up with new photos from contacts.

Most photos on Flickr can be viewed by anyone, including nonmembers. You can limit access to photos, or the option to comment on photos, to Flickr members, to your contacts, or to those contacts you identify as family or friends.

Search for people to add as contacts by choosing Contacts⇨People Search for individuals by name or e-mail address. To search for all of your friends at once, browse `www.flickr.com/import/people` to have Flickr scour your address book for members.

Anyone can add you as a contact. You receive Flickr mail when someone adds you as a contact. (The Flickr Mail link appears as a small envelope in the upper-right corner of every Flickr page. A number appears on the envelope when you have one or more messages unread.) When others add you as a contact it does not automatically make them *your* contact. You do not have to add these individuals as your contacts, but that is commonly done. The more contacts you have, the more people are likely to see and comment on your photos regularly.

To add someone as a contact, follow these steps:

1. **Click the name or icon (also called an *avatar*) of another Flickr user.**

 That person's photostream appears.

2. **Click Add *(screen name)* As a Contact.**

 A dialog box, shown in Figure 10-15, gives you the option to mark the new contact as a friend or as family — that gives the contact access to photos for which you have set privacy limits.

 You can also click the tiny triangle to the right of a person's avatar to drop down a menu of options, including Add As a Contact.

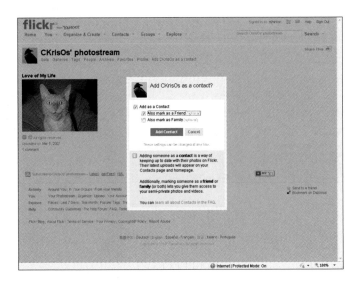

Figure 10-15: Add friends and family as contacts.

3. **Leave the friend and family check boxes unchecked to grant your new contact access only to those photos you flag as public.**

When someone leaves comments on your photos, consider viewing the commenter's photos by clicking her screen name. If you like what you see, add that person as a contact.

To see new photos your contacts have added, use the Contacts menu item at the top of each Flickr page. Flickr sends you mail every couple of weeks with recent photos from your contacts.

Keeping up with recent activity on Flickr

How do you know if anyone sees your photos? When you're logged in, Flickr shows how many times individual photos have been viewed, as well as sets and collections.

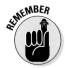

If you don't see certain menus or options, you may not be logged in. If you do not see your Flickr screen name in the upper right of the screen, sign in using the Sign In link. Some features are limited to Pro accounts.

To see who's commented on your photos, choose You⇨Recent Activity (or `http://flickr.com/activity/`). Figure 10-16 shows comments I've gotten recently on my photos (I've blurred names for privacy).

Figure 10-16: See who has commented or *favorited* your photos.

You see recent activity on your photos, including comments and those people who have marked your photos as favorites (by clicking a star above one of your photos). On the right side of the screen, you can change the time period you are reviewing. Options range from the beginning of your account to within the last hour. Also on the right of the screen, you see your stats, which record those photos most viewed the preceding day. More stats are available by choosing You⇨Your Stats.

TIP

See which of your photos are most popular by clicking the Popular link under the Your Photostream heading (first click You to return to your home page if needed). Photos are grouped according to most viewed, most marked as favorites by other members, and those with the most comments. All three of those properties factor into determining which of your photos are grouped as Interesting.

Editing with Picnik

Generally, you should edit photos before you upload. However, Flickr links your account to an online editing service called Picnik. The changes you save will apply to the photo on Flickr, but not to your original photo on your computer.

Picnik displays ToolTips (small pop-up help balloons) and Help text in every function.

To edit one of your Flickr photos, follow these steps:

1. On the individual photo page of a photo you intend to edit, choose Actions⟿Edit Photo in Picnik.

As Picnik loads, a progress bar displays. (You may have to install Flash, if you haven't already.) The first time you use Picnik, you have to accept the privacy policy.

Your photo appears below a toolbar (see Figure 10-17). A control to zoom in and out appears in the lower-right corner. The Edit tab displays buttons for editing (of course).

Photo credit: Merri Rudd

Figure 10-17: The Picnik editor uses toolbars across the top.

2. Make an edit or two. After each individual edit, click OK to save and return to the Edit toolbar to make more changes.

Most of these buttons display toolbars for the selected function, such as Rotate. (Cancel makes no changes, and Reset undoes changes made with a toolbar but leaves you on the toolbar to try again.) Options on the Edit toolbar include:

- *Auto-fix:* Makes programmed adjustments to exposure. May be worth trying just to see if that's all you need.

Buttons to Undo and Redo appear at the right-hand end of the toolbar, as do options to Save or Close Photo (without saving).

- *Rotate:* Rotate 90 degrees left or right, as well as to flip horizontally or vertically. The Straighten slider lets you nudge a photo horizontally less than 90 degrees.

- *Crop:* Position and size a box over an area of the photo. Everything outside the box is removed. Click and drag the box to move it. Click and drag the corners to resize and reshape the box. Experiment before you try options in the toolbar. In the drop-down menu under No Constraints, you can restrict the *aspect ratio* (width compared to height) of the cropped area in many ways. If you want to use precise dimensions, type those into the Actual Size boxes (width, then height) and check the box to Scale Photo.

- *Resize:* Type a new width and height to shrink or expand the photo. (Unlike Crop, the entire photo is included.) Check Use Percentages if you intend to use percentage instead of the default unit of pixels. Check Keep Proportions if you want the new size to be the same aspect ratio (width compared to height) as the original photo.

- *Exposure:* Click the Auto-Fix button to try first. Then use the Exposure slider to make the photo darker (left) or brighter (right). Use the Contrast slider to decrease (left; softer) or increase (right; starker) the differences between bright and dark areas.

 The Advanced button under Exposure adds sliders for Highlights (makes just the bright pixels brighter as you drag to the right), Shadows (makes just the dark pixels darker as you drag to the right), and Brightness (shifts all pixels darker — to the left, or brighter — to the right). The histogram displays the relative distribution of dark (left) and light (right) pixels.

- *Colors:* Click the Auto Colors button to let Picnik guess at adjustments. Otherwise, click the Neutral Picker button and then click in the photo on something that should be white or gray — this shifts color accordingly. Use the Saturation slider to drain (left) or intensify (right) the colors. Use the Temperature slider to make colors bluer (left) or redder (right).

 Often, if you haven't made adjustments before you take a photo indoors without a flash, the color seems off, perhaps too yellow. This is a problem with white balance. Use the Colors toolbar to tweak the white balance.

- *Sharpen:* Increase the contrast between adjacent light and dark pixels. A small change here seems to make the image sharper (not exactly the same as more in focus). Don't over-sharpen. The Advanced button gives you mind-boggling control beyond this section.

- *Red-Eye:* Fix red-eye (duh), which is the disturbing spot of red in the center of some eyes when a flash is used. (The red is the flash reflecting back from the retina.) With a flash, some animals have green-eye, instead of red. Click the Human or Furball button as necessary, then click in the center of the mis-colored eye. Repeat for each eye that has a problem.

Try Undo, Redo, and Reset (when you see it). Experiment and play. If you don't like the results, you can click Close Photo to return to Flickr without any changes.

3. Click the Save button.

The Save This Photo dialog box, as shown in Figure 10-18, appears.

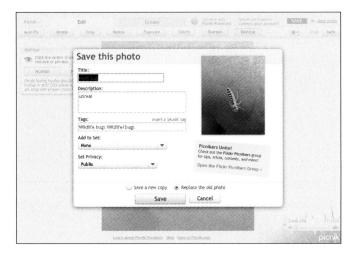

Figure 10-18: Options for saving your changes to Flickr.

4. (Optional) Change the title, description, tags, set, or privacy of this photo.

5. Choose Save a New Copy to leave the original as it was and add the edited version as a second photo, or choose Replace the Old Photo for that option.

6. Click the Save button.

After a brief time, you return to the photo page in Flickr. Congratulations!

The Create tab provides options to add numerous effects to a photo, mostly in the form of text and decals of various types. Specifically, these options are Effects, Text, Stickers, Touch-Up, Frames, Advanced, and Seasonal. If you want to turn a photo into an invitation or decoration, try these effects. Remember Undo. (Under the worst circumstances, return to Flickr and delete the mangled photo, then upload the original again.)

Some editing features are available only with the premium version of Picnik, which at this writing costs $24.95 per year.

11

Sharing Photos on Facebook

*F*acebook is the extremely popular Web site for connecting with people. Facebook *friends* — let that one term cover family, friends, classmates, colleagues, and others — frequently post short status updates describing what they're up to or thinking about. When you visit your Facebook home page, you see recent status updates from your friends, as well as other items they have posted or linked to.

One big advantage to Facebook: You already know someone using Facebook, possibly a lot of people. Facebook makes it easy to find people you know and meet new people, as well. Show your friends your photos one at a time or as entire albums. Your friends can comment or simply approve.

Facebook's people-tagging feature makes it easy to see everyone's photos of you or any of your friends.

 This chapter is only about photos on Facebook, but there is much more than that. Facebook has many features not covered here. Consider *Facebook For Dummies,* by Leah Pearlman and Carolyn Abram.

Flipping a Few Pages in Facebook

Before you upload photos, take a moment to look at a few Facebook pages.

Facebook has two main pages:

- **Your home page:** Click the Home link in the blue Facebook banner at the top of any screen. Your Facebook home page appears, as shown in Figure 11-1. On this page, you see the latest updates and comments from your Facebook friends, with the most recent updates at the top of the page and older updates as you scroll down the page. The home page lets you see what everyone is up to. You'll see this page more often than any other on Facebook.

- **Profile:** Click the Profile link in the Facebook banner. This is the page your Facebook friends see when they visit your page; see Figure 11-2. Your profile page starts on the Wall, where everything you post mixes with everything anyone posts for you.

Both the home page and the profile page provide a form called the Publisher at the top of the page. Use this to write a short message about what you're doing or thinking. Click the Share button.

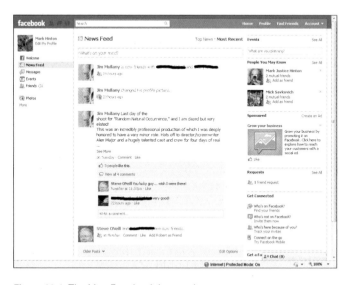

Figure 11-1: The blue Facebook banner has a menu.

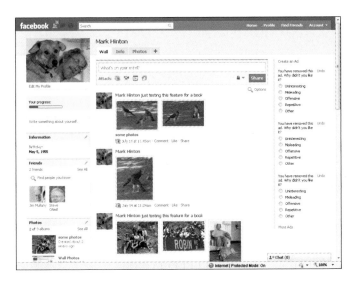

Figure 11-2: Your Wall shows things you have done on Facebook.

Customizing Your Facebook Account

Before you upload photos to Facebook, you may need to customize your privacy settings to control who can see your photos, as well as other aspects of your account. If you aren't on the Account Settings screen, choose Account⇨ Privacy Settings.

Here's what you can change:

- ✔ **Name, e-mail address, and password:** Click the Settings tab.

- ✔ **Security question:** Click the Change link to the right of the Security Question heading. Facebook asks you this security question if you can't remember your password. Choose a question from the drop-down list. Type your response to that question in the Answer field. Click the Change Security Question button.

- ✔ **Privacy options:** Click the Manage link to the right of Privacy. On the Privacy screen, click the Customize Settings link to see the different parts of your Facebook account. You can limit who sees what:

 - *Everyone:* There's no limit on who can see this part of your account. Anyone on Facebook can view this.

 - *Friends Only:* Only those people you specifically accept as friends (including family and others) can see this info. This is the most private option.

- *Friends of Friends:* This option extends access to your friends' friends.

- *Customize:* With this option, a separate dialog box appears so that you can limit access to just yourself or to selected friends. You can also block specific friends from seeing some information. If you use this option, click Save Setting to close the dialog box.

Click the Back to Privacy button to keep the changes you make to your profile privacy.

Or is this a warning? As with most programs and Web sites, Facebook has more than one way to do most things. Notice that Facebook places a menu on the right side of the blue banner at the top of the screen, beginning with Home and ending with Account. Other menus come and go depending on which screen you're on. Think of Facebook as a game.

Uploading Photos to Facebook

With Facebook, as with almost anything involving computers, there is usually more than one way to do anything. In this section, I show you three ways to upload photos: one at a time, as an album, or using Windows Live Photo Gallery (WLPG).

Publishing a photo on your Wall

You can upload (publish) photos one at a time to your Wall or to a friend's Wall — anywhere you see the Publisher text box, which displays "What's on your mind?"

Follow these steps to upload an individual photo:

1. **On your Wall (or a friend's), click in the text box that says "What's on your mind?"**

2. **Type some text to introduce or describe the photo you intend to upload.**

3. **Under the text box, next to Attach, click the first icon, which is for photos.**

4. **Click the Upload a Photo link.**

 If your computer is equipped with a Webcam, you can click the Take a Photo link.

5. **Click the Browse button. Use the Choose File to Upload dialog box to navigate to your photos folder and select one photo to upload. Click the Open button.**

 The filename appears in the box to the left of the Browse button.

6. **(Optional) Click the padlock icon to specify privacy settings for this one photo.**

7. **Click the Share button to upload the selected photo.**

 A thumbnail of the photo appears on the page, plus your text (if any), as shown in Figure 11-3.

8. **Click the photo to see the large version.**

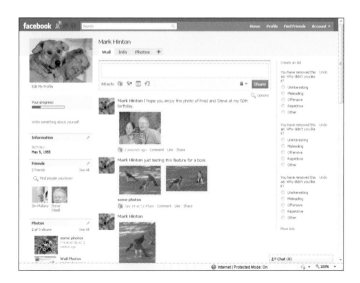

Figure 11-3: Photo thumbnails appear on your home page and Wall.

Uploading photos to a new album

The photos you upload individually to your Wall are added to an album called Wall Photos (fittingly). If you intend to upload a group of related photos, you can create a new album for those photos.

Follow these steps:

1. **On your home page, click the Photos link on the left side of the screen.**

 Your friends' most recent photos appear on the Photos page.

2. **Click the Upload Photos button at the top of the page.**

 The Add New Photos page appears (see Figure 11-4).

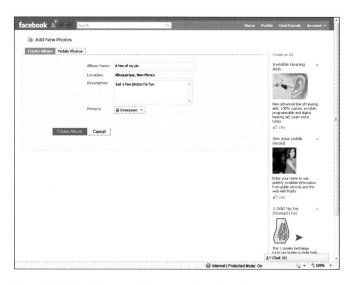

Figure 11-4: Provide some information about the album.

3. **Click the Create Album tab, and enter the following information (all of which is optional but recommended):**

 • *Album Name:* Appears anywhere the album appears.

 • *Location:* Identifies where these photos were taken, if only roughly.

 • *Description:* Says something about these photos.

4. **(Optional) Change the Privacy option.**

5. **Click the Create Album button.**

 The Upload Photos page appears.

6. **Click the Add Photos tab and then click the Select Photos button.**

7. **In the Browse Files dialog box, navigate to your photos folder, select the photo (or photos) you want to upload, and click Open.**

 To select multiple photos, hold down the Ctrl key as you select each photo.

8. **Back on the Upload Photos page, click the Select More Photos button if you want to add more photos.**

9. **When you are done, click the Upload Photos button.**

 A progress bar appears as your photos upload. Be patient, especially if you selected many photos.

 When the upload is complete, the Edit Album page appears on the Edit Photos tab, as shown in Figure 11-5.

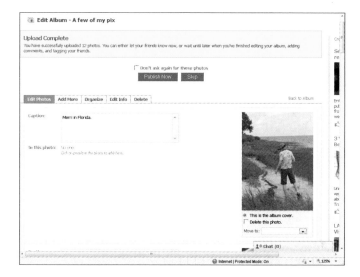

Figure 11-5: Edit information and options for the uploaded photos.

10. **Click the Publish Now button to go to the album page you just created (or updated) or click the Skip button to stay on the Edit Photos page.**

 Scroll down the page to see the options available for each of the uploaded photos. In addition to Caption and people tagging mentioned earlier, you find these options on the Edit tab:

 - *This Is the Album Cover:* This option makes the selected photo the thumbnail for the entire album.

 - *Delete This Photo:* This option appears as a check box below each thumbnail. Select it to delete this photo.

 - *Move to [Another Album]:* Select a different album to move this photo to.

11. **Make any changes you wish and click the Save Changes button at the bottom of the Edit Photos page.**

If you have not published this album, a dialog box prompts you to do so now. You can skip publishing until you are ready to show this album to the world.

You can access the following options anytime by clicking links in an album to Edit Photos, Organize Photos, or Add More Photos.

- ✔ **Edit Photos:** See the "Editing Photos on Facebook" section.

- ✔ **Add More:** Click this tab to upload more photos to this album.

- ✔ **Organize:** Drag photo thumbnails to rearrange the order of photos in the album. Click the Reverse Order button if you want to reverse order. (Is that what they mean by self-explanatory?) Click Save Changes to . . . you know.

- ✔ **Edit Info:** Use this tab to access the same options you saw when you created the album: name, location, description, and privacy. Click Save Changes after changes.

- ✔ **Delete:** To delete the entire album and its photos, click the Delete button.

Two more options that appear only on the album page (not My Photos or individual photo pages):

- ✔ **Share This Album:** Click this link to start a message to a Facebook contact with a link to this album.

- ✔ **Post Album to Profile:** Click this link for other people's albums you want to share. As you create albums, your albums are automatically posted to your profile (Wall).

Uploading photos with Windows Live Photo Gallery

Although uploading to Facebook through the browser isn't difficult, you may prefer to use Windows Live Photo Gallery (WLPG). Photo Gallery makes it easier to find the photos you intend to upload than the file upload dialog box the browser uses.

Use tags in Photo Gallery to help you. Tag photos you intend to upload — *upload* comes to mind as a logical tag. You may also want a *Facebook* tag for those photos you have already uploaded to Facebook (and delete the *upload* tag from those photos you have finished uploading).

Follow these steps:

1. **Start Photo Gallery.**

 See Chapter 8 for more about WLPG.

2. **In Photo Gallery, choose the photos you intend to upload to Facebook.**

 Use the check box in the upper left of each photo to select it.

3. **On the Home tab of the Ribbon, click the Facebook button in the Share section on the right.**

 Look for a white "f" on a blue background, as shown in Figure 11-6.

Facebook button

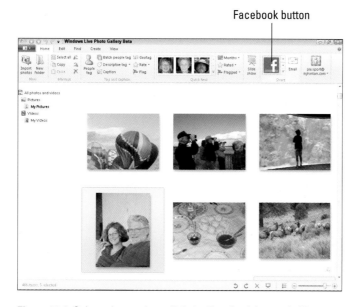

Figure 11-6: Select photos, then click the Facebook button in Share.

If necessary, you can scroll through buttons for other services or click on the Create tab.

4. **Authorize the Photo Gallery to connect to your Facebook account.**

 You only have to do this the first time you connect to Facebook via Photo Gallery. A check mark should appear next to "Let me publish photos to Facebook and tag my Facebook friends in them" under the Photos & Videos heading. You can deselect the options under "You can also," which pertain to other aspects of Windows Live.

5. **Click the Connect with Facebook button to authorize the connection.**

6. **On the Log-in screen, type your e-mail address and Facebook password. Click the Log-in button.**

 The Request for Permission screen appears.

7. **Click the Allow button.**

 Facebook opens in your browser.

8. **Click Allow on the next screen.**

 If you see a prompt to Allow Offline Access, click that button.

9. **Close or minimize the browser and return to Windows Live Photo Gallery.**

 The Publish on Facebook dialog box opens.

10. **Create a new album or select an existing album and click Next to continue.**

 For a new album, enter the album name and description. Specify privacy using the drop-down menu; Everyone is the default.

11. **Link any people tags to Facebook friends and click Next to continue.**

 If you use people tags in WLPG, doing this step now saves you from tagging people in Facebook.

12. **Click the Publish button to finish uploading your photos.**

 While your photos are uploading, a dialog box pops up to show progress. Don't click Stop unless you change your mind about uploading.

13. **When uploading is complete, click the View button.**

 Your album opens in the browser. See Figure 11-7.

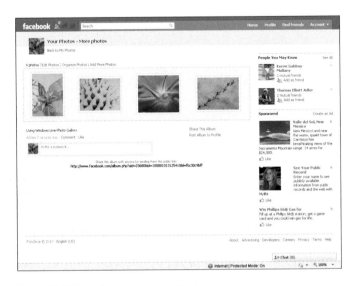

Figure 11-7: Your album appears in the browser.

Editing Photos on Facebook

In most contexts, *editing* a photo refers to *altering* the photo itself, perhaps by cropping, resizing, or adjusting exposure. That kind of editing is not currently available in Facebook. You have to alter the photo before you upload it.

Instead, Facebook lets you edit options, such as a caption, for every photo you upload. Some of these options appear on the individual photo page, as in Figure 11-8; others appear after you click the Edit This Photo link on a photo page.

Figure 11-8: You can edit a few options for each photo.

Consider these options:

- **Add a Caption:** Describe the photo in a few words or a couple of sentences.

- **Rotate Photo Left or Right:** Odds are, you rotated a photo before uploading, but if not, use these functions, which appear as buttons with arrows.

- **Share:** Use this option to let people know about this picture. See the section "Sharing Photos and More."

- **Tag This Photo:** Identify people in the photo. See the section "Sharing Photos and More."

- ✔ **Edit This Photo:** This link merely opens a form with caption and people tagging, among others.

- ✔ **Delete This Photo:** This option speaks for itself. You may want to make sure you still have the original photo on disk.

- ✔ **Make Profile Picture:** Make this the photo associated with your account and anything you post.

Sharing Photos and More

Facebook is all about sharing. Several different functions are related to sharing photos, videos, links, and more. You find many of these functions in more than one place, such as your Wall, a friend's Wall, your home page, photo pages and albums, so I'll describe them here as a group, regardless of where they turn up.

- ✔ **Comment:** Click a Comment link or click in a comment text box and say what you will.

- ✔ **Like:** Click the Like link to indicate you like something (and people say computers are hard). "Like" is a vote for an item; you can "unlike" something you previously liked, but there isn't a standard way to dislike something.

- ✔ **Share:** Click the Share link or button for a form that automatically contains a link and an excerpt of the item you're sharing, including a thumbnail for photos. You can add a comment to this item. Shared items appear on your Wall unless you click Send as a Message Instead, in which case, you address the item to one of your Facebook contacts.

- ✔ **Tag This Photo:** Use this function to identify faces in a photo. Tags link to your Facebook contacts' photo pages. Click on each face and select the person from the list of contacts that pops up. Click Done Tagging above the photo when you are finished.

 Facebook doesn't use tags as categories or labels for things other than people.

- ✔ **Report This Photo:** Use this link to report a photo you find offensive or illegal.

- ✔ **Share This Photo with Anybody by Sending Them This Public Link:** If your privacy settings allow you to share a photo with everyone, click this link to copy a link to the photo into an e-mail message. (Or highlight the text below this link, copy, and paste that into an e-mail.)

Printing Your Photos

*1*n the pre-digital days of film, in order to see photos, people printed them. Those prints were passed around or stored in envelopes (with their negatives) — often in shoe boxes in the back of a closet — until someone found the time to mount them in photo albums.

These days, the vast majority of digital photos never make it onto paper — and the forests breathe their thanks. Viewing photos on-screen gives them an extra brightness. (Much like old-school film slides.) On-screen, you can sort and re-sort. You can zoom in and pan. You can edit. You can e-mail and upload. Prints have none of that flexibility.

Still, a print is an easy way to transport and share a photo. A large print of a special photo makes a nice decorative addition to your home or office.

In this chapter, you find out how to print on your own printer and use a printing service. You also consider some of the novelty print options. (Photo mouse pad, anyone?)

Printing at Home

Printing at home means nearly instant gratification. You can print a photo to include in a card or letter for a friend. You can print photos for guests.

Buying a printer

To print photos at home, you need an inkjet printer. These printers use tiny nozzles to spray the ink onto the paper. Printed pages require a few seconds to dry before handling. Typically, these printers have one black cartridge for text printing and one or more separate color ink cartridges. Some cartridges are refillable, but most are recyclable instead. Inkjet printers are fast, relatively quiet, and produce good results.

You need a cable to connect the printer to your computer. If a cable doesn't come with your printer, you'll have to buy one separately. This is likely a USB cable, although some older printers use a parallel printer cable.

 Consider an all-in-one printer, which is a multifunctional device that includes an inkjet printer, a fax machine you connect to a phone line, and a scanner. Using a scanner, you can convert old photos into digital files. Pictures in your old family albums can enter the 21st century as digital photos.

Setting up your printer

Take your new printer home and set it up in a convenient spot near your computer. (You can share a printer between computers using a network, though that's beyond this chapter's topic.)

Follow these steps:

1. **Take your printer out of the box. Keep all the packing material together until you know you won't need to return the printer.**

2. **Arrange all the components for easy access.**

 In addition to the printer, you'll probably find ink cartridges or a toner cartridge, a power cable, and a CD with printer software. Read the instructions for setup that come with your printer.

3. **Remove all tape from the printer and place the printer within cable length of your computer.**

 Most printers ship with the print mechanism fastened in place in some way. Look for brightly colored tape, paper, or plastic indicating what you need to move or remove to release the print mechanism.

4. **Insert the ink or toner cartridge before you turn the printer on and place paper in the paper drawer or tray.**

5. **Unless your printer's instructions say otherwise, before you connect the printer to the computer, insert the CD into the disk drive.**

 The setup program should start automatically.

6. **Follow the prompts to set up your computer.**

7. **After the software setup ends, plug the printer cable into the printer and into the computer and turn the printer on.**

 You may see some informational dialog boxes or pop-up messages as configuration completes.

Confirm that your printer is installed properly by following these steps

1. **Choose Start⇨Devices and Printers.**

 You should see an icon for your new printer on-screen.

2. **Click or double-click your printer icon to open the program that monitors your printer's activity.**

3. **Click Customize Your Printer.**

 The properties dialog box for your printer appears, as shown in Figure 12-1.

4. **At the bottom of the General tab, click the Print Test Page button.**

 If a test page does not print, check both ends of the cable and make sure the printer is turned on. Double-check all the preceding steps and try to print a test page again. Contact the printer manufacturer, the location you bought the printer from, or the Web for more help.

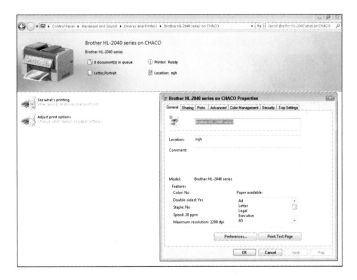

Figure 12-1: Print a test page to ensure your printer is working.

Printing directly from your camera or card

You can print in several different ways without using a computer. Each of these requires that both your camera and your printer support the same method.

Before you use any of these methods, look for a print function on your camera's menus. If your camera has a built-in print function, you can select the photos you want to print before you connect to the printer. This is sometimes labeled DPOF (Digital Print Order Format). If your camera does not have a print function for selecting photos, your printer may have this feature. If neither the camera nor the printer lets you select photos, you may have to print all the photos on the memory card. (If you have hundreds of photos on your memory card, this probably isn't a good option for you. See the "Printing from your computer" section.)

Here are the methods you have to print your photos directly from your camera or memory card:

- **Memory card slot in printer:** If your printer has a card slot for the type of memory card your camera uses, remove the card from the camera and insert the card into the printer. Put your thumb on the card's label and insert metal contacts away from your hand. The printer detects the card. Use the printer's menus and screens to control how the photos print.

- **PictBridge:** The PictBridge standard uses a USB cable to connect cameras to compatible printers. Look for a Print option in your camera's menus and for the word PictBridge on the printer. Connect the USB cable from the camera to the printer. The USB connection on the printer for the camera is different from the one that connects the printer to the computer; it should be in front or on top of the printer. The printer detects the camera. Use the printer's menus and screens to control how the photos print.

- **Camera dock:** A few cameras have a *dock,* which is a small device the camera sits on or in. The dock may be used to charge the camera, or to connect it to a computer or printer. Connect the camera to its dock and the dock to the printer. The printer detects the connection. The dock may provide print controls. Otherwise, use the printer's menus and screens to control how the photos print.

Printing from your computer

For flexibility and control, use your computer to print your photos, as well as to organize and edit them. I use Windows Live Photo Gallery in this section, but any photo program will have similar features and steps.

Using Windows Live Photo Gallery, follow these steps:

1. **In Photo Gallery, select the photo you want to print.**

 If you want to print more than one of your photos at the same time, use the check box in the upper-left corner of each photo to select those you want to print. (The next steps are the same in Gallery view or File view. See Chapter 8 for information on using Windows Live Photo Gallery.)

 You can also print any photo from Windows Explorer. Select the photo, right-click, and choose Print.

2. **Choose File⇨Print⇨Print.**

 To skip the menus, press Ctrl+P.

 The photo opens in the Print Pictures dialog box, shown in Figure 12-2.

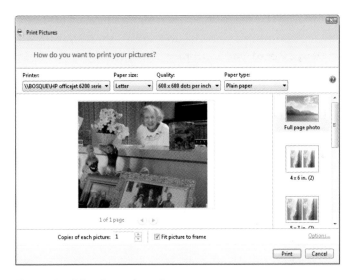

Figure 12-2: Print photos through your computer.

If you selected more than one photo to print, use the right triangle below the photo (or the right arrow key on the keyboard) to preview each of the selected photos.

3. **(Optional) Specify the size of each print.**

 The number of prints that fit on one page appears in parentheses next to each size. Select from these sizes:

 • *Full page photo:* This option prints one photo per page. The photo fills most of the page.

- *4 x 6 in. (2):* Use this to print two photos per page (if you select more than one photo or more than one copy). This is a standard print-size for photos.

- *5 x 7 in. (2):* Prints two photos per page (if you select more than one photo or more than one copy). These prints are larger than those from the 4 x 6 in. option.

- *8 x 10 in. (1):* This option is the same as Full page, unless you have changed paper size in the printer options (see Step 6 for more on this).

- *3.5 x 5 in. (4):* This option prints four smaller photos per page (if you select more than one photo or more than one copy).

- *Wallet (9):* Use this option to print up to nine small photos per page (if you select more than one photo or more than one copy). Each print is 3 x 2¼ inches.

- *Contact sheet (35):* Use this option to print up to 35 very small photos per page (if you select more than one photo or more than one copy). Each print is 1½ x 1 inches. The filename of each photo appears below the photo. This is a quick way to evaluate the print-worthiness of a large number of photos at once.

4. **(Optional) Choose the number of copies to print in the box below the photo, along the bottom of the dialog box.**

 If you want more than one copy of your photo, increase the number of copies of each picture. (Enter a number or click the small triangles to the right of the number to increase or decrease the number.) If you select more than one photo in Step 1, you print this number of copies of each photo. Two copies of three photos equal six prints, of course. That requires six sheets of paper for full-sized prints but only one for wallet-sized — with space for three more prints.

5. **(Optional) Uncheck and re-check the Fit Picture to Frame option, watching how that changes the print preview.**

 If checked, this option expands the shorter of width or height of the photo to fill the available space and eliminate any white space around the photo. As a result, the longer of width or height may extend beyond the edges of the print frame. For images that don't fit standard print proportions, Fit Picture to Frame cuts off some portion of the print. For Figure 12-3, the Fit Picture to Frame option is checked. The photo on the left is fine either way, whereas the other photo shows the potential problem of fitting (filling the frame). When the width of that narrow photo is expanded to fit the frame, the top and bottom of that photo are cut off. (The right-hand photo is also cropped badly for printing as a standard-size print. See Chapter 9 for information on cropping photos.)

 Unchecked, the entire photo fits within the available space, but you may have blank space above and below or to both sides of the photo.

(This space is shown as off-white around the photo in the dialog box.) Figure 12-4 shows two photos with the Fit Picture to Frame option unchecked. Both photos are acceptable, although the one on the left has excess blank space on the top and bottom.

Use the setting that looks best for the selected photos. For many photos, this option won't make much of a noticeable difference.

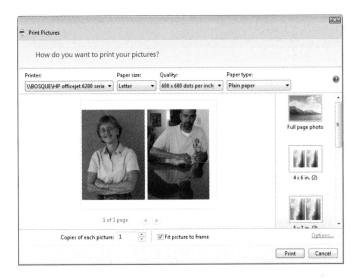

Figure 12-3: The Fit Picture to Frame option can cut off some pictures.

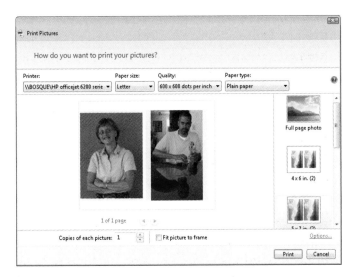

Figure 12-4: Two photos with the Fit Picture to Frame option unchecked.

6. **(Optional) Change any of the printer options that appear across the top of the dialog box.**

 Four options may be available, depending on the selected printer:

 - *Printer:* Your current default printer (possibly your only printer) is listed automatically. If you have another printer, you can choose it here.

 - *Paper size:* Letter-size paper measures a standard 8½ x 11 inches. If you are printing other sizes, you may need to choose a different paper size from this list.

 - *Quality:* The numbers here refer to dots per inch — more dots make smoother images. For the best prints, use the highest available numbers. You can switch to a lower quality for drafts and quick prints.

 - *Paper type:* Plain paper is the default option. If your printer supports other paper types, such as photo paper, you see those listed here.

Nothing lasts forever, but prints on regular paper printed at home probably won't last as long as top quality prints from a printing service. If you are printing at home for the ages, pay extra for *archival quality* photo paper. Print a test on regular paper first. That way, you don't waste special paper as you get the options set the way you want them. You can also buy pigment-based ink, instead of the standard dye-based, for longer lasting prints.

7. **When you're ready to print, click the Print button.**

 The dialog box indicates a wait. Your prints should come out of the printer soon after. The more photos you select to print at once and the more copies you specify, the longer this step takes, as Photo Gallery formats each print.

If nothing prints a few minutes after the dialog box disappears, check to make sure that the printer is on and its cable is connected. Choose Start⇨Devices and Printers. Double-click to open the icon for your printer and look for error messages.

Using a Printing Service

With a good personal color printer and special photo paper, you can produce excellent prints. However, printing services, including your local drugstore or discount store, can print your photos beautifully, cheaply, and quickly. When you compare do-it-yourself printing to using a printing service, doing it yourself may not be worth the effort and cost.

A printing service, such as those provided by Walgreens or Costco, generally offers prints at two standard sizes: 3 x 5 inches and 4 x 6 inches. Prints at these sizes are fairly inexpensive, but you still get high quality.

The higher the resolution of the original photo, the larger you may be able to print in good quality. Test a printing service with a small order of standard prints before ordering large prints.

You can choose to physically travel to a photo printing service (gasp) or you can find one online. With the latter, you post your photos to the online service and either have the prints mailed to you, or you stop by later to pick them up.

Any place that prints photos probably accepts online orders or prints from disk. Ask at the corner drugstore, department store, or neighborhood photo shop.

Before you use a printing service, print your photos on your own printer — keeping in mind that whatever their quality, the service's quality will be better. Test prints will give you a better idea of whether the photo is suitable for printing. Be sure to edit the photo appropriately before you print it.

Prints are usually rectangular. With cropping, your photo could be square. When printed, the image may have white space on either side or, worse, the square may be expanded to fill the rectangle, cutting off two edges of the original photo. Imagine a square photo of a person standing: If her head and feet touch the top and bottom edges of the rectangular print in landscape orientation, there will be added white space on either side; in portrait orientation, her arms may be off the edges. If her arms touch the left and right sides in either portrait or landscape orientation, she may lose her head and feet. Whether the printing service's software or a technician makes the adjustments, be prepared for a cropped photo to be adjusted in the printing process. Even an uncropped original probably has slightly different dimensions _(aspect ratio)_ than those of standard prints. This becomes a bigger issue with bigger, more expensive prints. So start with small prints.

Buying prints in-store

Just before the turn of the century, photo-printing services spread to drugstores and department stores everywhere. Businesses that still print photos are certainly set up to accept a disk from you. In some locations, you'll find an automated kiosk into which you insert some device containing your photos.

Your photos may be on a CD or DVD, although some services accept flash drives or camera memory cards. Place only the photos you want to print on

this disk — anything on the disk that you don't plan to print may result in unwanted prints. Extraneous files also make more work for you to pick and choose your prints.

Copy your photos directly to disk. Do not create a slide show or video from your photos on the disk before trying to print them.

You don't have to have a computer to print your photos. Take your camera to any photo printing service. There, you can insert your camera's memory card into the store's printing kiosk or just hand the whole thing over to an employee to take care of.

If you want to handle some photos differently — say, make an 8 x 10 print of only one photo — be very clear about the filename of the exception and make sure the service understands. Otherwise, you could end up with 8 x 10 prints of every photo on the disk. You might even consider having two separate disks so that you can keep the custom print separate from all the others.

If the service provides a photo kiosk — a kind of ATM for photos — follow these steps:

1. **Insert your disk.**

 If the kiosk can't read your disk, ask an employee what disks or formats the kiosk uses.

 The kiosk scans your disk and displays thumbnails of each photo found.

2. **Select each photo you want to print using a touch screen.**

 Look for check marks over the photos. Press your finger on a check mark or check box to change your selection.

 After you select your photos, the kiosk may offer an option to edit those photos. Even if you have already edited your photos, you can use the preview in the kiosk's edit process to confirm that the way your photos will print is acceptable.

3. **(Optional) Use the kiosk's menus to resize, crop, rotate, or move each photo within the print frame.**

4. **Specify the size of each print and the number of prints you want.**

 You may also have options for special printing, such as glossy, which has brighter colors, versus flat matte, which resists fingerprints.

5. **Choose between using the kiosk's own internal printer and using the store's larger photo printing machine.**

 The store's larger printer produces better quality prints.

Ordering prints with your browser

To order prints online, you create an account with an online printing service. Here are a few popular ones to consider (along with local pickup locations):

- ✔ www.costcophotocenter.com (pick up at Costco)
- ✔ www.shutterfly.com (pick up at Target)
- ✔ www.snapfish.com (pick up at Walgreens or Staples)

These are just a few, but you probably have lots of local alternatives, such as your local Wal-Mart or Walgreens drugstore.

To order prints through an online service, follow these steps, beginning with browsing the Web site you intend to use:

1. **Create an account and log in.**

2. **Upload your photos using tools provided by the service.**

 Some services upload pictures one at a time, but most allow you to upload many pictures simultaneously.

 Some services can pull your photos from elsewhere on the Web, including from Flickr.

 The resolution of your photos may have been reduced during uploading to nonprinting services. So for larger prints, upload files directly from your computer.

 Your service may enable further editing of the print after uploading. Ideally, editing isn't necessary because you've already done it. However, if you can preview the print, you may see some problem with the print area that you can fix through editing online.

3. **Select the size and number of prints for each photo. Select other options such as glossy finish or borders.**

4. **Specify delivery method.**

 Some services allow direct pickup or mail delivery; others offer only one of those.

5. **Before confirming your order, review each item in your shopping cart and pay attention to charges for handling, shipping, and tax.**

Figure 12-5 shows the confirmation screen from a series of steps in an online print order.

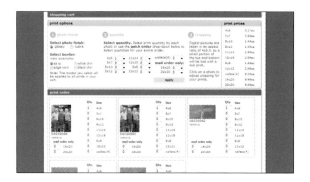

Figure 12-5: Ordering online involves setting up an account and uploading your photos.

Many services allow other people to order prints from your photos (with your permission, of course, and at their own expense). You may be able to create an online album for friends and family to access and order their own prints.

Ordering prints in Photo Gallery

If you're using Windows, it's easy to order prints online from any one of a dozen services supported by Photo Gallery. The process is very similar to the one described in the preceding section, "Ordering prints with your browser." The advantage of Photo Gallery is you can pick your photos before you begin your order, using Photo Gallery's tags, sorting, and editing.

Follow these steps:

1. In Photo Gallery, select the photos you want to print.

If you want to print more than one of your photos at the same time, use the check box in the upper-left corner of each photo to select those you want to print.

2. Choose File⇨Print⇨Order Prints.

A list of available services appears, as shown in Figure 12-6.

After you have used one of these services through Photo Gallery, that service appears directly on the Print menu, eliminating the need to pick it from the list the next time you order prints.

3. Choose a service from the list.

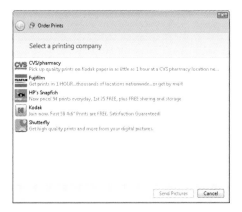

Figure 12-6: Choose an online service through Photo Gallery.

Most of these services have local pickup, many in just one hour. All of these services can mail photos to you, if you prefer. The process is similar for all services. You can use more than one service and change services anytime.

4. **Click the Send Pictures button.**

 A privacy notice opens, telling you that your photos may contain information you consider private. (Odds are, there is no financial data or anything that would contribute to identity theft in this data. See Chapter 8 for information on the data stored in photos.)

5. **Check the Don't Show This Again box, if you don't want to see this dialog box in the future and click the Send button to continue.**

 A dialog box appears as each photo is uploaded to the service you selected. How long this takes depends on the number of photos, the size of those files, and the speed of your Internet connection. Up to a minute per photo is a reasonable estimate.

 When your photos are done uploading, the order form appears next, as shown in Figure 12-7. Thumbnails of your selected photos appear, along with boxes to specify how many prints you want of the available sizes. You may see some sizes marked as not recommended (using an exclamation point), meaning that the service doesn't expect the quality of that size print to be acceptable. The price for the prints of each photo appears next to that photo. Although some services, such as CVS, display a total on this screen and a link to update that total as you make changes, not all services do so. In some cases, you won't see a total until the end of the process.

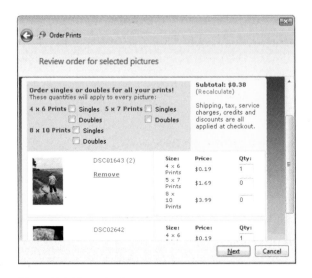

Figure 12-7: The order form.

6. **Change the quantities (in the Qty boxes) you are ordering as you wish.**

 You can also click a link to remove a photo you don't want to print (or set the quantity to zero).

7. **Choose between photo finishes:**

 • Glossy is slick and shiny

 • Matte is textured and resists fingerprints

8. **Choose Next to continue with your order.**

 The delivery options screen appears next.

9. **Choose between local pickup (based on your zip code) and delivery by postal mail.**

 Some services may not offer a choice in delivery method.

10. **Give more details on how you want to get your photos:**

 • *If you selected local pickup:* A list of locations appears. Choose the most convenient location. If you chose mail delivery, enter your mailing address and choose shipping options. Click Next to continue.

 • *If you chose to pick up your prints:* A dialog box may appear to allow you to select what time to pick them up. Make a choice and click Next to continue.

11. **Fill in the account setup information and click Next to continue**.

 All services require a name, e-mail address, and a password of your choice (keep a record of your password in a secure place).

 You may receive a security alert regarding a certificate for this print service. This is a standard browser security measure and not a concern if you see this for a reliable merchant you are familiar with. Choose Yes to continue.

12. **Enter your credit card info in the next dialog box. Use your name exactly as it appears on your credit card account. Click Next to continue.**

 A final confirmation of the order and price appears.

13. **Confirm your order and click Next to continue.**

 A receipt appears.

14. **If you want a copy of this receipt, select the on-screen Print option.**

 You should also receive a receipt by e-mail.

15. **Click Next to continue. Click the Finish button on the last dialog box.**

The next time you use this service to print, the process is the same, except you log in using the information you used to create your account.

Printing books and novelties

You can print your photos in many ways other than standard prints. Publish your own photo book in sizes ranging from postcard-sized booklet to coffee-table hardcover.

Photos can be printed on almost anything, including mugs, t-shirts, other clothing, even cakes. You can order high-quality business cards, postcards, or notecards that showcase your photos. You can even put your photos on postage stamps.

The process of ordering specialty items is very similar to ordering prints online: Find a service, select the product, upload a file, and customize some settings.

Here are six services that provide options beyond standard prints:

 ✔ www.shutterfly.com

 ✔ www.mypublisher.com

 ✔ www.blurb.com

- ✔ www.zazzle.com
- ✔ www.moo.com
- ✔ www.cafepress.com

Look very closely at previews and watch for warnings about resolution to be certain your prints look best.

Figure 12-8 shows part of the process of ordering a photo postage stamp online.

Figure 12-8: Stamps, mugs, clothing, and more can bear your photos.

Part V
The Part of Tens

The 5th Wave By Rich Tennant

"That's a lovely scanned image of your sister's portrait. Now take it off the body of that pit viper before she comes in the room."

In this part . . .

The Part of Tens is the icing on every *For Dummies* cake, the sweet stuff you can't get enough of. Here are ten tips for taking or making better photographs. Use Picasa to edit photos and publish them to the Web. Finally, what you can do with a camera and no computer. What are you waiting for?

Photo by Merri Rudd

13

Ten Tips for Better Photos and Videos

*B*efore you begin shooting pictures, a few simple steps can ensure that your photos and videos turn out as well as they can. After you've taken the shot, some simple edits can improve photos even more. This chapter provides ten easy tips for taking better photographs and videos.

Know Your Camera

To take pictures, all you really have to know is how to turn the camera on and confirm it is in Automatic mode. However, your camera is capable of much more, even if you don't use all of its features. Beyond the topics covered elsewhere in this book, here are six more features to look for and adjustments you can make on your camera:

- Turn off digital zoom to avoid pixilation (jagged dots).
- Turn on image stabilization to avoid blurring.
- Turn off automatic flash to avoid unexpected flashes that may startle your subject. Automatic flash may go off pointlessly in landscapes or when using the zoom or macro feature.
- Turn on flash when the scene is bright but the subject is in shadow or lit from behind (*force* or *fill flash*).
- Use exposure compensation to push a photo lighter or darker.
- Use white balance to compensate for fluorescent, incandescent, and other tinted light sources.

Become One with Your Camera

The camera does you no good if you leave it somewhere else. Take your camera with you. Don't be afraid to look like a tourist or a camera geek. And the camera does you no good if it's turned off. Have the lens cap off, the camera on and in hand, and be ready for the next great photo.

Even so, practice discretion. People may not want you to photograph them, so be considerate. Point your camera down when you're not taking pictures. Ask for permission to take photos of people you don't know. Flowers and animals, on the other hand, seldom object to being in photos.

Use a Tripod

A tripod is a must for shooting under low light or with some longer lenses. A tripod is also quite handy for self portraits and group portraits. You may want a full-size tripod, but everyone needs a pocket-size version at a minimum. Figure 13-1 shows just some of the size variations available, plus a monopod leaning against the wall. In selecting a tripod, look for one that is easy to adjust and which feels steady.

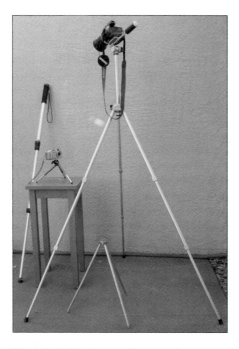

Figure 13-1: Tripods come in many sizes.

For videos, a tripod reduces distracting camera movements. Good tripods let you pan smoothly left, right, up, or down.

Change Your Perspective

Move around as much as you can under the circumstances. Try crouching for shorter or lower subjects. Try holding the camera over your head to clear a crowd. (A tiltable LCD is very helpful in such cases.) Move left and right of the subject to try different angles. You'll discover interesting facets of the subject and new angles on the light. Photograph flowers up close with the light source behind them for interesting color and details. In Figure 13-2, the cosmos blossom on the left is seen from the front, whereas the shot on the right is from behind, revealing the translucent nature of flowers (and leaves).

Figure 13-2: Change your perspective to reveal insights into your subject.

If you move while taking videos, do so very slowly. This includes panning and zooming in and out — go slowly.

Take Lots of Pictures

Aside from your initial investment for the camera, digital photos essentially cost you nothing. Go wild. Don't take just a few photos, take dozens. Don't come back from vacation with 50 photos; come back with 500 — you just need to remember to pack enough memory cards to fit 500 photos, if you don't plan to move photos from camera to computer as you go. Examine your photos for new ideas or mistakes in composition and exposure.

This liberation comes with an obligation: Don't expect anyone to look at every picture you take, no matter how much they love you. Before you show your photos to friends and family, select the better ones for show and skip (or delete) the less interesting ones. If you have five cool shots of a scene, pick the best, and maybe the second best, to show.

Be Quiet

If you're shooting videos, avoid making distracting sounds or engaging in distracting conversations (or monologues, as the case may be). Let people know when you're shooting video or "what'cha doin'?" could end up on the soundtrack. Keep in mind other noises such as wind and traffic you might tune out but which could spoil a video.

Being quiet matters in taking photos, too, especially with wildlife or candid shots.

Keep It Short

Videos produce large files that take up lots of storage space, as well as the time it takes to copy large files to your computer. Consider your audience: Do they want to sit through 20 minutes of a kid in a sandbox? Keep most videos short — under a couple of minutes, rarely over five minutes.

Back Up Your Files

It should be a given with all digital data that you have a plan for frequent and regular backups. (Odds are you don't. No show of hands here.) There are many different schemes for backup — from full backups of the entire computer to selective backups of individual folders or files. The question is: What will you do when you change your mind about an edit or deletion? Move your files from the camera to the computer and back them up before you begin deleting or editing. Then back them up again after you've carefully organized, edited, and tagged them.

Learn to Edit

You can perform the most basic editing functions with tools you may already have or that you can download from the Web for free. These essential edits include rotating, cropping, and resizing photos. Much more sophisticated editing allows you to tweak individual pixels and completely transform a photo. Start with the basics and move on to fancier tasks when you're ready.

Figure 13-3 shows the original photo of a praying mantis on the left. The background is distracting (and irrelevant) and the tilted post is, too. The cropped and straightened photo appears on the right of Figure 13-3.

Figure 13-3: Simple edits can greatly improve some photos.

Share and Participate

If you like your photos, someone else will, too. Share your photos a few at a time by e-mail or in larger batches through a Web-based photo or video sharing site. (Don't e-mail videos, just upload them.) Give back to your community by looking at other people's photos and commenting appropriately. Everyone wants his or her photos to be seen.

Ten Tips for Picasa Users

*P*icasa is from Google, the search engine people. (There's an understatement.) Picasa has two separate components that do not have to be used together:

- ✓ Picasa Web Albums provides Web space for photos, much like Flickr or Facebook. I like Picasaweb's albums and slide shows more than those other two services. (But I use all three for different purposes.)

- ✓ Picasa software is a photo organizer and editor, comparable to Windows Live Photo Gallery.

When you set up an account with Google for any service, such as Gmail, Google Calendar, Google Docs, or Picasa Web Albums, that account connects you to all of Google's services. To sign up for Picasa, go to `http://picasa web.google.com`. Picasaweb lets you create up to 10,000 albums of 1,000 photos each or up to 1GB (you can pay $5 per year for 20GB).

This chapter contains suggestions for getting started with Picasa Web Albums and Picasa software. Each of these facets of Picasa has some pretty cool features.

Change Your Gallery URL

When you first set up your Picasaweb account, the Web address you share with others is based on your Google account username or ID number. If you want something catchier, you can change your URL. Choose Settings➪Photos Settings➪General➪Your Gallery URL. For example, I changed the URL for my gallery (shown in Figure 14-1) to `http://picasaweb.google.com/photosbymjh/`.

Figure 14-1: Picasa Web Albums.

Your account has an unlisted gallery URL for private sharing of photos not visible to the general public. To see this URL, choose Settings⇨Photos Settings⇨General⇨Your Unlisted Gallery URL. The URL is generated automatically. You can reset that URL (but not specify it) by clicking the Reset Unlisted Gallery Secret Key link.

Share and Link to Your Albums

When you find a photo that you want to share with friends and family, you have a few ways to do so:

- ✔ Click the Share button to create an e-mail with a link and an embedded thumbnail. If you have Gmail contacts, you can e-mail those contacts individually or as groups. Or, you can manually enter any valid e-mail address.

- ✔ Click the specific buttons for sharing on Blogger (the B icon) or Twitter (the t icon). The first icon next to Post On is for Buzz.

- ✔ Copy the URL from the Paste Link in Email or IM box to include in an e-mail or instant message.

- ✔ Copy the code in the Paste HTML to Embed in Website box to include the photo on your blog or Web site.

- ✔ Click the Embed Slideshow link (see Figure 14-2) to include a slide show on your blog or Web site.

Send link in e-mail. | Create a slideshow.

Include on your web site.

Figure 14-2: Copy code for a static link or a dynamic slide show on your own blog or Web site.

Rearrange Your Photos

If you aren't happy with the order in which your photos appear in an album, rearrange those photos. Browse the album and choose Edit➪Organize & Reorder (see Figure 14-3). You can use the Sort Photos By function or simply drag and drop photos in any order. Click the Done button when you're finished.

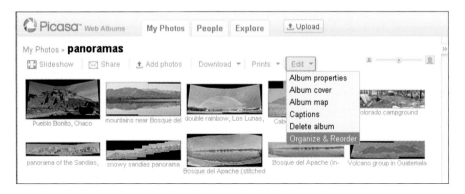

Figure 14-3: Edit the order of photos in each album.

For an album, the Edit button also provides these five functions:

- **Album Properties:** Title, date, description, place taken, some sharing options.

- **Album Cover:** Select which photo appears on your home page.

- **Album Map:** Use Google Maps to pinpoint a location for the photos in this album.

- **Captions:** Edit the text associated with each photo.

- **Delete Album:** Are you sure?

Edit Your Photos

Browse a photo and click the Edit button for these six options (see Figure 14-4):

- **Set as Album Cover:** Make this photo appear on your home page.

- **Delete This Photo:** Are you sure?

- **Edit in Picasa:** If you have Picasa installed on your computer, this option opens Picasa to edit the copy of the photo on your computer (the *local* copy). When you finish your changes, click the Update Online Copy with This Version button (the icon looks like two snapshots connected by a recycle symbol).

- **Edit in Picnik:** Online editor that doesn't change the local copy.

- **Copy to Another Album:** Select the album you want this photo copied to.

- **Move to Another Album:** Select the album you want this photo moved to.

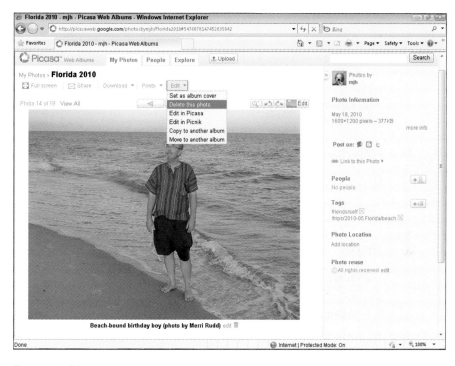

Figure 14-4: Edit individual photos.

Use Picasa Web Albums with Windows Live Photo Gallery

Yes, you can. This is the best of two worlds. You just need to add a plug-in to connect Windows Live Photo Gallery (WLPG) with Picasa Web Albums. Follow these steps:

1. **In WLPG, click the Create tab. In the Publish section, click the triangle with a line over it to expand that area.**

2. **Click Add a Plug-In.**

 A Web site opens in your browser.

3. **Click the link for Picasa Web Publisher (also Picasa Web Albums Live Publisher).**

 Another Web site opens.

4. **Click the Free Download link. Run the download.**

5. **After running the installer, restart WLPG. In the Share section of the Home tab, click the Publish on Picasa Web Albums icon.**

 It looks like a piece of a jigsaw puzzle. (You may have to scroll through these icons.) The same puzzle icon appears in the Publish section of the Create tab.

6. **Enter your Picasaweb account information to log in.**

 Now you can upload photos to Picasa Web Albums from Windows Live Photo Gallery.

Consider adding a *picasa* tag in WLPG for those photos you upload to Picasaweb. (If you're compulsive about this stuff.)

Follow the same steps to install plug-ins for Facebook and YouTube.

Install Picasa Software

Picasa software is available for free from Google (www.picasa.com). Download, install, and run the software. (On the last screen of Picasa Setup, note the options to set Google as your default search engine and to send anonymous usage stats to Google — you can uncheck these, if you wish.)

The first time you run Picasa, you select where to search for photos: Limit the search to "My Documents, My Pictures, and the Desktop," or search the whole computer, which is selected by default.

Another first-time option concerns which file formats to give Picasa dominion over. Although you can use multiple programs interchangeably to view or edit your photos, only one can be the default program — the one that opens a file when you double-click it. If you use WLPG, click the Select None button until such a time as you prefer to use Picasa by default. Otherwise, the next time you run WLPG, it will ask to be your default program.

Remember to Save Your Changes

WLPG automatically saves changes. For some people, that takes getting used to. Picasa has a different issue regarding saving changes. When you edit a photo and return to all of your photos, you see the edited version of that photo. You don't see any message that you need to save those changes. I'm not worried about losing the changes in Picasa. But if you access that photo outside of Picasa (for example, using Windows Explorer, as shown in Figure 14-5), the photo you see there (and copy or move) is the unedited original.

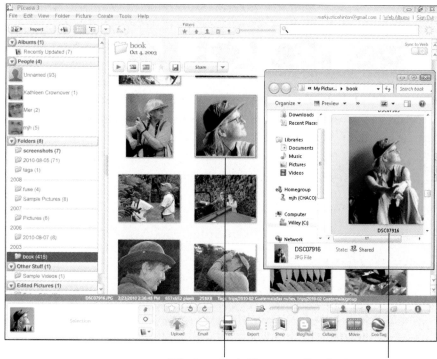

Edited version in Picasa. Unedited version in Explorer.

Figure 14-5: Did you remember to save your changes?

If you exit Picasa, the original photo is the one you see using any other program. To make your changes stick, you have to save (Ctrl+S or right-click) while you're in edit mode or with the photo selected as you look at all photos. Although it is not unusual to have to save changes deliberately, it is very unusual that a program doesn't remind you to do so and doesn't have a Save button or link on-screen. (In fact, I see no indication on-screen that the photo has changed, except for the Undo button on the edit screen.)

Publish to Picasa Web Albums

Although you don't have to use Picasa Web Albums and Picasa together, they're a natural fit. In particular, take advantage of these options when working with both:

✔ Pick a photo on the Web to edit on your computer. See the section "Edit Your Photos."

✔ Use Sync to Web (in the upper-right corner of any album or folder) and Picasa copies changes you make on your computer to Picasa Web Albums. No need to remember to upload. To prevent individual photos in a synced folder from uploading, right-click the photo and choose Block from Uploading. Or sync only starred photos (choose Tools➪Web Albums➪Sync Starred Photos Only).

Use Gmail to Send Photos

Gmail is a very popular Web-based e-mail service from Google. Hey, Google makes Picasa, too. It's no surprise you can use the two together. (To do this with WLPG requires you to install e-mail software on your computer and set up your Gmail account in that software.)

Select one or more photos in Picasa. Click the Email button at the bottom of the screen and select Google Mail. Enter your Gmail account information and sign in. (If you have an account with Picasaweb or Gmail, you have an account with both.) The Compose Mail window appears with thumbnails of your photos. You can erase the canned text Picasa sticks in the subject line and the body of the e-mail message.

Hide Buttons in the Toolbar

Picasa software features over a dozen buttons at the bottom of the screen (refer to the bottom of Figure 14-5). It looks like a bad video game. Although you should take some time to consider these buttons, get rid of the ones you never need. Right-click one of the buttons and select Configure Buttons (or choose Tools➪Configure Buttons). Double-click buttons on the right to remove them from the screen (or on the left to add them).

If you would like to use Picasa to upload photos to Flickr or Facebook, you can install buttons for these functions (from `http://picasa2flickr.sourceforge.net` and `http://apps.facebook.com/picasauploader`, respectively).

15

Ten Tasks That Don't Require a Computer

1 think half the fun of photography involves having photos on a computer. Then you can view, edit, print, e-mail, and publish to your heart's content.

However, you don't have to have a computer to do some of these things. Even if you own one, you might find yourself away from your computer but ready to do more than take photos. This chapter looks at some things you can do *sans* computer.

The longer you go without access to a computer, the more spare memory cards you need, as well as a system for keeping the cards in order and safe when they aren't in the camera.

Keep your batteries in mind and extra batteries on hand, because you don't want to run out of power in the middle of any camera operation.

Use Your Camera for More Than Picture-Taking

That LCD is for more than composing shots. It enables you to do a few things directly on any camera:

- ✓ **View photos and videos.** Zoom out for a display of multiple photos and zoom in for details in a selected photo (pan over the photo with the arrow buttons).

- ✓ **Delete photos.** With the photo you intend to delete on the LCD, use the button or menu item for deleting (usually a trashcan icon).

✓ **Edit in-camera.** Your camera may enable you to rotate, crop, fix red-eye (as well as avoid red-eye), adjust colors, resize, or add special effects like borders or intentional distortion (fish-eye lens effect).

Print at a Store

Take your camera or your memory card to a local drugstore or discount store. If they print photos, more than likely they can print photos directly from your card. An in-store kiosk reads all kinds of cards and lets you select just those photos you want to print. You can even edit photos there. If you don't want to do it yourself, store personnel can take care of the details for you. See Chapter 12 for more on printing.

While you're at the store, pick up a lens cloth suitable for cleaning eyeglasses. Gently dust your camera lens periodically. Use a soft cloth to wipe down the whole camera now and then.

Print on Your Printer (Without a Computer?!)

Some printers connect directly to cameras via USB using the PictBridge standard. Use your camera to mark selected photos for printing and to initiate the PictBridge session. Other standards include Picture Transfer Protocol (PTP) and Digital Print Order Format (DPOF).

Some printers have a built-in card reader. In that case, you select the photos on the printer itself.

You may opt for a full-size printer at home or a small, portable printer for the road.

Show Your Photos and Videos on TV

Use the cable that came with your camera to connect the camera to a TV (see Figure 15-1). Not only can you show photos, but the big screen may also make it easier to deal with the camera menus for other tasks. Some cameras connect to a TV using the older RCA connectors (red and white; if there is a yellow connector, that's for audio). Newer cameras may use an HDMI connector for HDTV. Check your owner's manual.

Figure 15-1: Connect your camera to a TV.

Some of the newest TVs have built-in card readers. Some DVD players and the Roku XR streaming media player accept USB devices. That has the added advantage of letting you use the TV or player remote control for your photos. (Very few cameras have their own remote controls.) Get an adapter to insert your camera memory card to act as a USB flash drive. Look at an office supply or discount store for such devices.

Use a Digital Photo Frame

Buy a digital photo frame that accepts the same card your camera uses. Remove the card from your camera and insert it in the digital photo frame — instant slide show! Some frames let you edit (especially rotate or delete) photos from the card. Some have remote controls.

Use a Media Player

Okay, now you're treading ever-closer to getting a computer. However, many media players on the market accept memory cards, especially the SD type. You could use one of these to display photos.

If you actually want to copy photos from your memory card to a device for backup purposes or to free space on the card, there are such devices. However, for the price and the added value, I think you're better off with a netbook computer.

Upload Wirelessly

If you have a camera with built-in wireless connectivity, plop down in a coffee shop or airport terminal and press a button to upload your photos.

If your camera accepts a full-size (not a mini or micro) SD card, Eye-Fi (`http://www.eye.fi/`) sells cards with wireless capability built into the card, as well as GPS for geotagging photos as you take them.

Use Your Cellphone Camera

Most cellphones have built-in cameras comparable to a relatively low-end P&S. The iPhone v4 deserves special note here because it shoots 5 MP and because the *apps* (applications, software) give the iPhone phenomenal editing options.

Most cellphones let you select a photo as your desktop background. Most also let you link a photo to a contact, so that photo appears when that person calls.

With a cellphone and Internet service, you can e-mail and publish photos out of your hand from almost anywhere.

Bird Watching

A few superzooms have greater magnification than a pair of binoculars. More importantly, an adequate photo may settle all dispute about whether that was a magnificent hummingbird.

Digiscoping involves pairing a camera with a spotting scope, which many birders use (or with a telescope). You may have success simply holding the camera up to the lens of the scope — the LCD is very useful here. I took the photo in Figure 15-2 by holding a camera up to one binocular lens. In fact, a pocket-size P&S may be more suitable than a superzoom. Try zooming in with the camera, but that may create a tunnel effect called *vignetting*.

Figure 15-2: Avoiding the camera's zoom may prevent *vignetting* (tunnel effect) while digiscoping.

For easier digiscoping, buy a mounting bracket suitable for both your camera and the scope. Or put the camera on its own tripod for precisely aligning scope and camera.

Zeiss (www.zeiss.com) makes a spotting scope with a decent built-in camera. The results are impressive. On the other hand, some binoculars with built-in cameras use a separate lens for the camera, so you don't actually shoot the magnification you see through the lenses.

Bop a Bear on the Nose

A few years ago, a visitor to Yellowstone National Park defended herself from an aggressive bear by hitting it on the nose with her camera. Don't try that with a skunk. (That line — the funniest in the book — belongs to my wife. Thanks, dear.)

Index

• *D* •